CW00323678

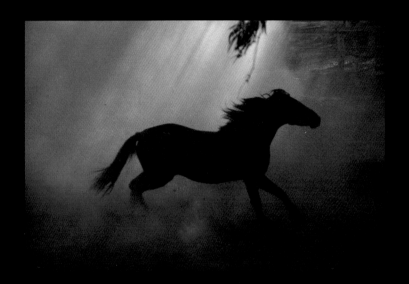

And God took a handful of southerly wind,

blew His breath over it and created the horse.

Bedouin Legend

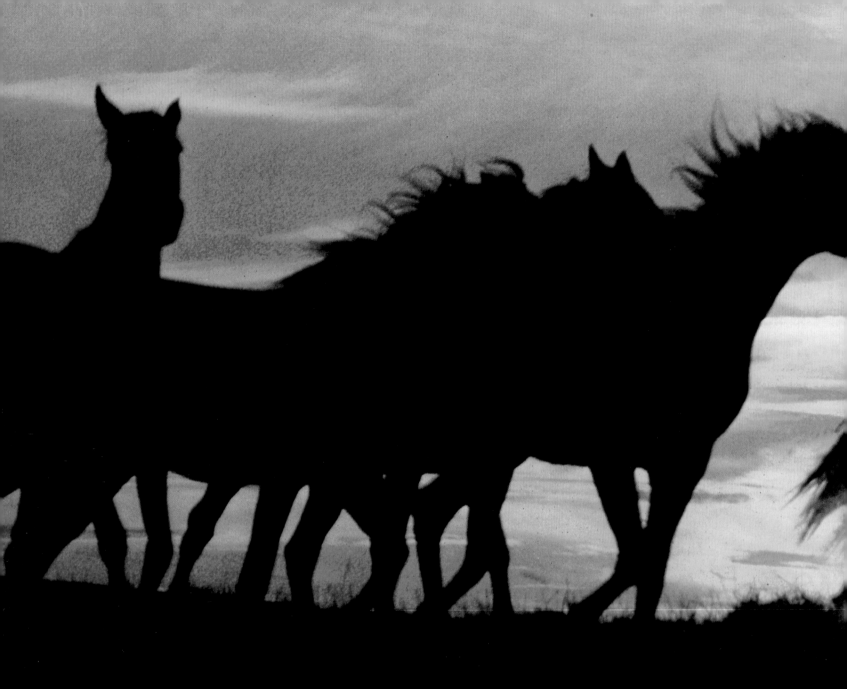

foreword by
JAMES A. MICHENER

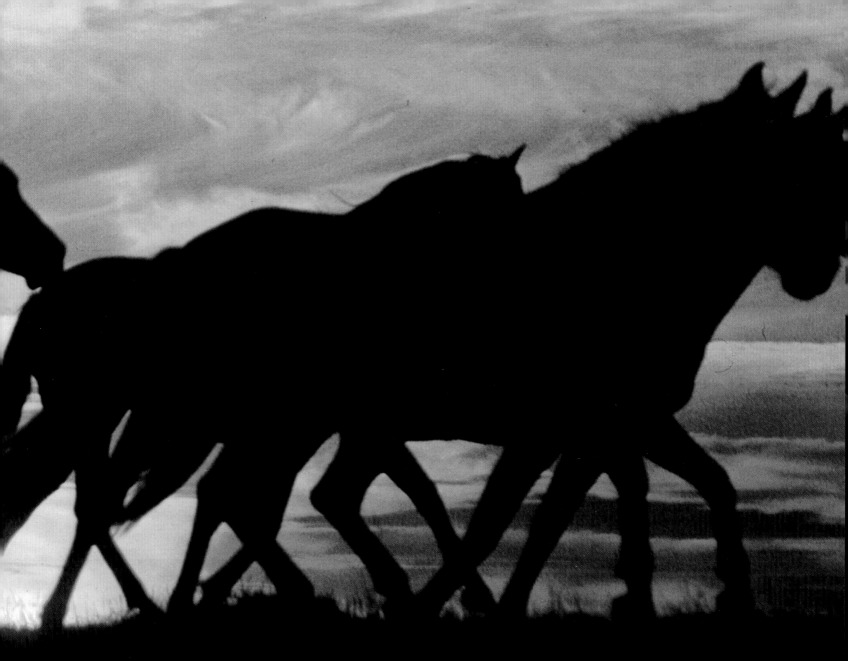

ROBERT VAVRA
EQUUS
the creation of a horse

For John Fulton

In all Sevilla not to match with you
Has lived a prince so royal,
Nor any heart so staunch and loyal.
Golden airs of Andalusian Rome
Circled your head and gilded it.
How graceful with your paints and brushes
And in the ring.
And on Majestad how you brightened
The fair days every spring.
Now ride together
Through the clouds of fame,
To be remembered with every mention
Of your noble name.
Olé! John Olé! Olé! Olé! Olé! Olé!

EVERGREEN is an imprint of Benedikt Taschen Verlag GmbH

© 1998 for this edition: Benedikt Taschen Verlag GmbH
Hohenzollernring 53, D–50672 Köln
© 1977 Robert Vavra
© 1977 for the English language edition: William Morrow and
Company Inc.
Drawings and design: John Fulton

Library of Congress Catalog Card Number: 98-84603

Printed in Spain
ISBN 3-8228-7621-6
GB

DURING my lifetime I have met dozens of writers and photographers in dozens of different countries, but I have encountered none who could both write and photograph with the artistry of Robert Vavra. The fact that he is also a devoted naturalist makes him the only person I know capable of producing this gracious tribute to the horse.

Though equus has fired the imaginations of painters from the prehistoric hunter-artists of Altamira to Leonardo da Vinci, Velázquez, Goya and Picasso, still, in the history of photography no cameraman has recorded the horse with such excitement and personal style as are shown in these pages—pictures so exquisite they are of universal appeal.

I met Robert Vavra almost twenty years ago, shortly after he had arrived in Spain, when he was still more boy than man. Few of us who knew him in those days, including creative men like Ernest Hemingway, David Lean and Tom Lea, made his acquaintance without being impressed by his enthusiasm, his natural manner, his feeling for animals, and his personal style as a photographer. While others who admired his work left Sevilla, I was so impressed by his distinct style and his sensitivity to people and places that, one afternoon while I sat in his studio studying a batch of his recent photographs, it occurred to me that he might be just the person I had been looking for to help me with a book I had long planned but never written: a philosophical appreciation of the Spanish experience. To accomplish this I would need both words and photographs, and it seemed highly probable that Vavra could supply the latter. However, at that time I did not raise the question of our working together, because I was entwined with another subject which would absorb my attention for some years: a novel on the Holy Land.

In the spring of that year 1959, I often accompanied Vavra to the wild marshes of the Guadalquivir where he was photographing and taking notes on the Spanish fighting bull, an animal he felt to be in danger of eventual extinction and about which he was preparing a book. During those delightful outings, I had the opportunity to appreciate his naturalist's eye as he pointed out creatures and told me of their ways, among them the Bee-eater and the Hoopoe, birds which would later become important in my own work.

It was not until 1966 that I managed to get back to Sevilla for Holy Week and its ensuing feria; now I was ready to devote uninterrupted time to the book on Spain, and I proposed to Vavra that he cooperate with me in an unusual way: 'I want photographs, but not the ordinary kind presented in the ordinary way. If I write about the cathedral at Toledo, I don't want the reader to see on the facing page a faithful shot of the cathedral's facade. I want you to roam Spain at the same time I do, you going your way, I going mine. When we're finished, we'll put the text and photographs together in some haphazard way, so that your portrait of a fighting bull might possibly face my words about the cathedral.' Because of Vavra's special intuitions I never doubted that his photographs and my words would unite to form the impression I sought. When *Iberia* was published half my correspondents said, 'I liked the pictures better than the text.' The other half said, 'When a man writes about Toledo cathedral in an illustrated book, I expect to see a photograph of the cathedral.' But all agreed that it was a happy union.

While I was finishing my text on *Iberia* Vavra started an interesting new project. He had seen, been inspired by and begun to write a book around paintings by Fleur Cowles. He was now working in reverse; in my book he had supplied the graphics to accompany my words, in *Tiger Flower* he was producing the words to accompany someone else's graphics. As he organized unrelated paintings into an artistic sequence and wrote a story around them his poetic insight and sense of direction appeared. When I saw *Tiger Flower* I was reassured in my early conviction that Vavra was destined for fine things in the field of nature writing and the photography of wild life.

As I first turned the pages of this book with each photograph as exquisite as the one before, I expected to come across one or two that weren't quite up to the rest, but I am sure the reader will agree that each of the pictures in this book has its own lovely unity; each is not only a revealing study of the horse, but also an example of the author's unmistakable style. Last spring when Vavra and I stood together in the darkness of the Denver Museum, admiring the millions of years old remains of the ancestral horse, and he told me of his plan to do this book on horses, I would not have believed that in less than forty full working days he could take all the photographs reproduced here. But in the fall of that same year I received the Spanish edition of this book. Those amazingly short days of work seem a special feat when one considers that all of the horses were photographed at liberty in situations where Vavra had little or no control of his subjects. Other fine books of photographs I have seen, regardless of their themes, were taken over periods that ranged from two to ten years.

The photographs here are a feast for the eye, but Vavra's sensitive combination of them with quotations from all ages and peoples makes this book a special experience—one in which the eternal beauty of the horse is revealed again and again. Vavra has also provided us with more than fifty pages of notes on his personal observation of the social behavior of equines which laymen as well as students of animal behavior will find intriguing.

Some years ago the enterprising curators of the Amon Carter Museum in Fort Worth came up with a great idea for an art exhibition: gather from all over the world examples of great art depicting the Appaloosa horse, and what they were able to assemble was astounding. They had paintings from Persia, from China, from Africa and especially from Europe. Rubens, Titian, Delacroix had all depicted these majestic animals in their works, and had done so in a manner which proved they loved horses.

Robert Vavra, with his camera and pen, has now produced a worthy successor to that exhibition. For these photographs are works of art; they are interpretations of the horse as perceptive as those done by Stubbs and Remington. They are a joy to see, because they evoke the inner nature of the horse, and the words which Vavra will later quote from things I've written will indicate my love for this splendid animal.

James A. Michener
St. Michaels, Maryland

February 24, 1977

EQUUS
the creation of a horse

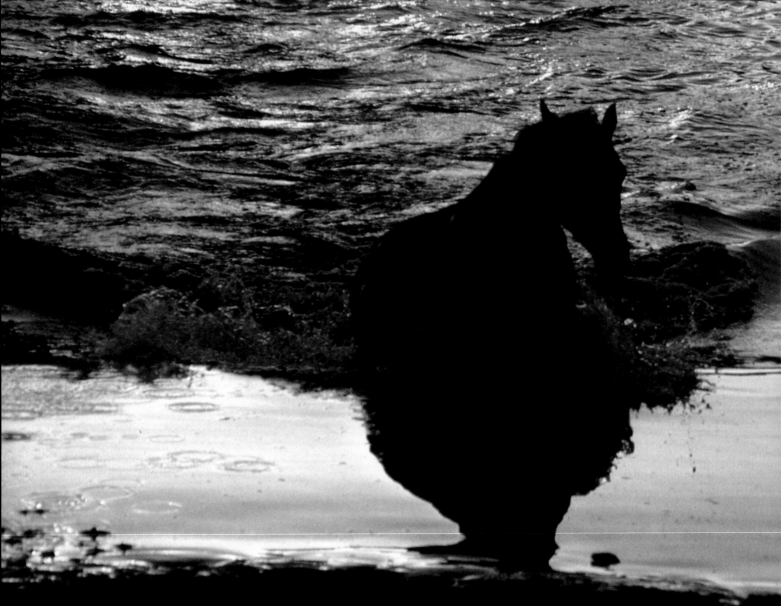

He arrived as equus some two million years ago,

as splendid an animal as the ages were to produce,

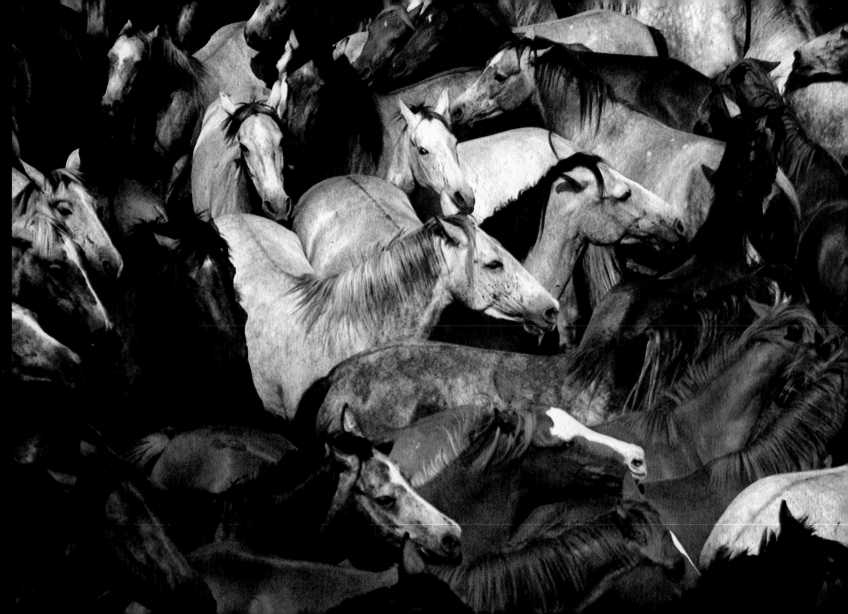

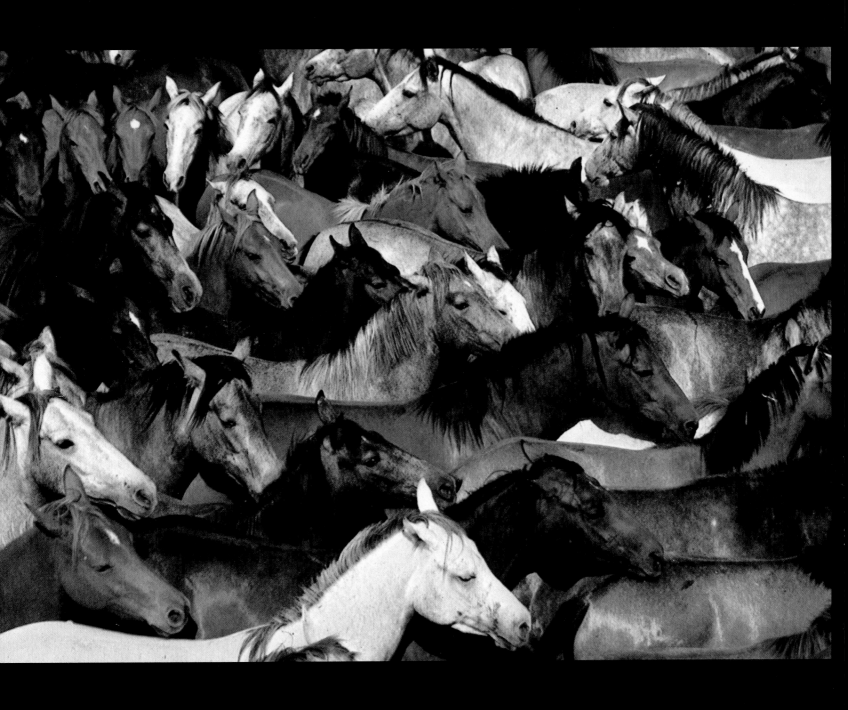

the four winds are blowing

some horses

are coming

Teton Sioux — Song of the Horse Society

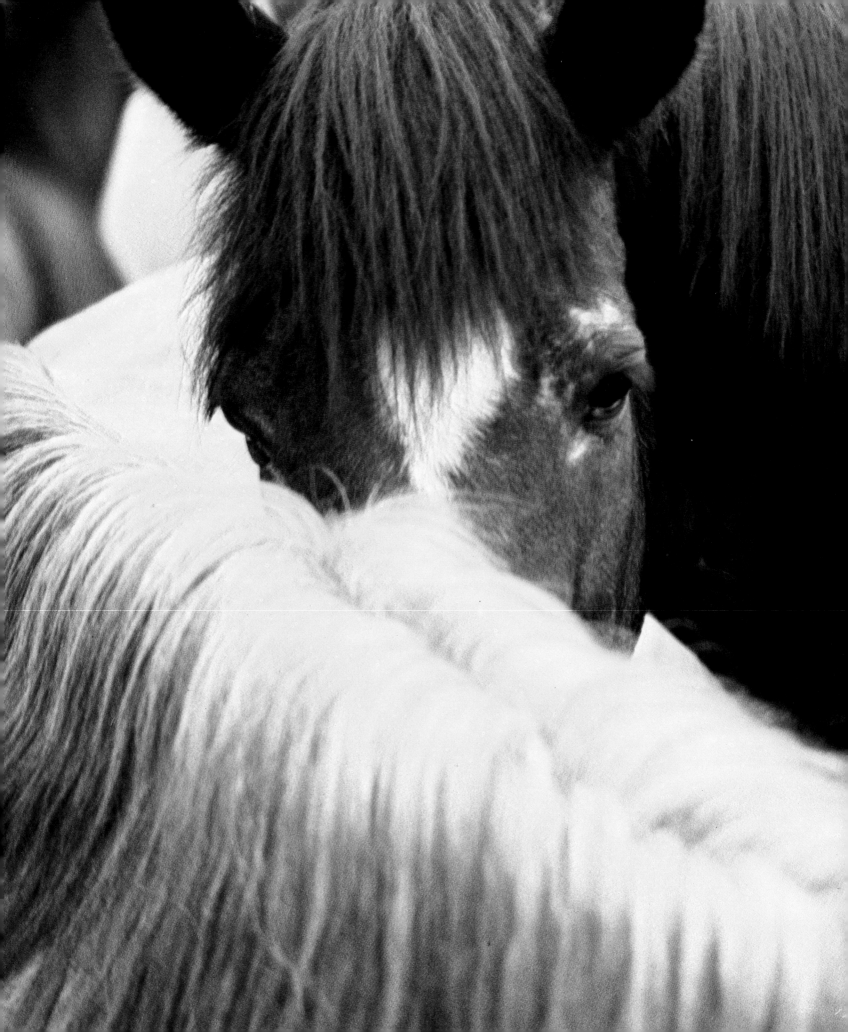

. . . they move in herds, assemble

for the pleasure of being together,

and become quite attached to

each other.

Buffon

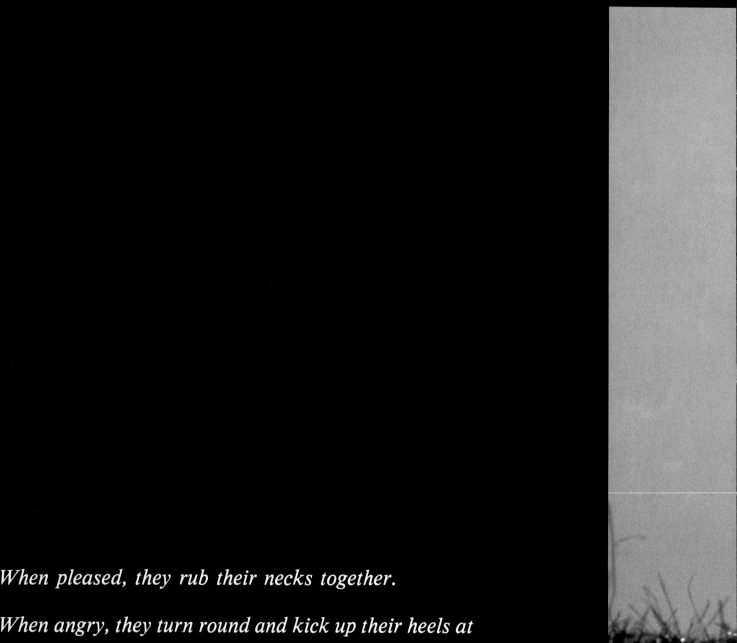

When pleased, they rub their necks together.

When angry, they turn round and kick up their heels at

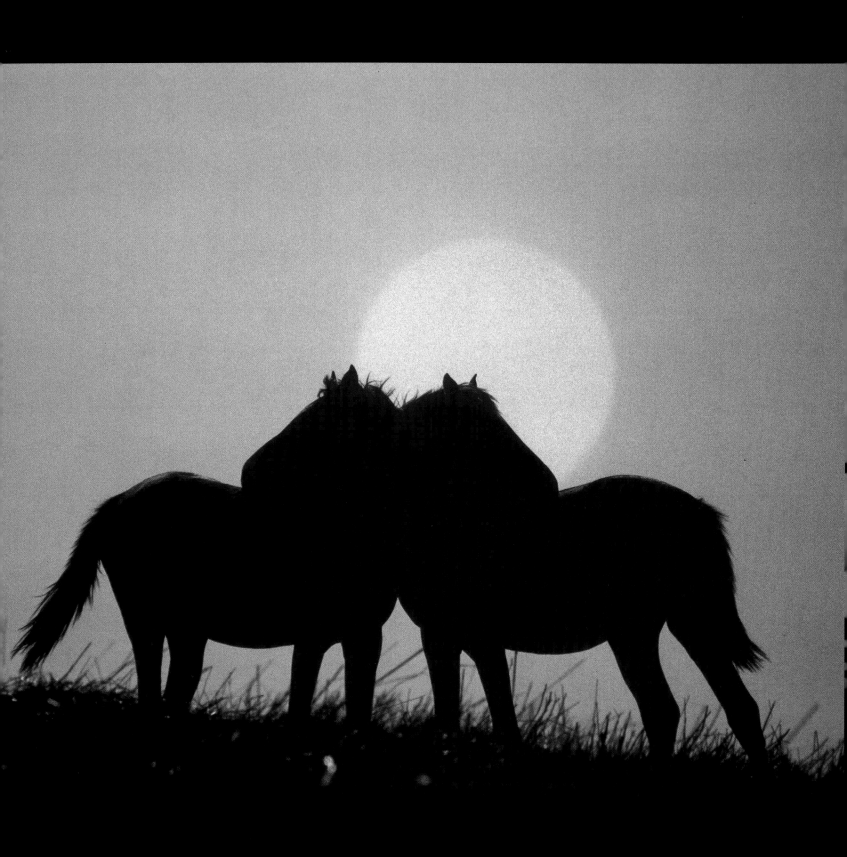

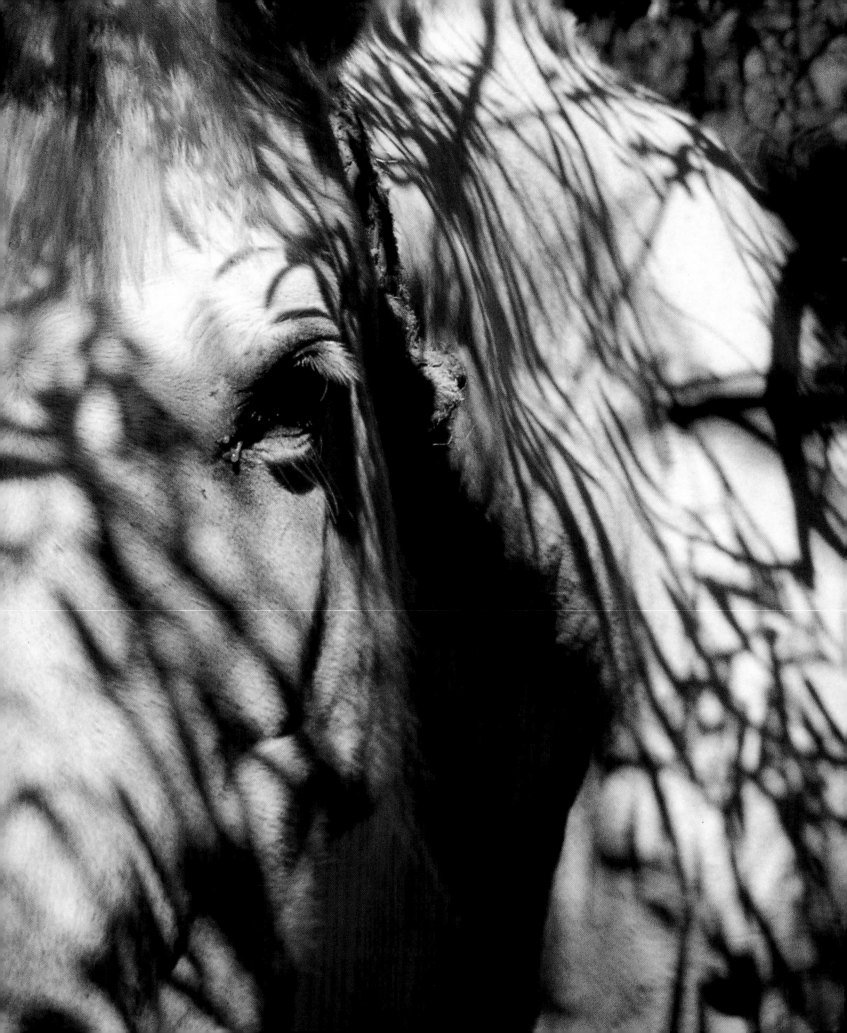

A strange stillness

dwells in the eye of

the horse,

a composure that

appears to regard

the world from a

measured

distance . . .

It is a gaze from

the dephts of a

dream . . .

Hans-Heinrich-Isenbart

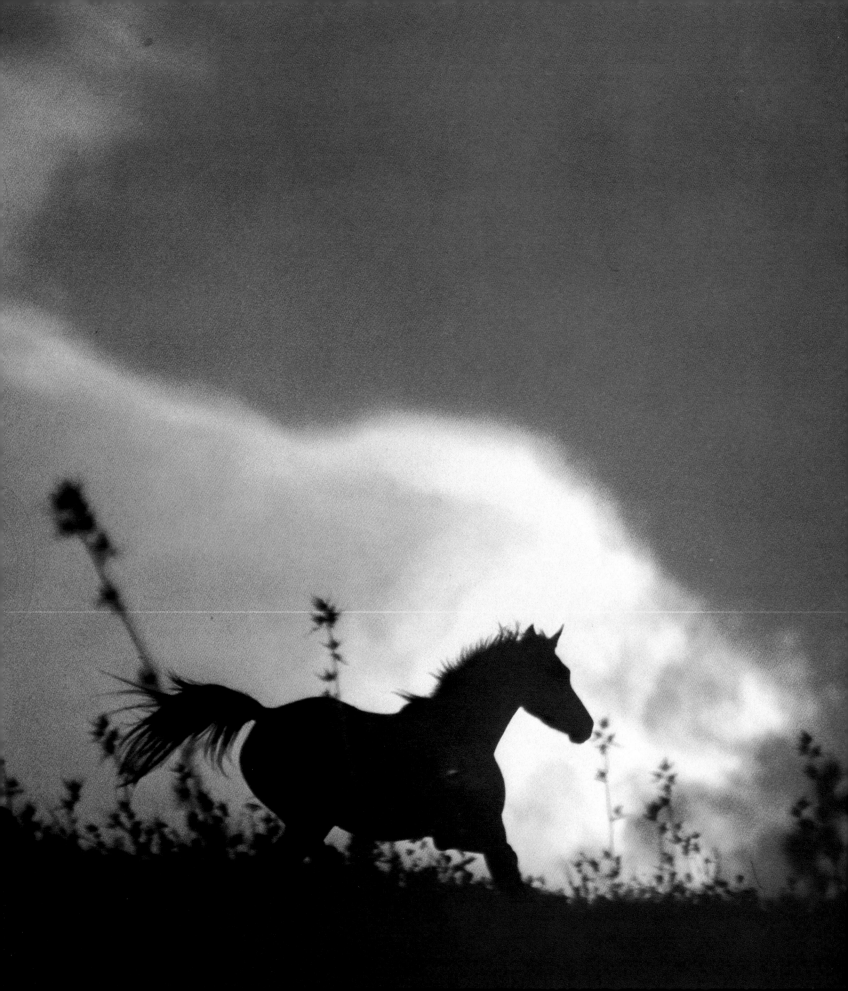

Far back, far back in our dark soul

horse prances . . . The horse,

the horse! The symbol of surging

potency and power of movement,

of action . . .

D. H. Law

The rigid curved neck, such as ancient sculptors

modeled . . . the interplay of muscle . . . in each of

his poses he was . . . the composite of all the equestrian

statues of history.

Felix Salten

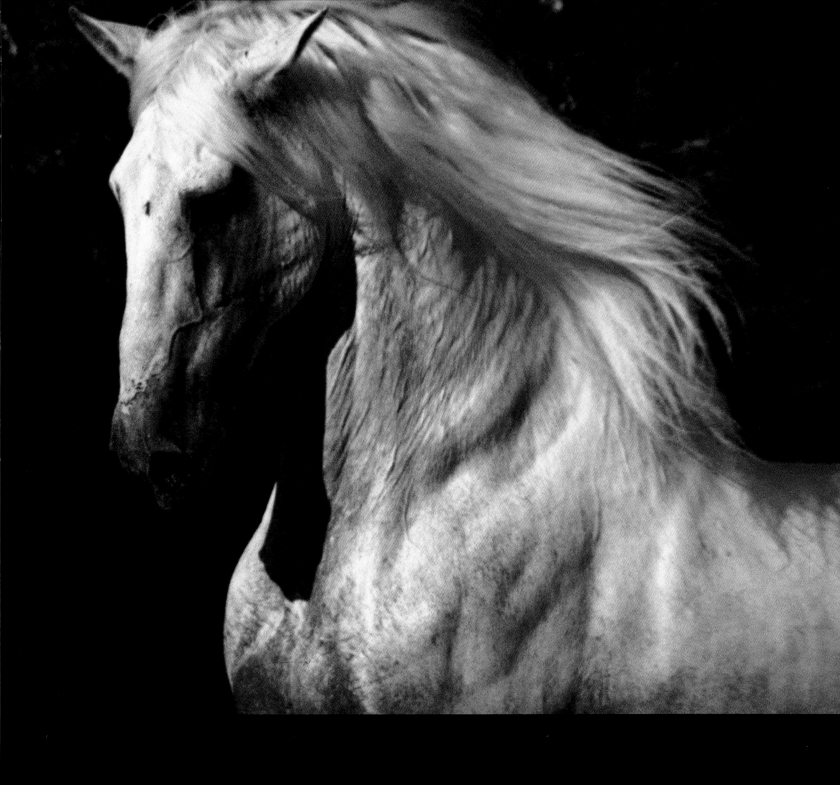

By reason of his elegance,

he resembles an image

painted in a palace,

though he is as majestic

as the palace itself.

Emir Abd-el-Kader

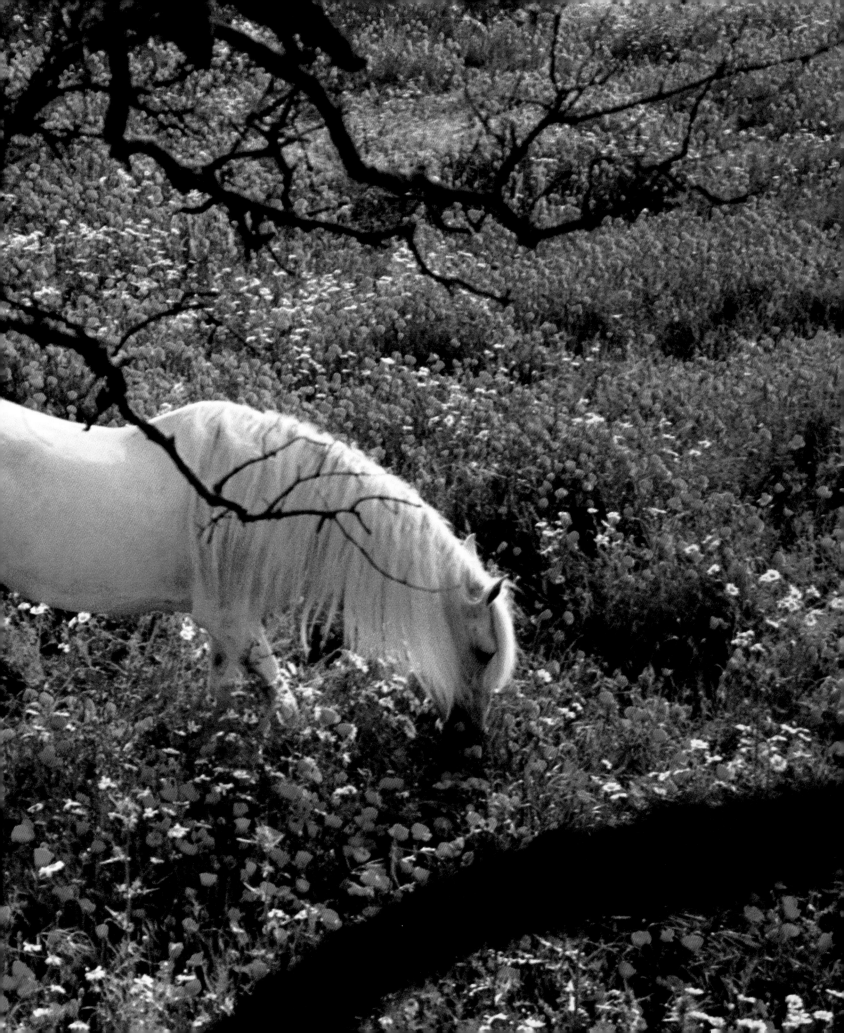

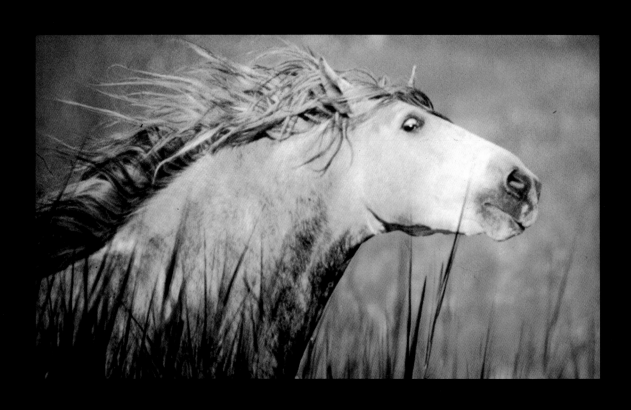

Hast thou given the horse strength?

Hast thou clothed his neck with thunder?

He swalloweth the ground with fierceness and rage

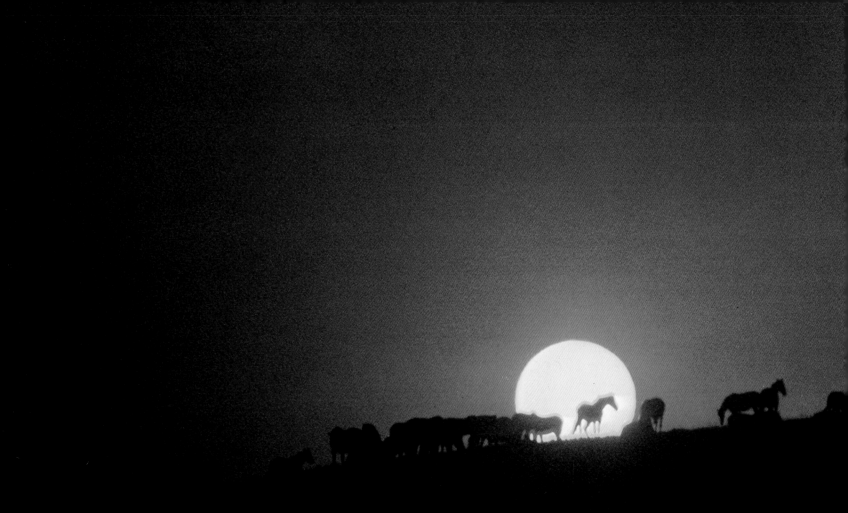

Horse of the sun, who slowly crosses the surface of the earth,

turquoise horse, I have made a sacrifice to you!

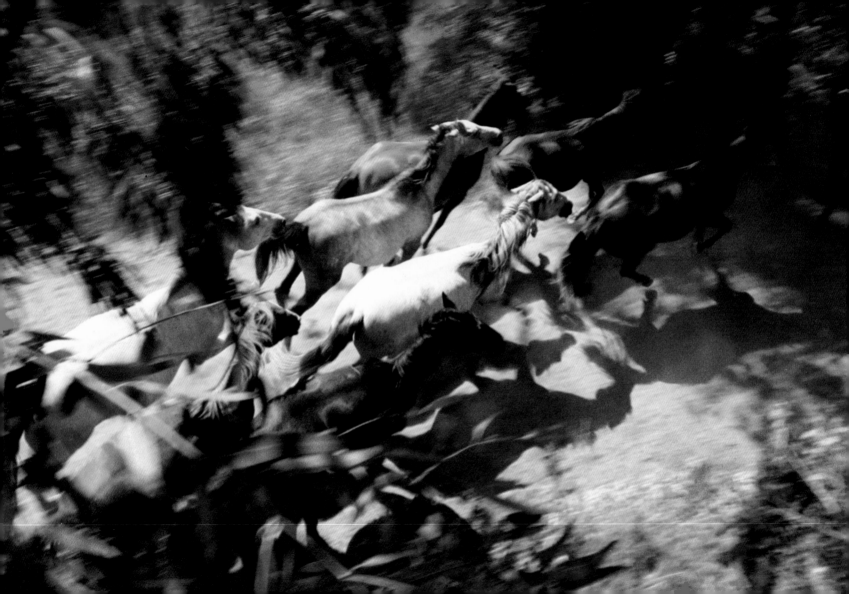

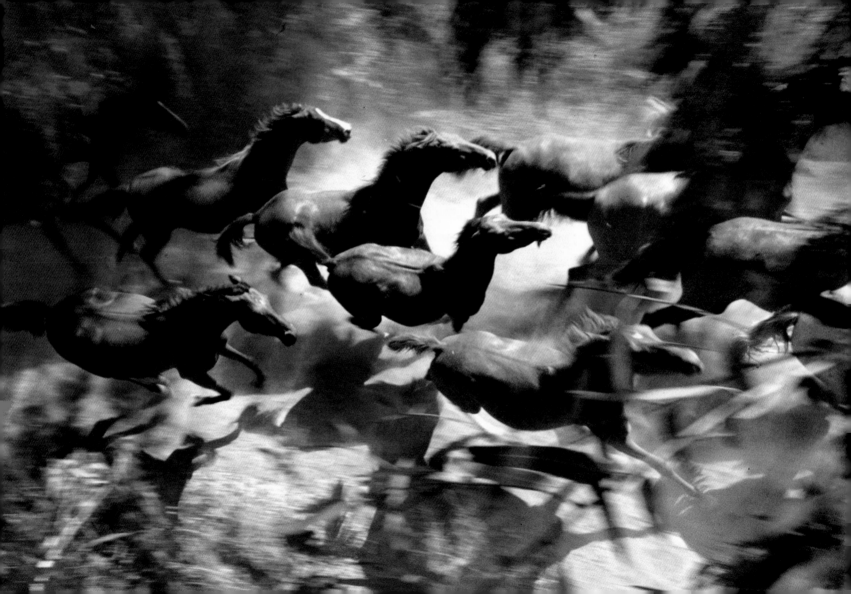

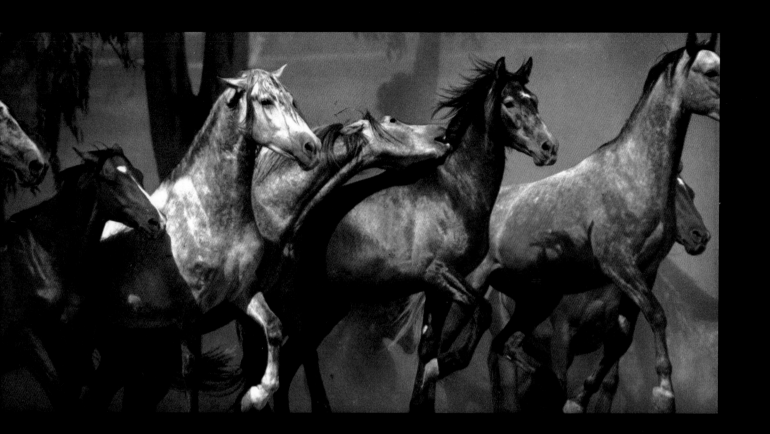

. . . this pageant of proud horses, grey and bay, sorrel and black . . .

with blazing eyes and glistening flanks, recalled a procession of gladiators

marching to some circus, hidden from view, but near at hand . . .

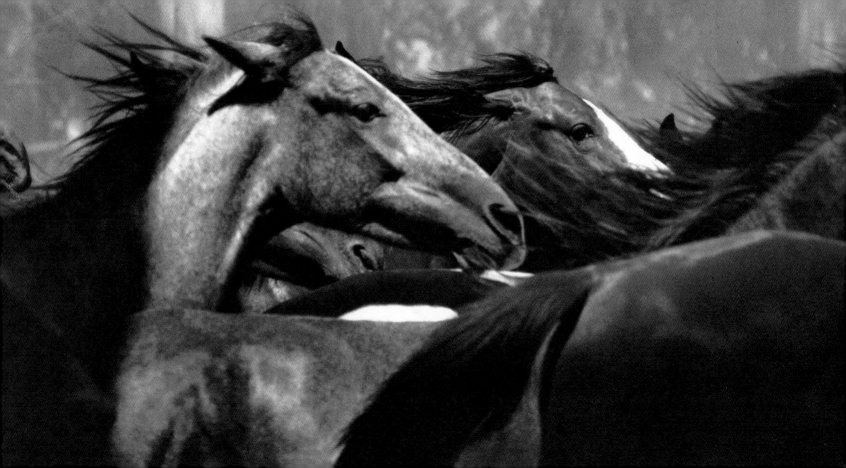

I watched the great stallions rake the air with their forefeet,

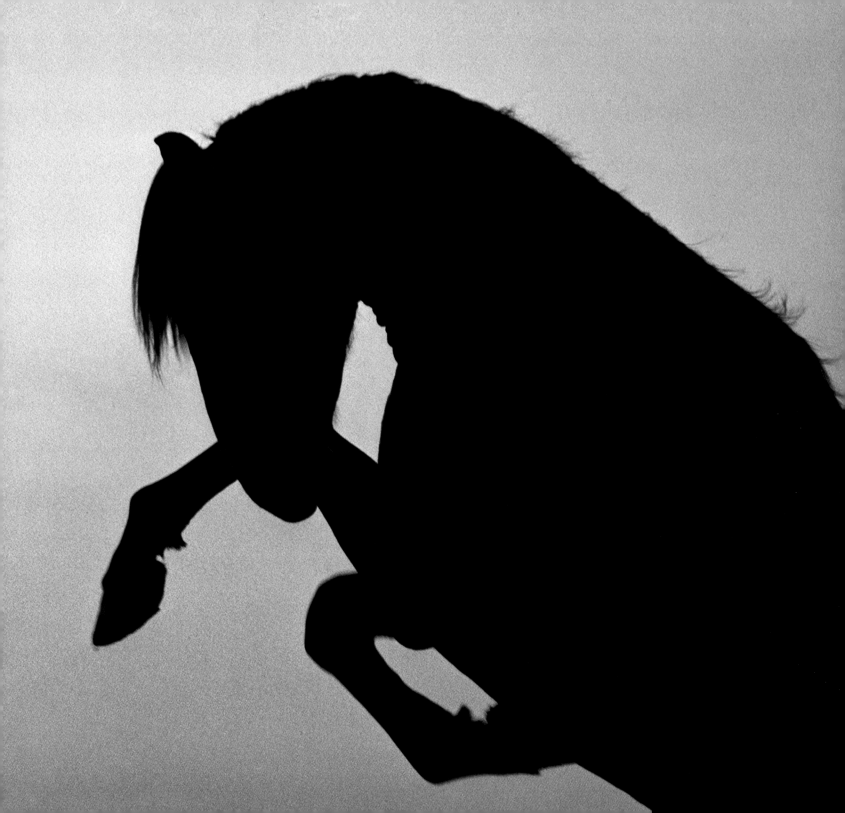

High in the air they rose on their hind legs,

their forelegs pawing, striking madly at each other.

Walter Farley

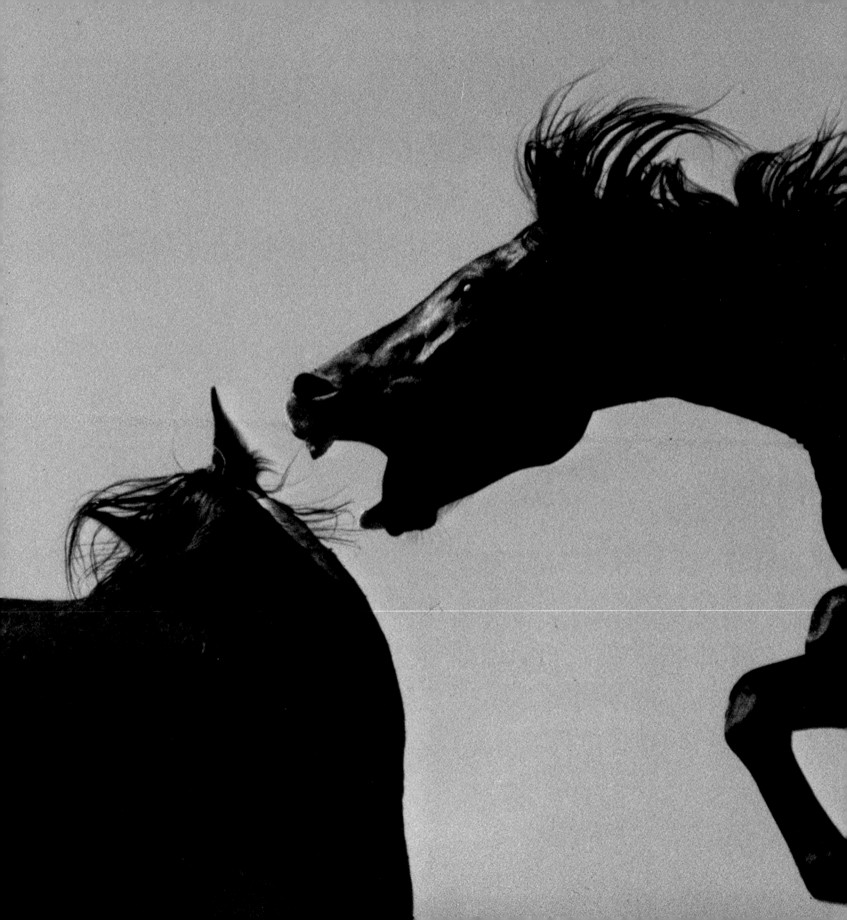

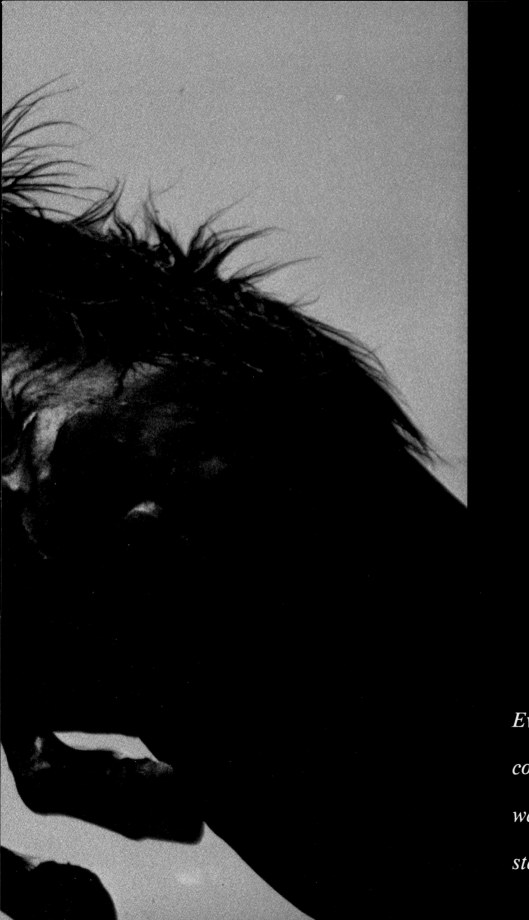

Even what Gros and Rubens

conjured up to depict the Furies

was nothing compared to these

stallions.

Eugène Delacroix

There on tips of fair fresh flowers

feedeth he;

How joyous is his neigh,

There in midst of sacred pollen

hidden, all hidden he;

How joyous is his neigh . . .

Navajo Song

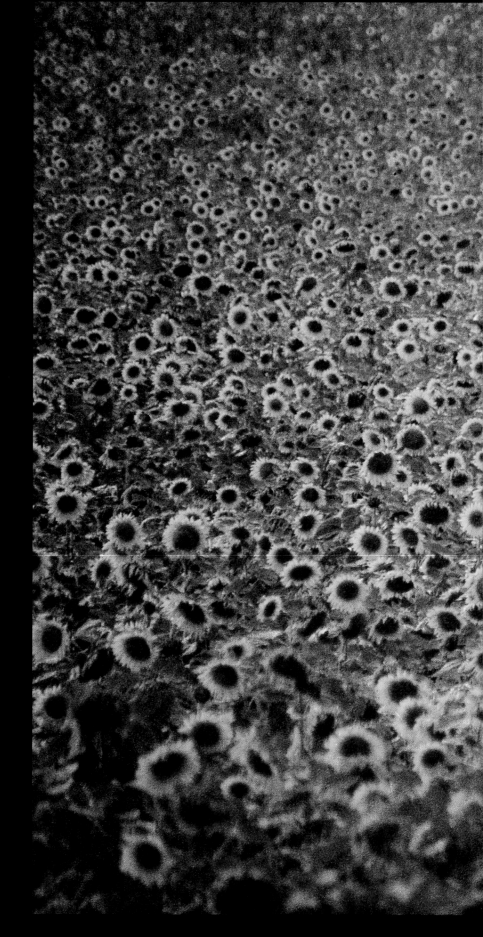

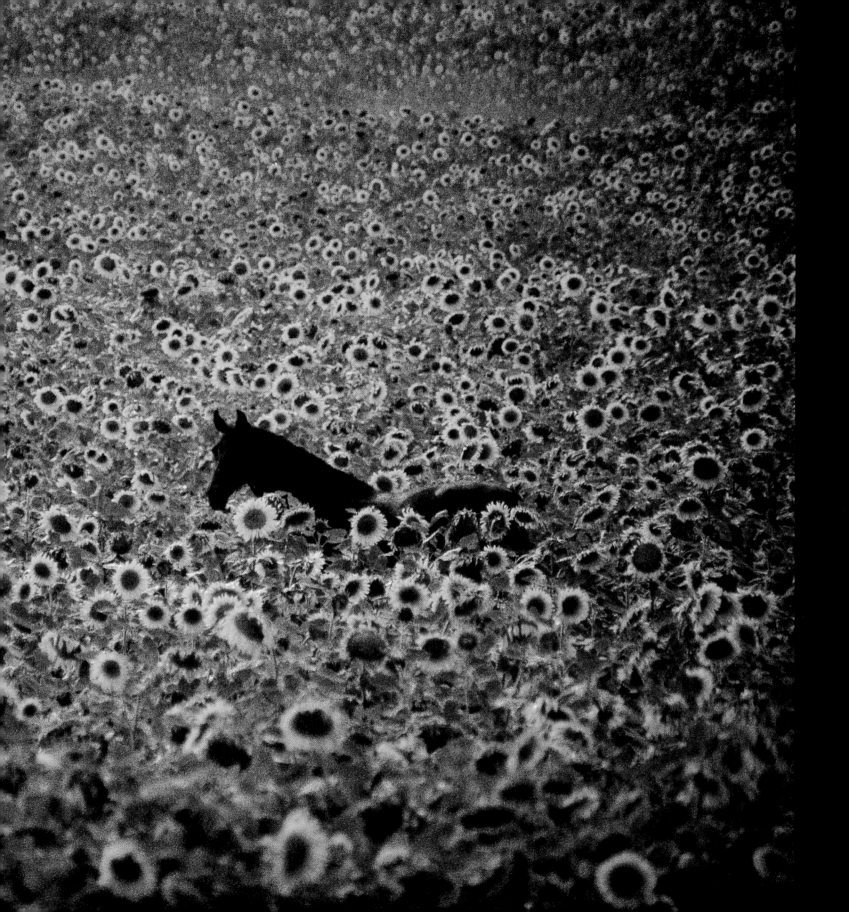

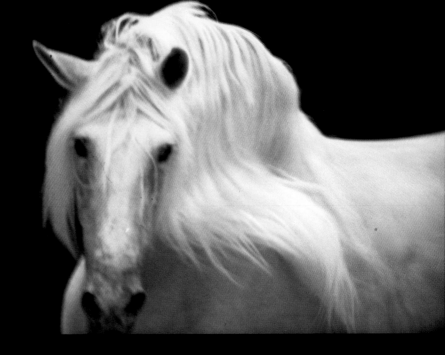

. . . *through his mane and tail the high wind sings,*

Fanning the hairs, who wave like feather'd wings.

William Shakespeare

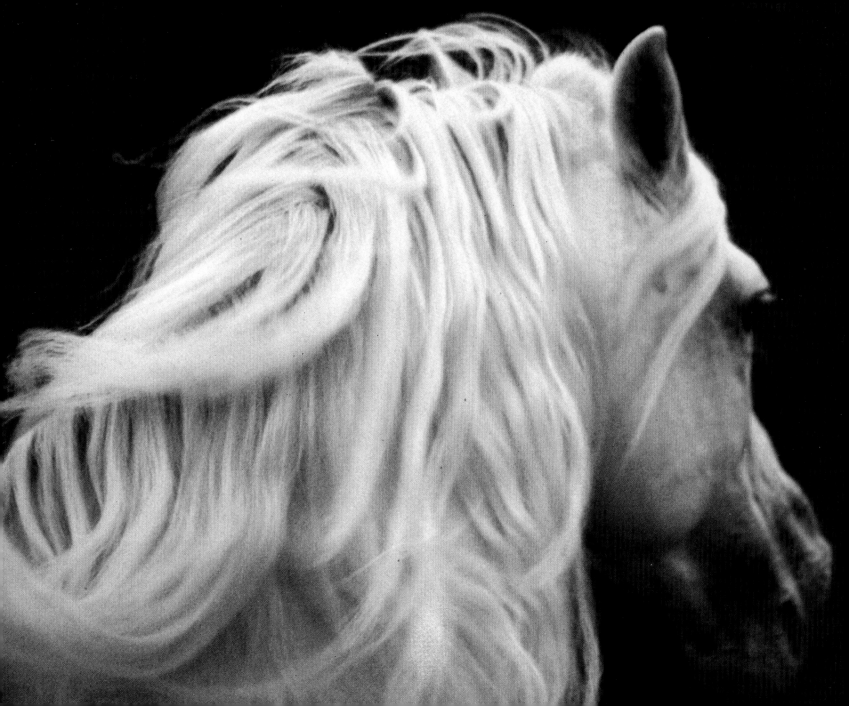

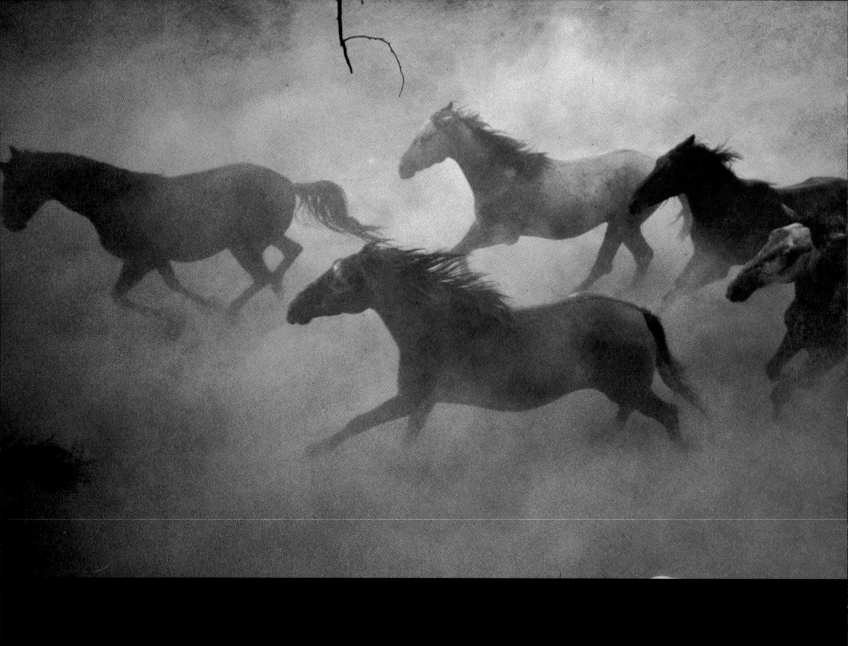

. . . to look across the expanse of the cave ceiling and see

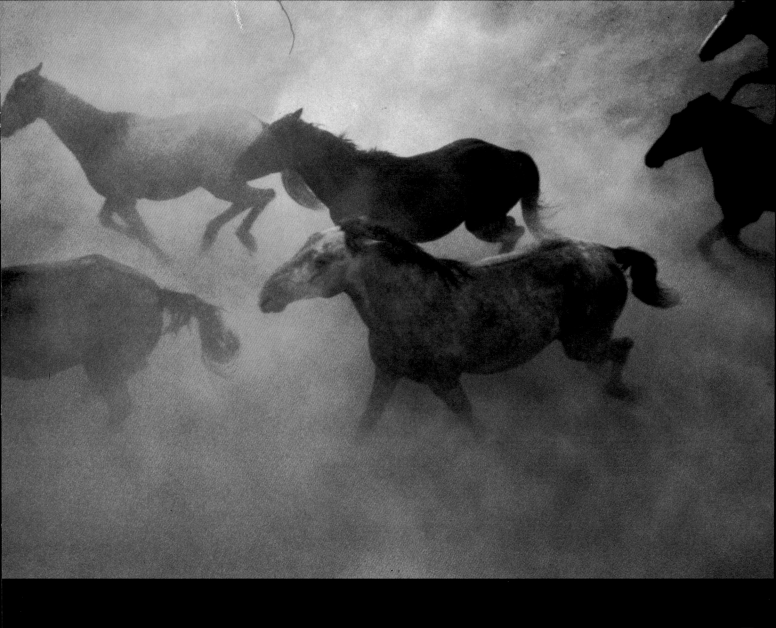

the animals rising and falling mysteriously along the rocky

surface is to see . . . drawings done by men who studied

animals and who loved them.

He is swift and strong among the swift ones, but it is that flowing mane and tail that mark him chiefly from afar.

Ernest Thompson Seton

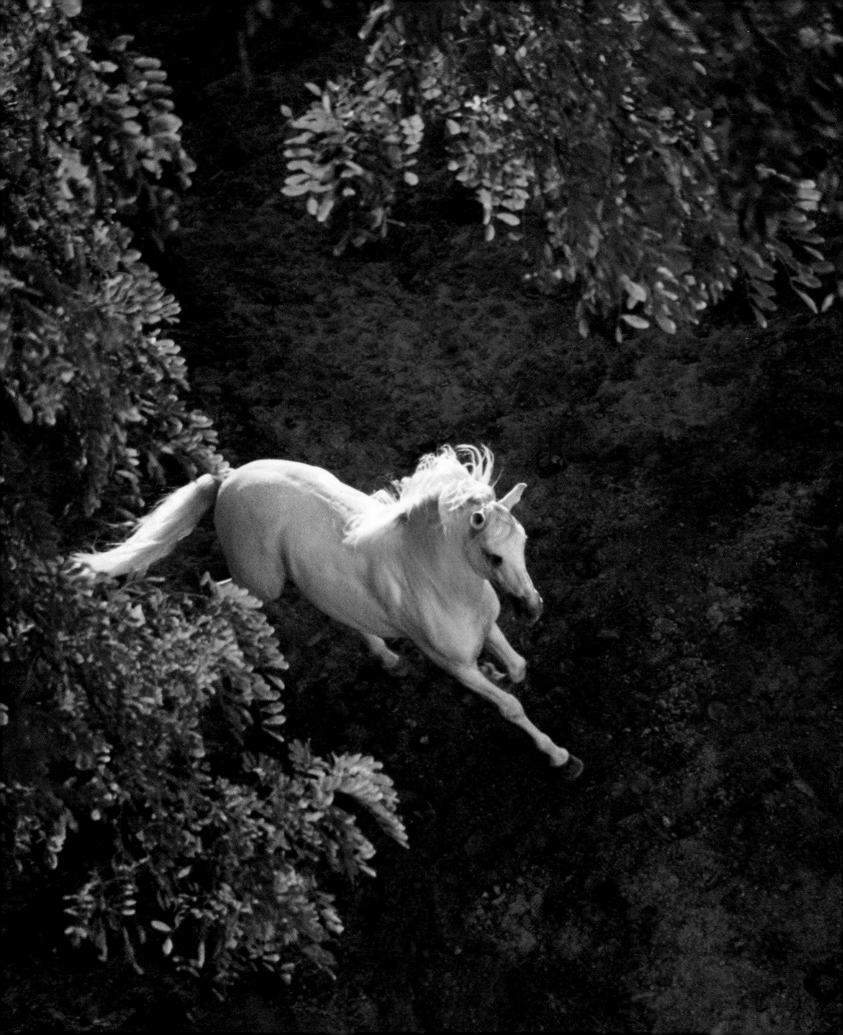

Seeds spring from seeds, beauty breedeth beauty . . .

By law of Nature thou art bound to breed,

That thine may live, when thou thyself art dead;

And so in spite of death thou dost survive,

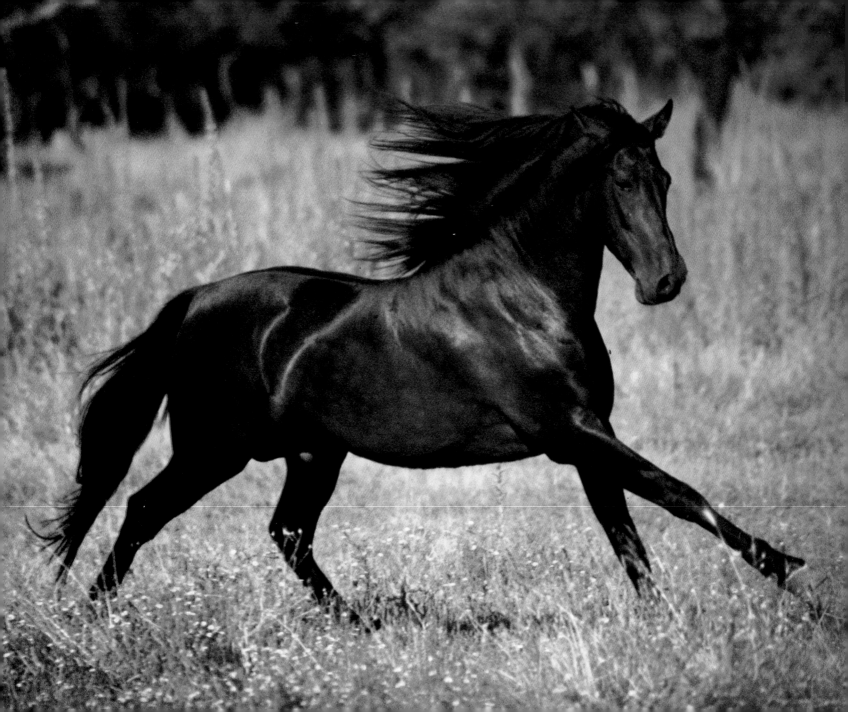

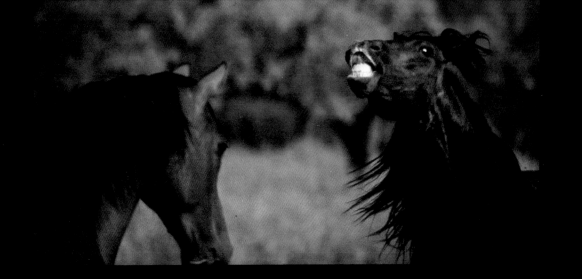

From the West comes a red mare . .

She comes to me.

Navajo Chant

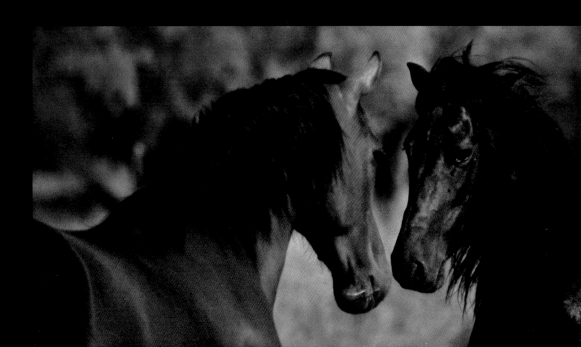

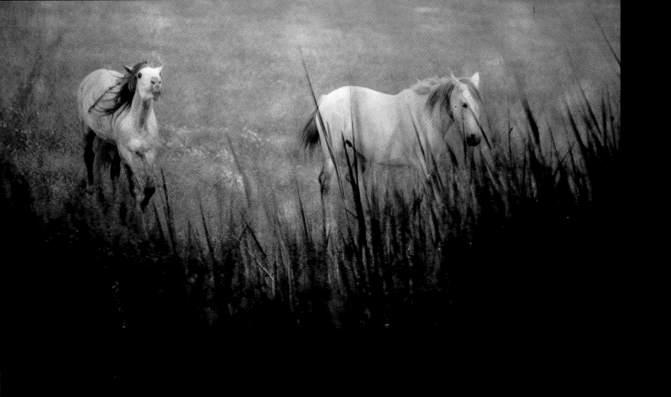

From the North comes a white mare . . .

She comes to me.

Navajo Chant

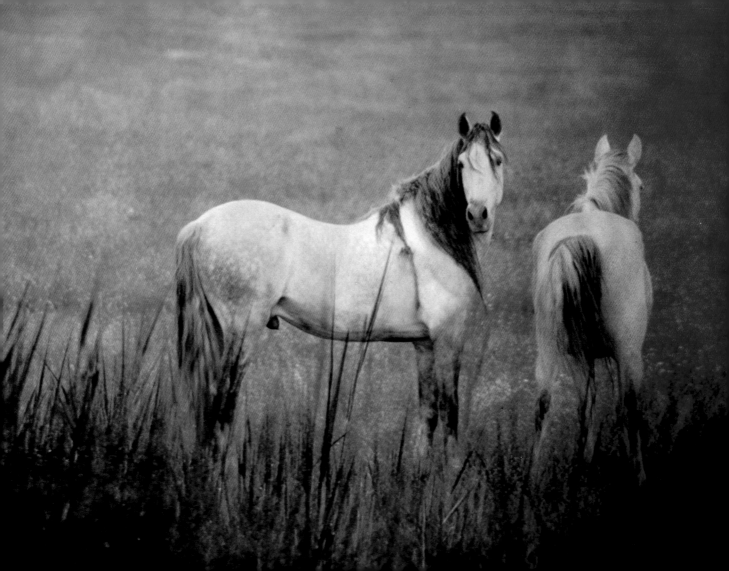

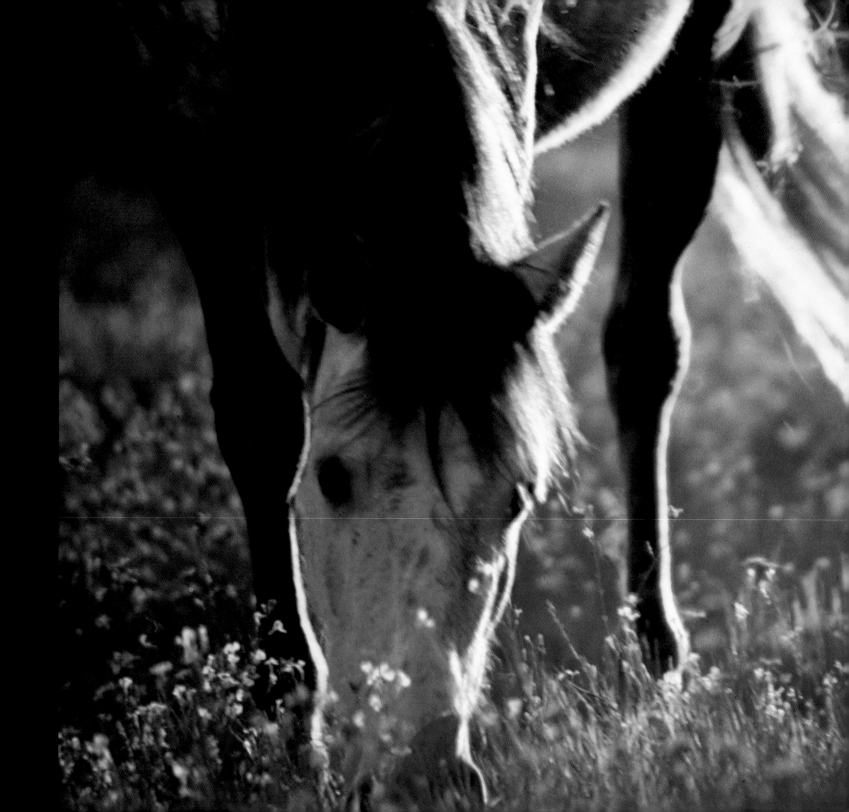

. . . all shining beautiful and gentle of herself,

she seemed a darling life upon that savage

soil not worthy of her gracious pasterns:

the strutting tail flowed down even

to the ground, and the mane was shed by the

loving nurture of her mother Nature.

Charles M. Doughty

5

His ears up-prick'd; his braided hanging mane

Upon his compass'd crest now stands on end . . .

His eye, which scornfully glisters like fire,

Shows his hot courage and his high desire.

William Shakespeare

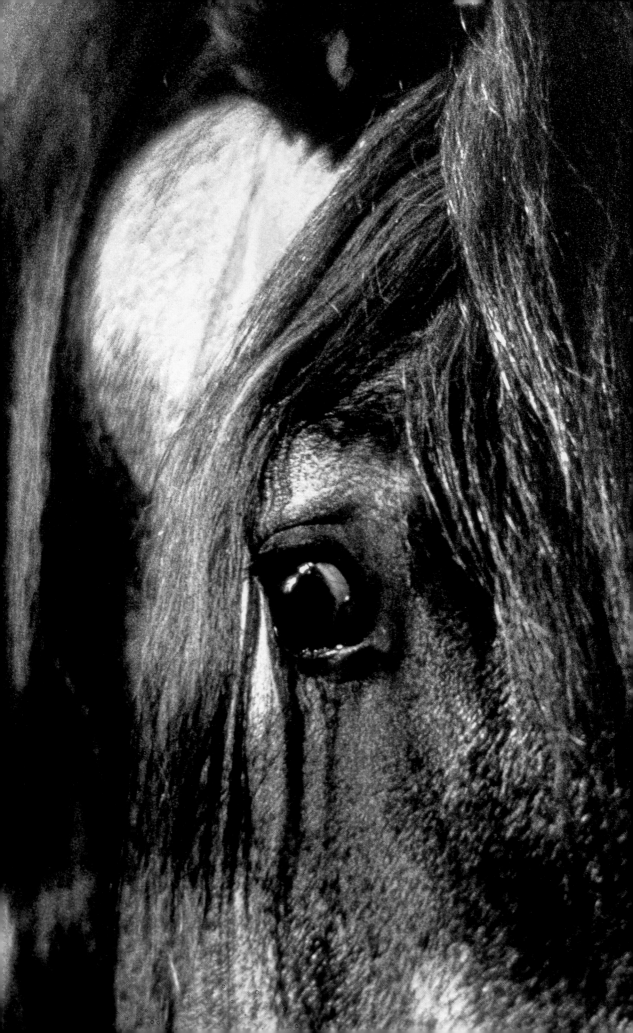

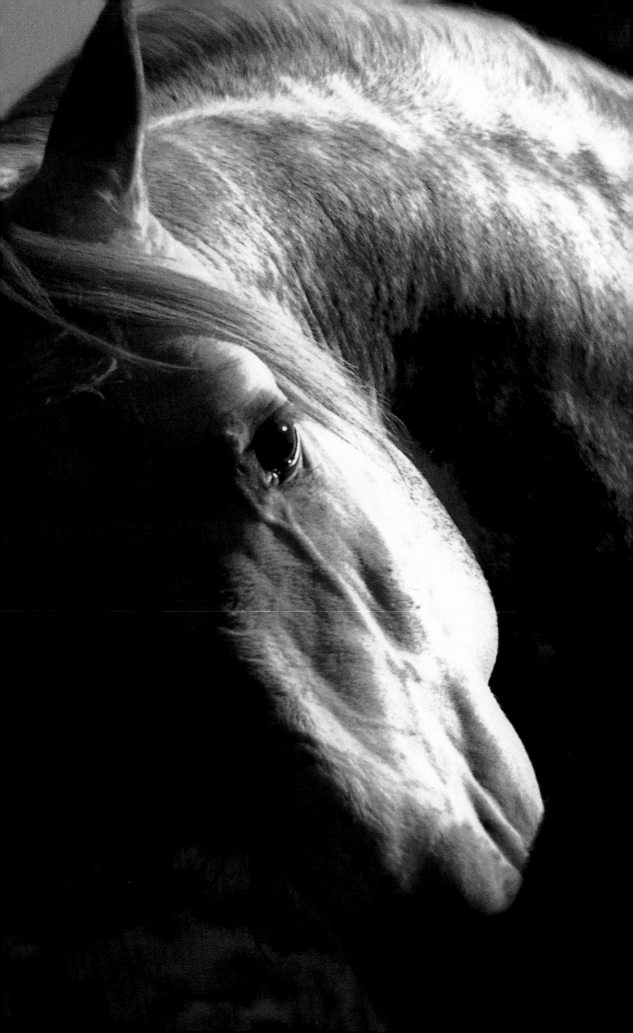

. . . with his subjects browsing all

See how the stallions shake

in every limb,

If they but catch the scent

of love upon the breeze.

Virgil

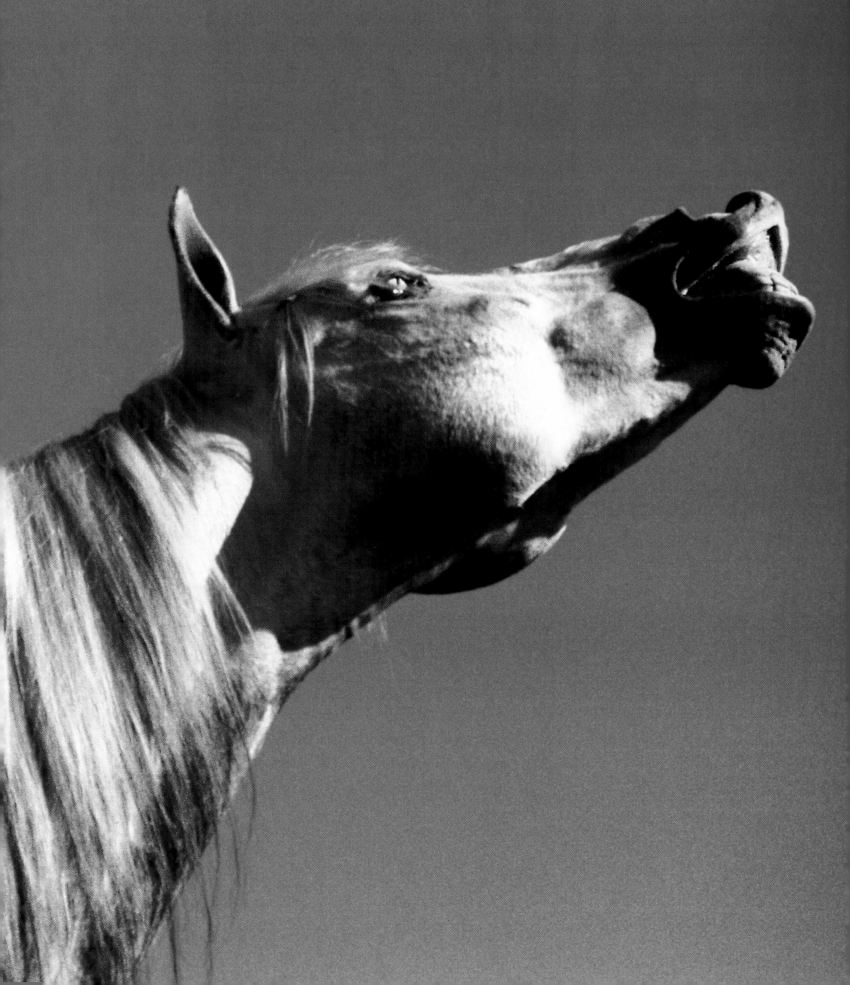

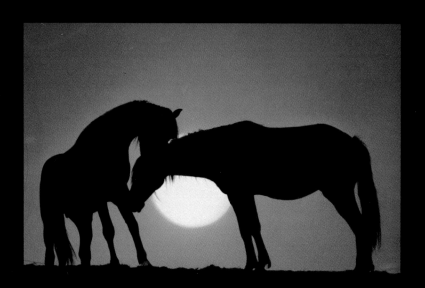

The stallion caressed the mare's lips

with his warm, velvety muzzle,

and she lowered her head, seemingly entranced

by his sensual nuzzling.

Robert Vavra

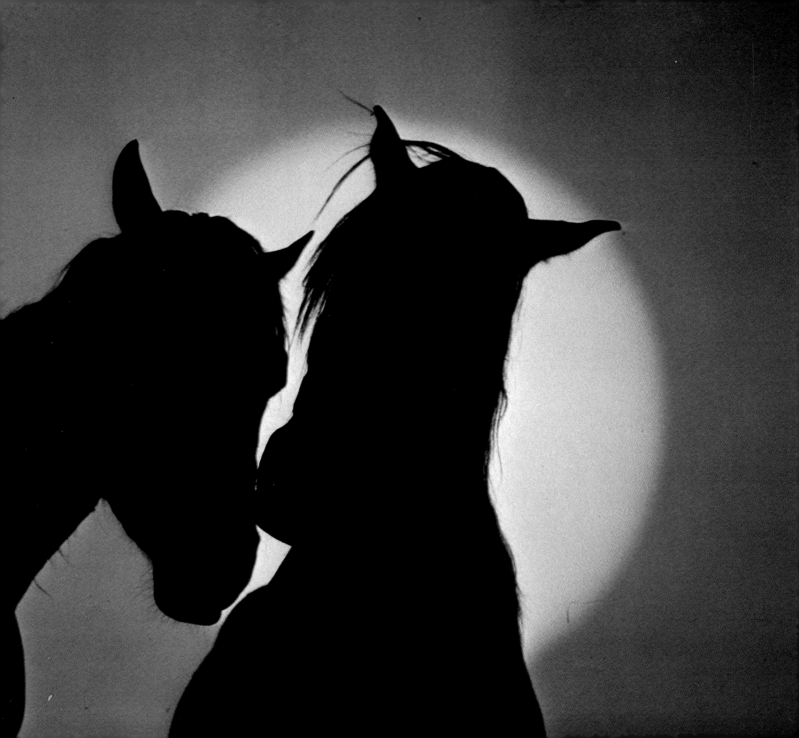

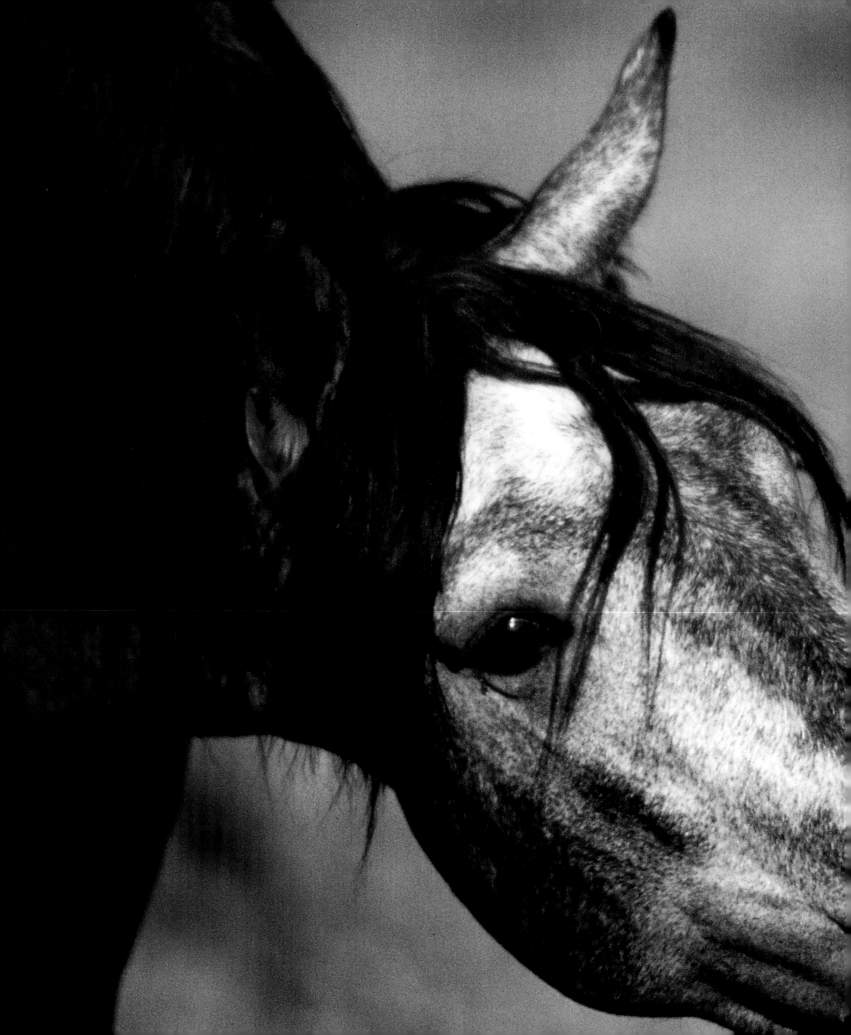

. . . gigantic beauty of a

stallion . . . eyes full of sparkling

wickedness . . . nostrils dilate . . .

well-built limbs tremble with

pleasure . . .

Walt Whitman

63

. . . scenting the mare, the stallion began to paw the ground,

roll his eyes and neigh, wild with excitement.

Bernal Díaz del Castillo

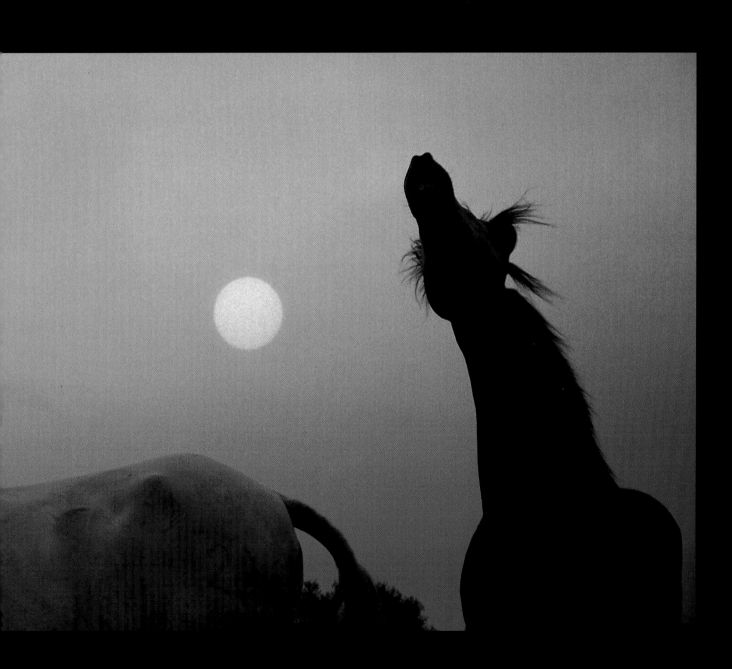

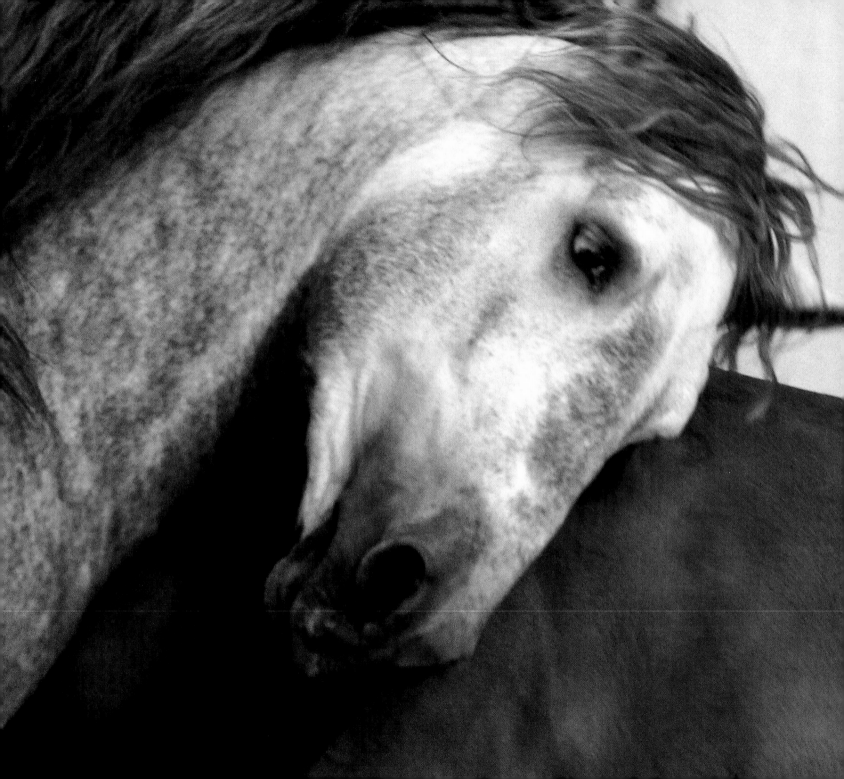

Wheeling after her, neighing, and plunging,

he arched his splendid neck and pushed aga

the sunlight, and little shivers

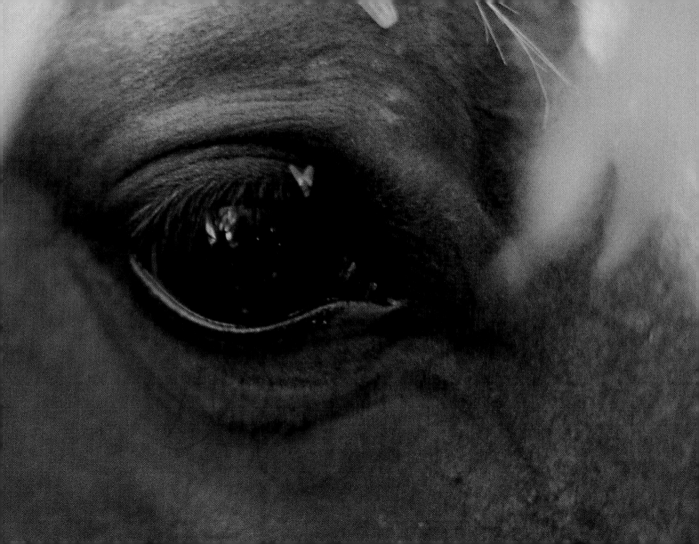

The horse stood on its hind legs . . . I could

smell it, so lovely *. . .* I could *hear* it breathing,

so exciting . . .

William Saroyan

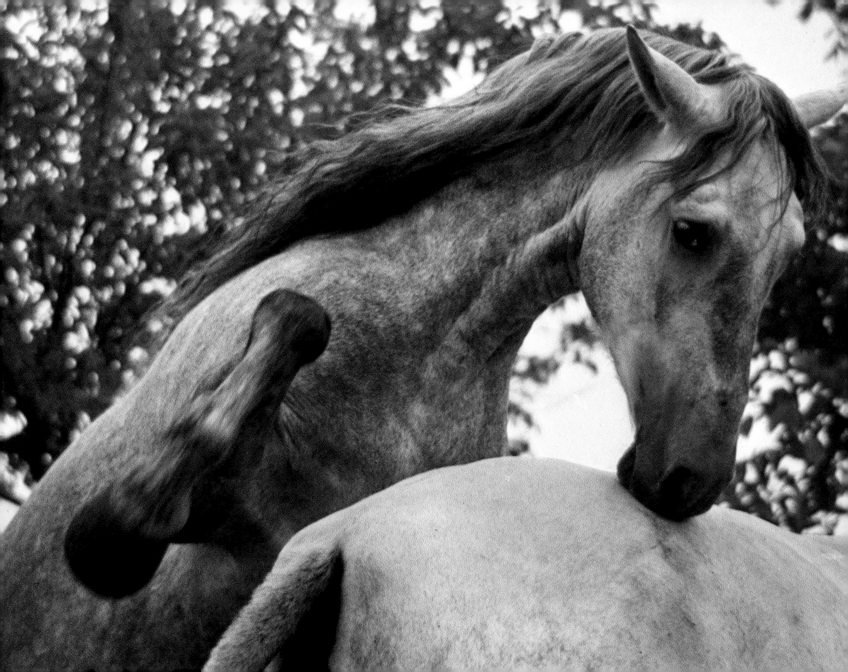

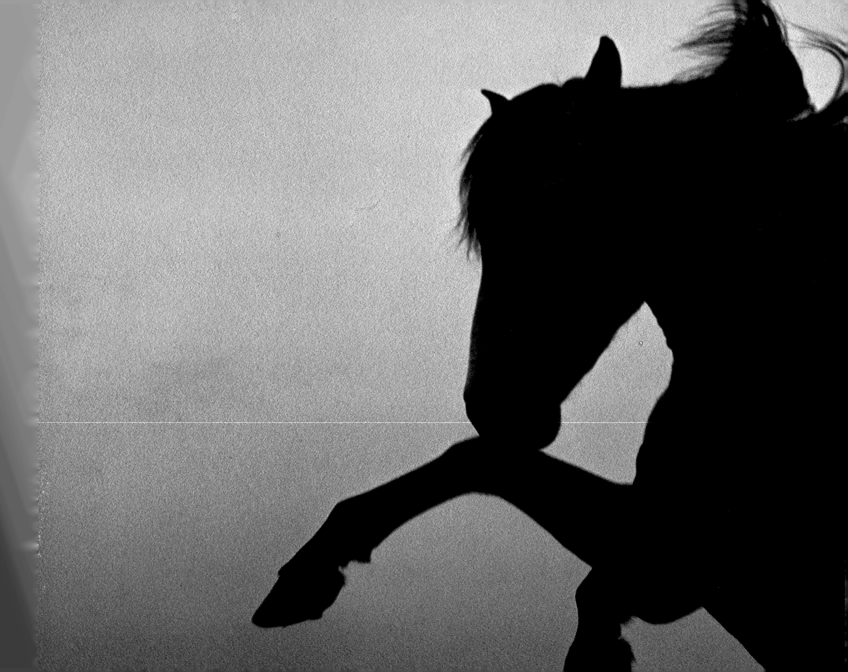

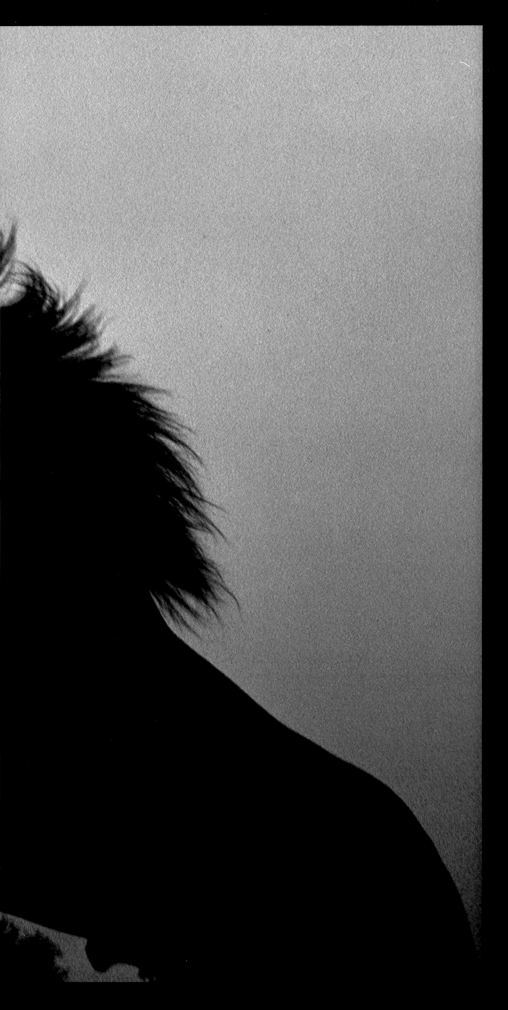

Right into the stars he reared aloft,

his red eye rolling . . .

Flung back on his haunches,

he loomed . . . then leapt—

and the dim void lightened.

William Rose Benét

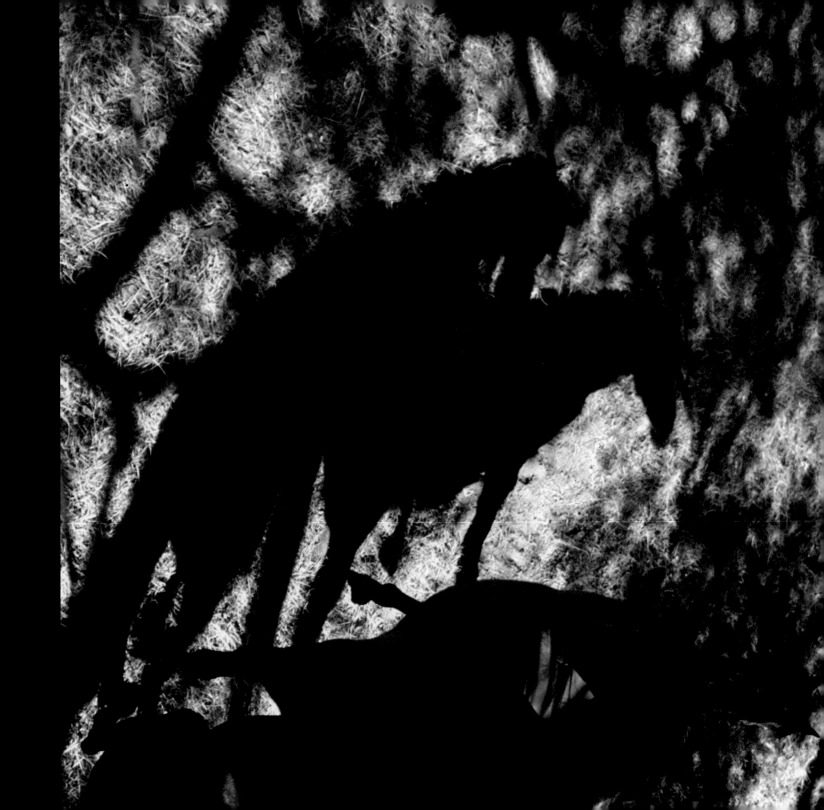

The sun was high and there was no sound

but the calling of a hawk and the stallion's heavy breathing,

as the shadows of the mating horses slid slowly

across the earth like a prehistoric cave painting brought to life.

Robert Vavra

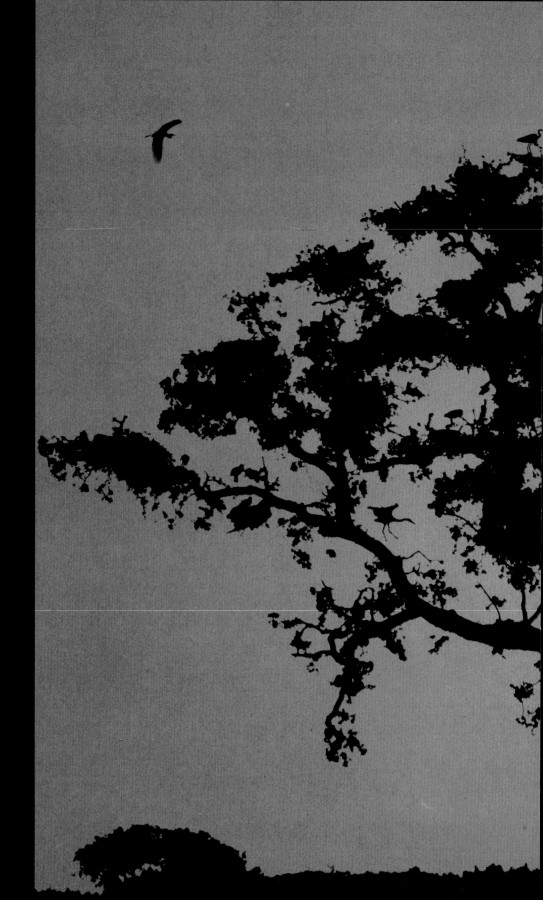

And God blessed them,

and God said unto them,

Be fruitful,

and multiply . . .

Book of Genesis

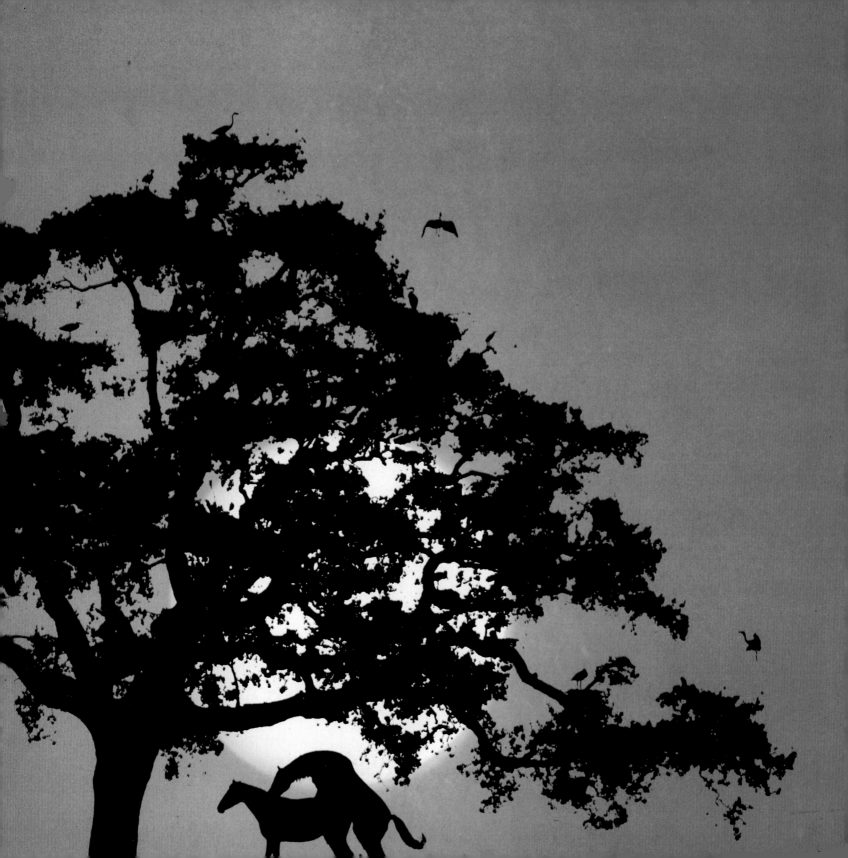

The sun rises through a brea

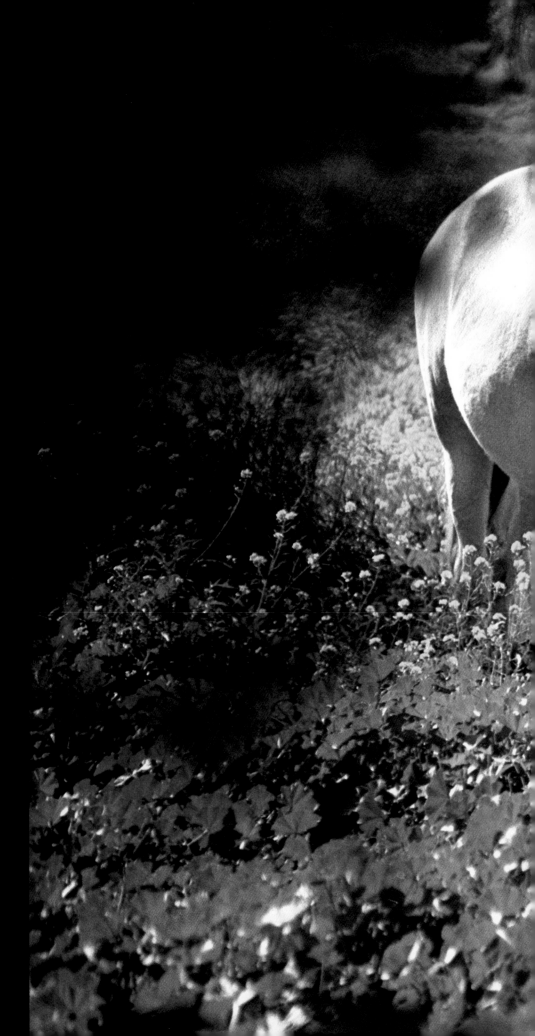

Henceforth the mares

demand the greater care.

When in the course

of months they are

in foal,

Allow them not to gallop

in swirling floods.

But let them graze in

glades by brimming

streams.

Virgil

80

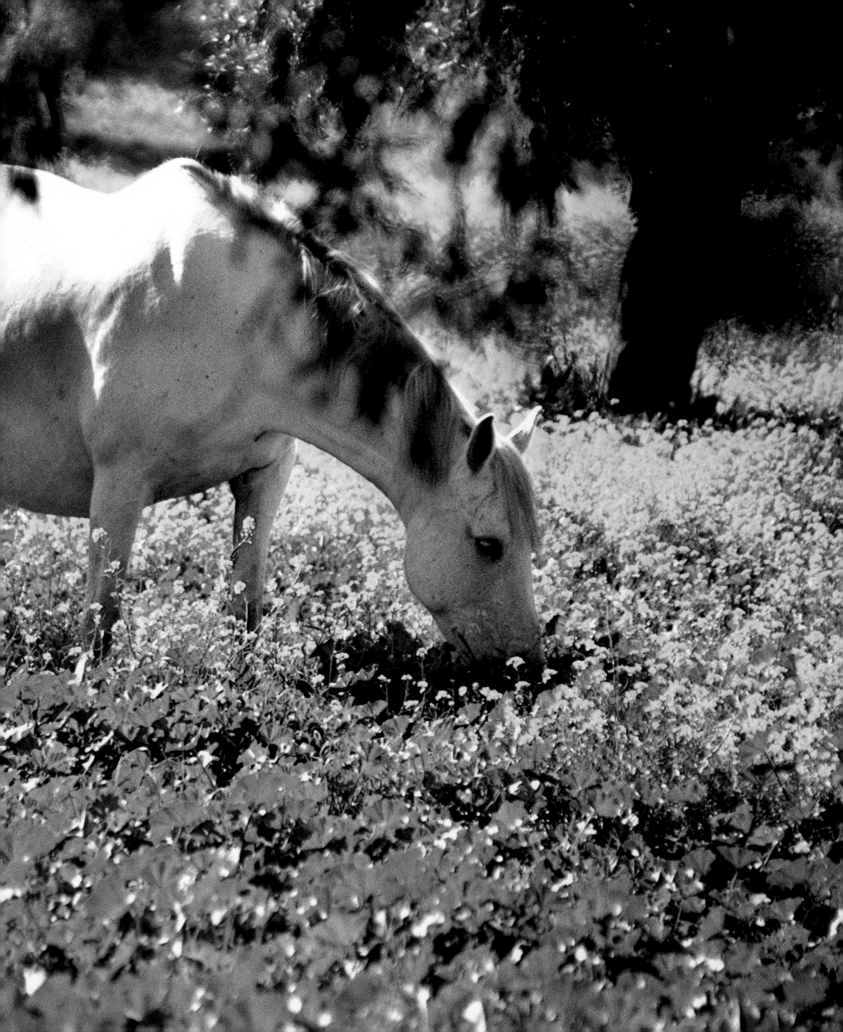

The stomachs of ma

bulging with gold.

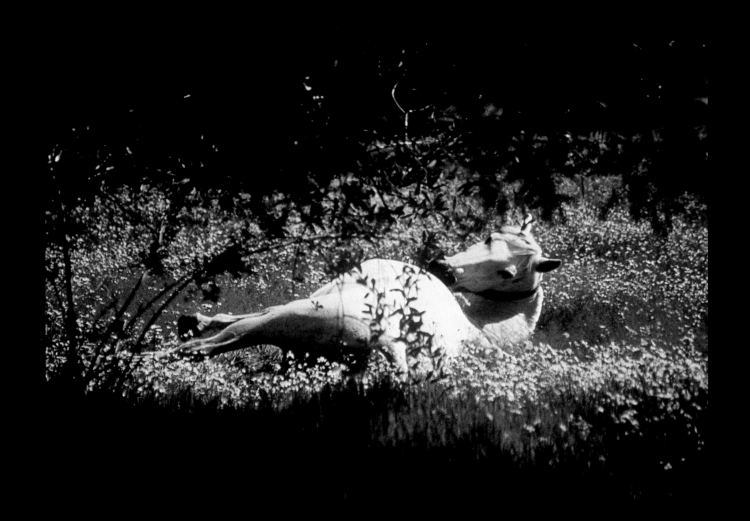

The laboring mare lay down on the ground.

The foal, impose his will as he might, was helpless.

The violent surges continued, coming at regular intervals,

and he was being turned this way and that . . .

until he took the position of a diver,

front hoofs stretched out and his little muzzle

resting on them . . . There was the sensation

of movement through a passage and suddenly a jar

as he slid out to the earth.

Mary O'Hara

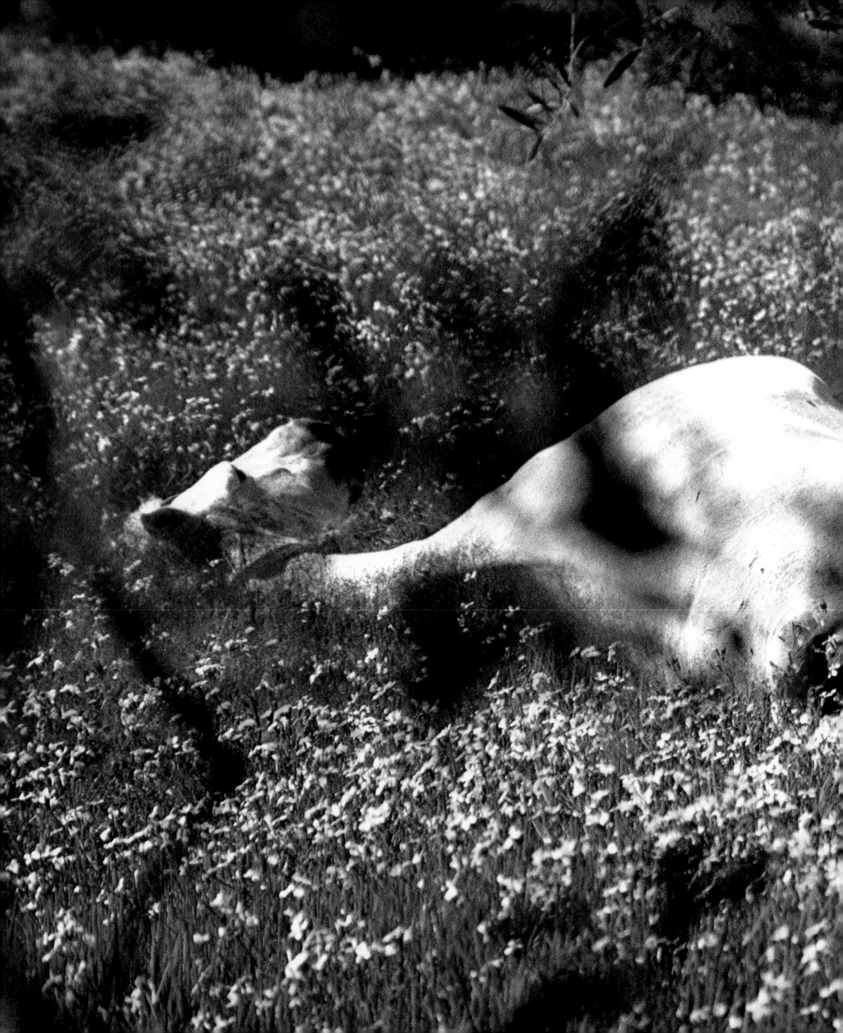

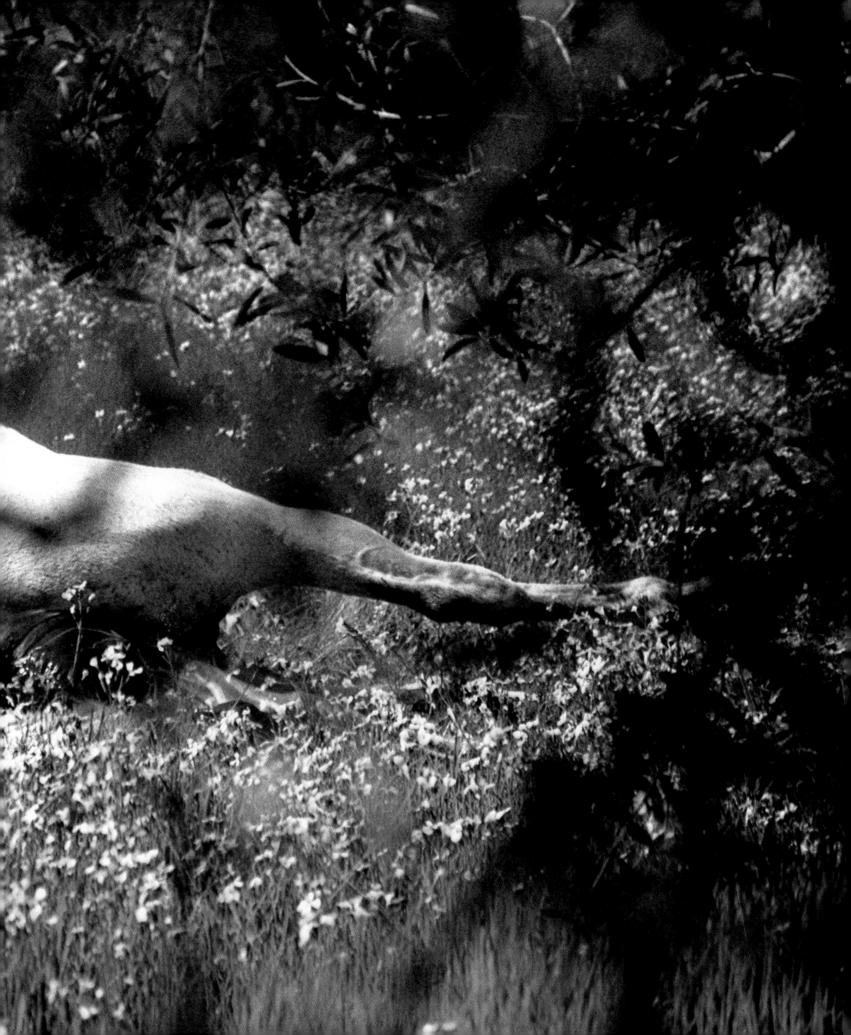

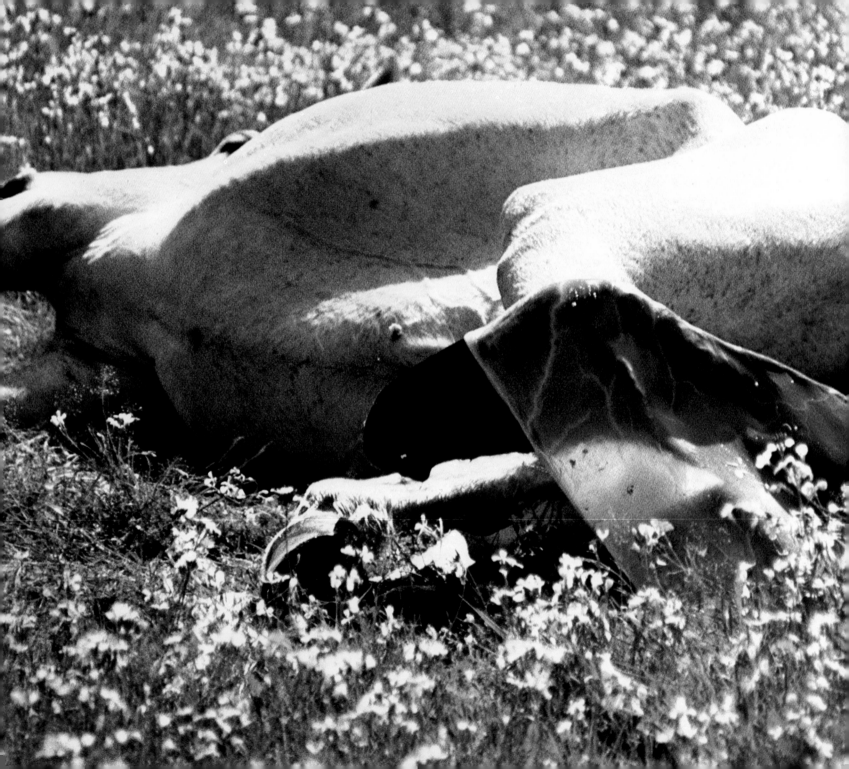

There was life in that silver

shroud. Through its

beautiful transparency,

a pair of black, shiny hoofs

tore...

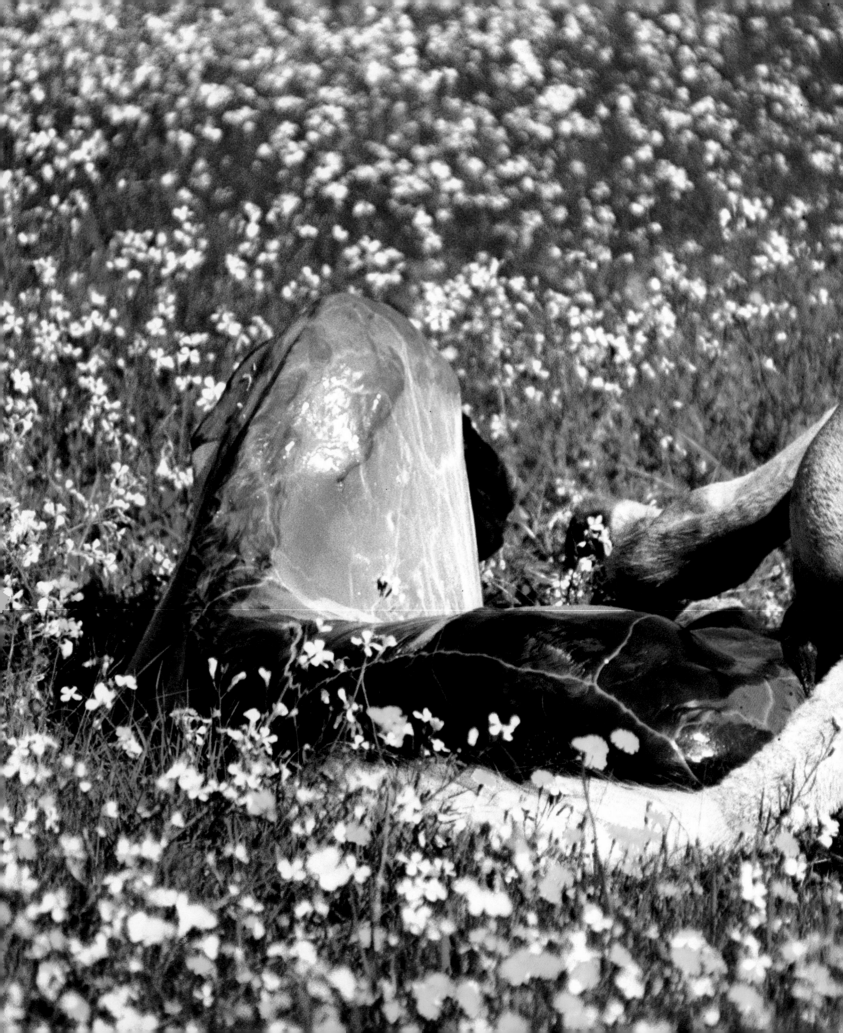

He kicked the covering off

himself . . . abalone shell foal . . .

black onyx foal . . .

Navajo Legend

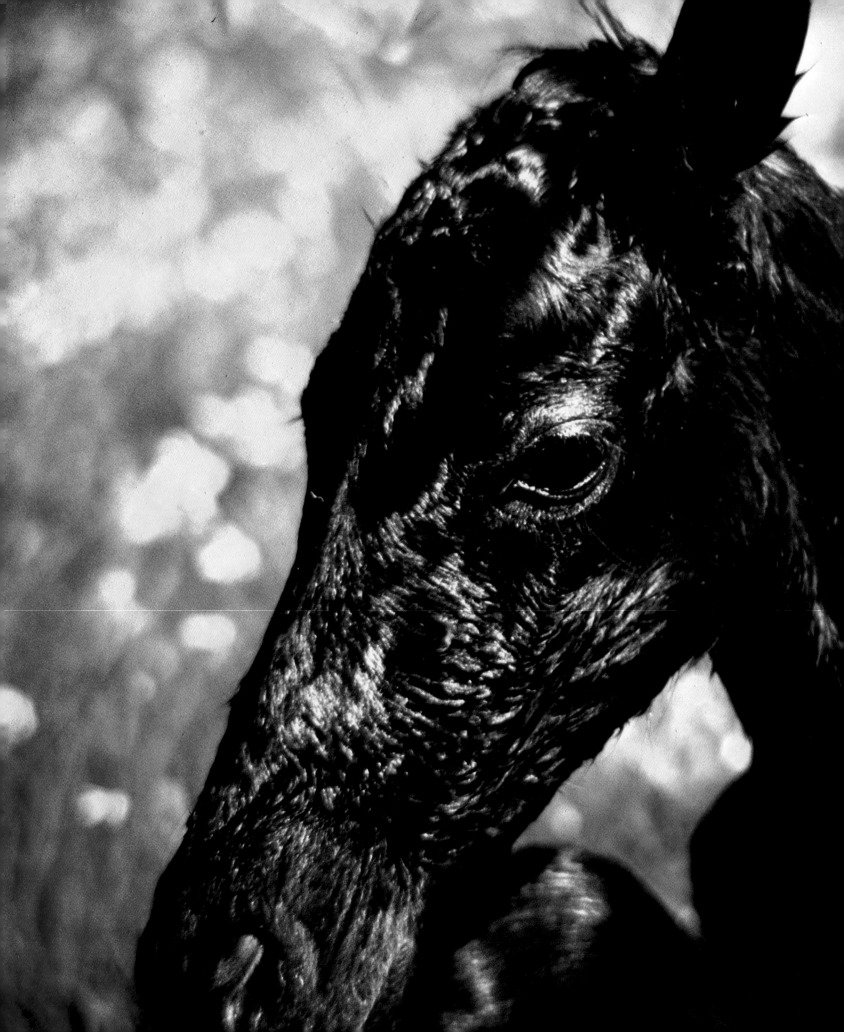

And God took a handful

of southerly wind,

blew His breath over it and

created the horse.

<div align="right">Bedouin Legend</div>

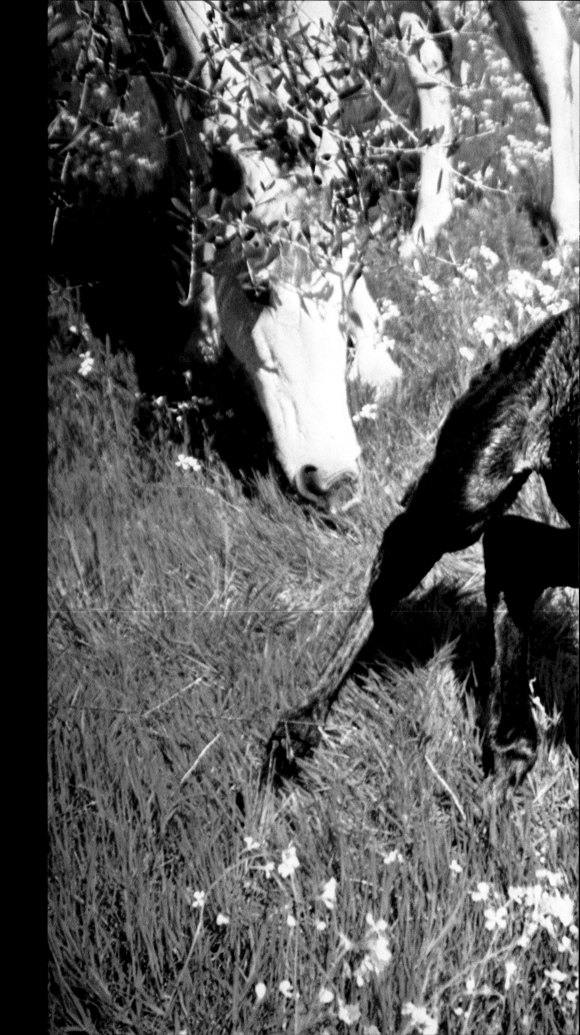

The foal tried to get up.

He thrust out his forefeet,

but they splayed

and he seemed to get all

tangled up with himself.

Marguerite Henry

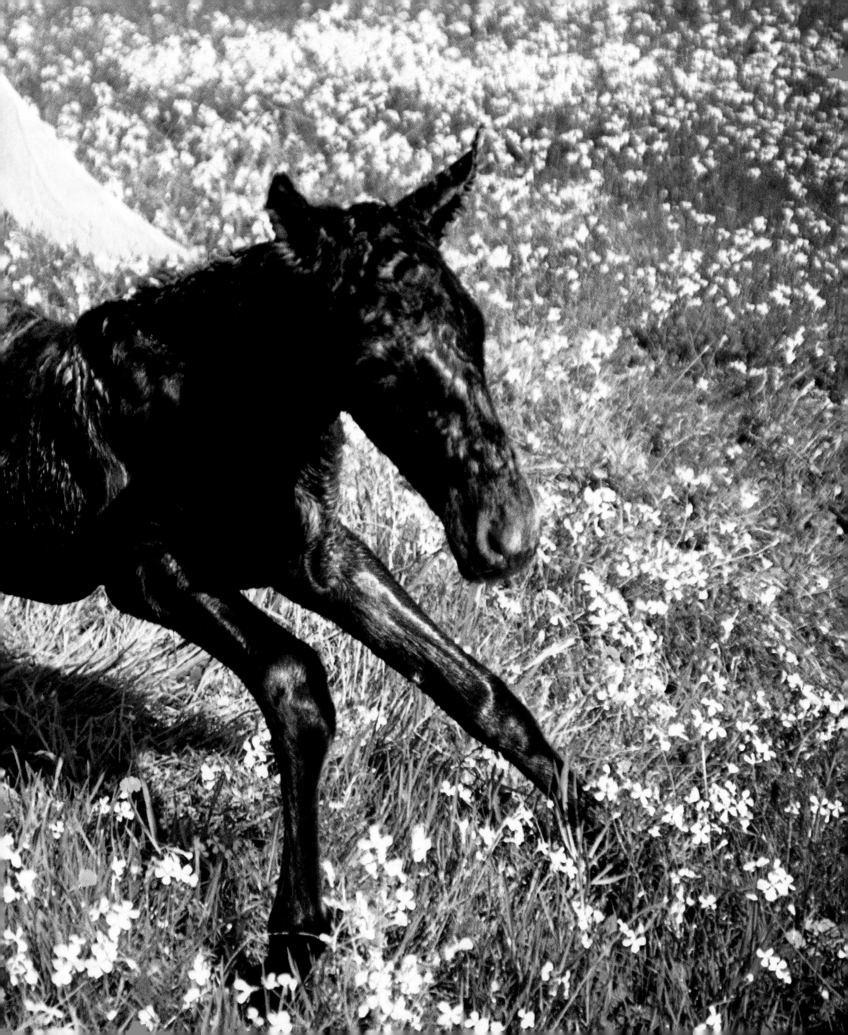

It seemed that Mother Nature

was sure agreeable that day

when the little black colt

came to the range world,

and tried to get a footing

with his long wobbly legs . . .

Taking in all that could be seen,

felt, and inhaled, there was no day,

time nor place that could beat

that spring morning . . .

Will James

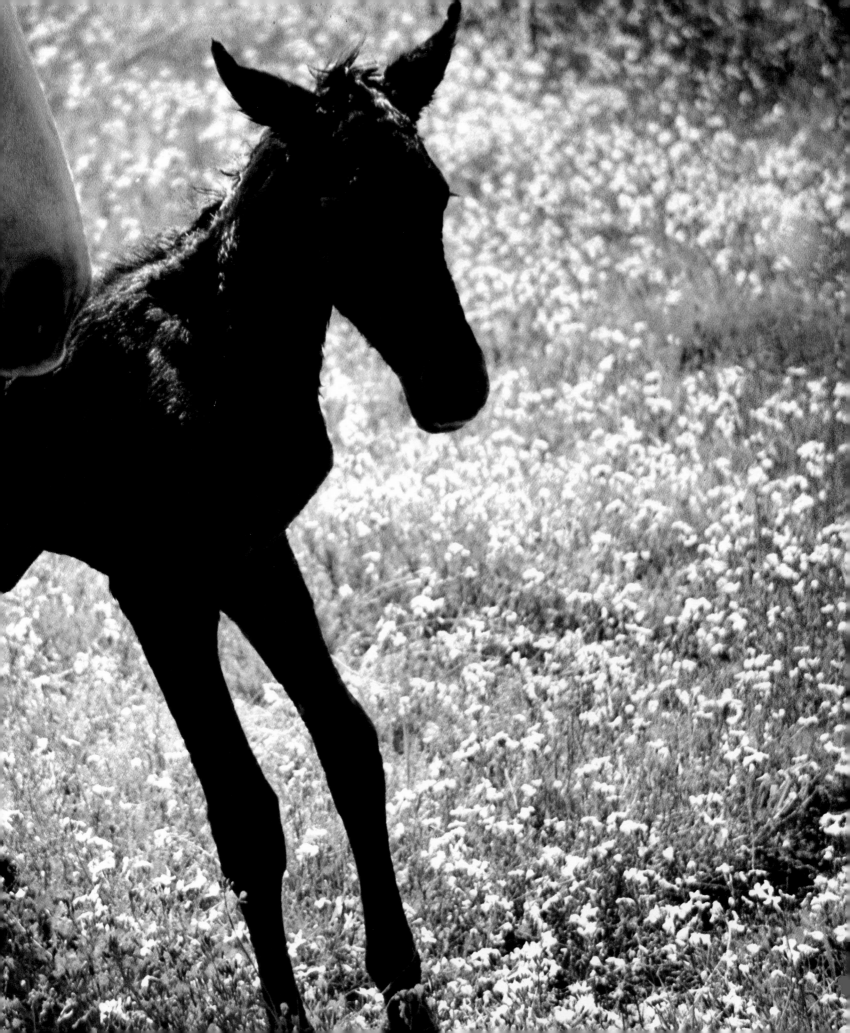

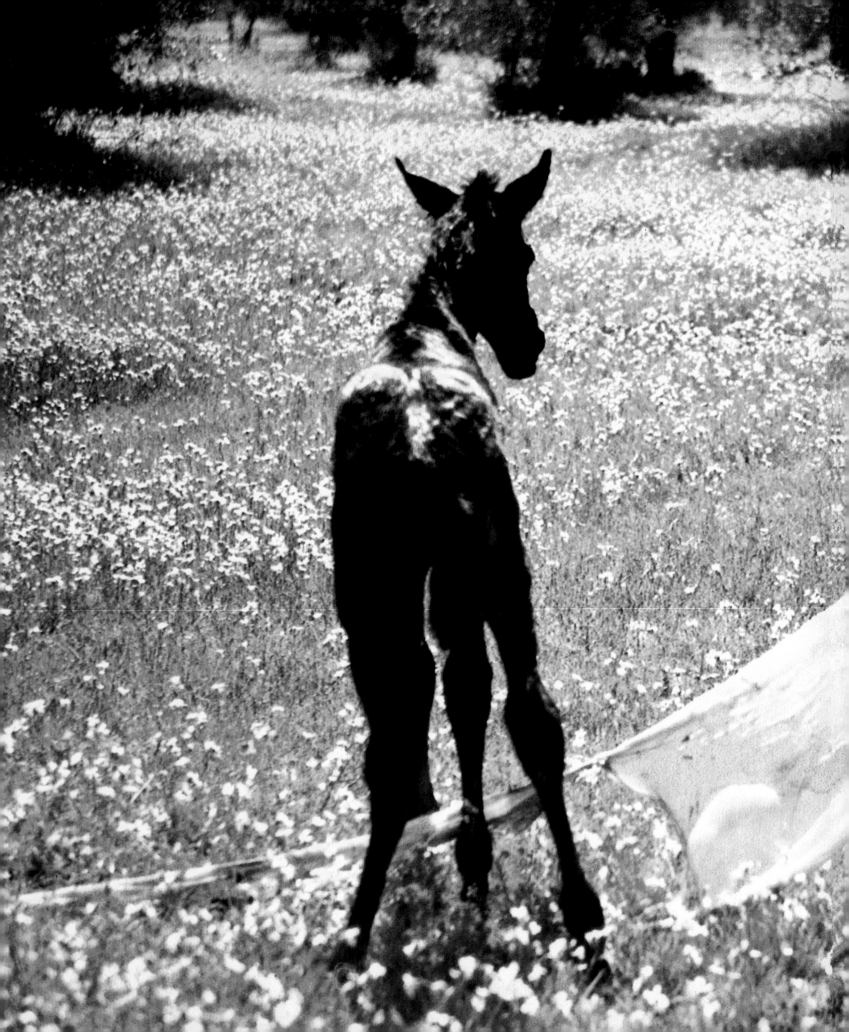

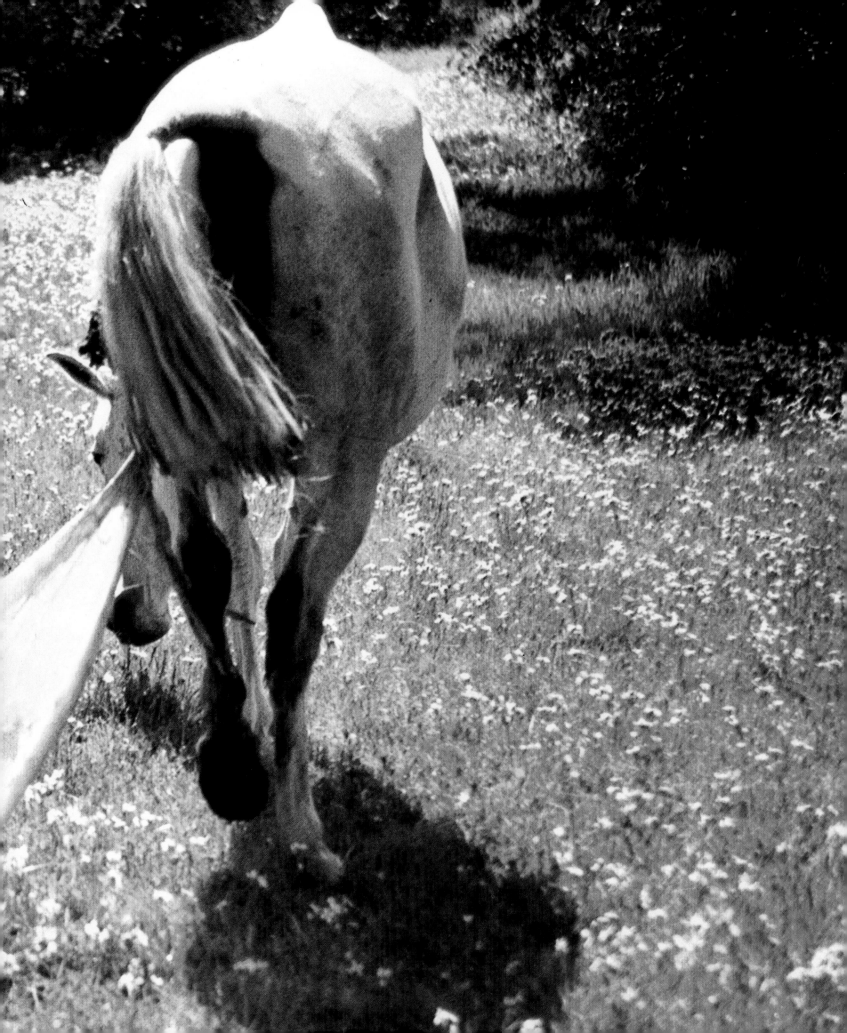

He was very much of a prince now,

doing as he pleased, commanding this flow

of nectar. There was a new miracle of heat

and power and arrogance inside of him . . .

Mary O'Hara

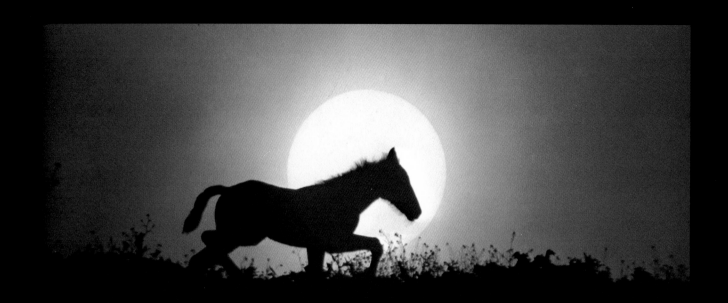

Right from the first the foal of noble breed

Steps higher and more lightly treads the ground.

Virgil

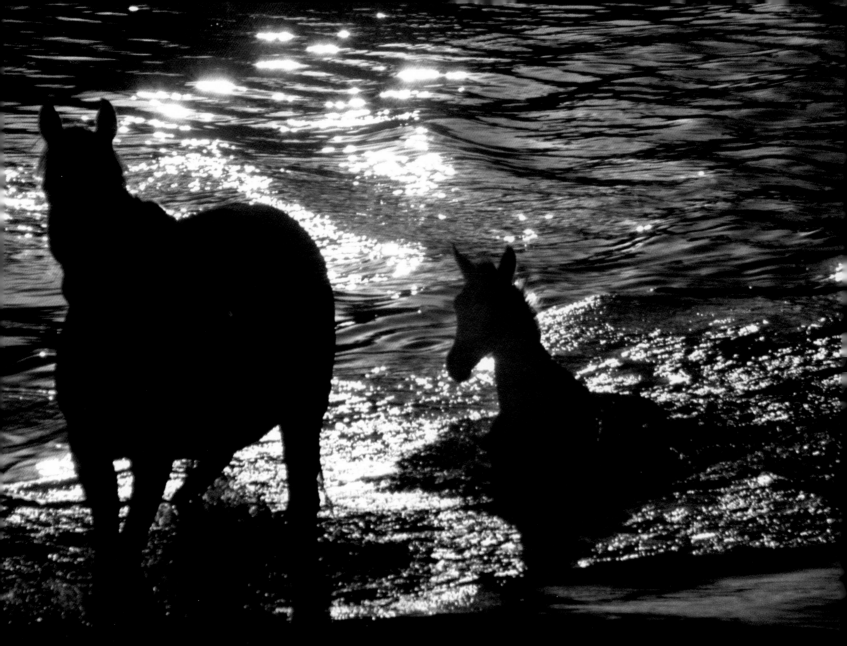

Blue are the skies of opening day;

The bordering turf is green with May;

How nervous and keen he was

with his small head and his fine legs!

Juan Ramón Jiménez

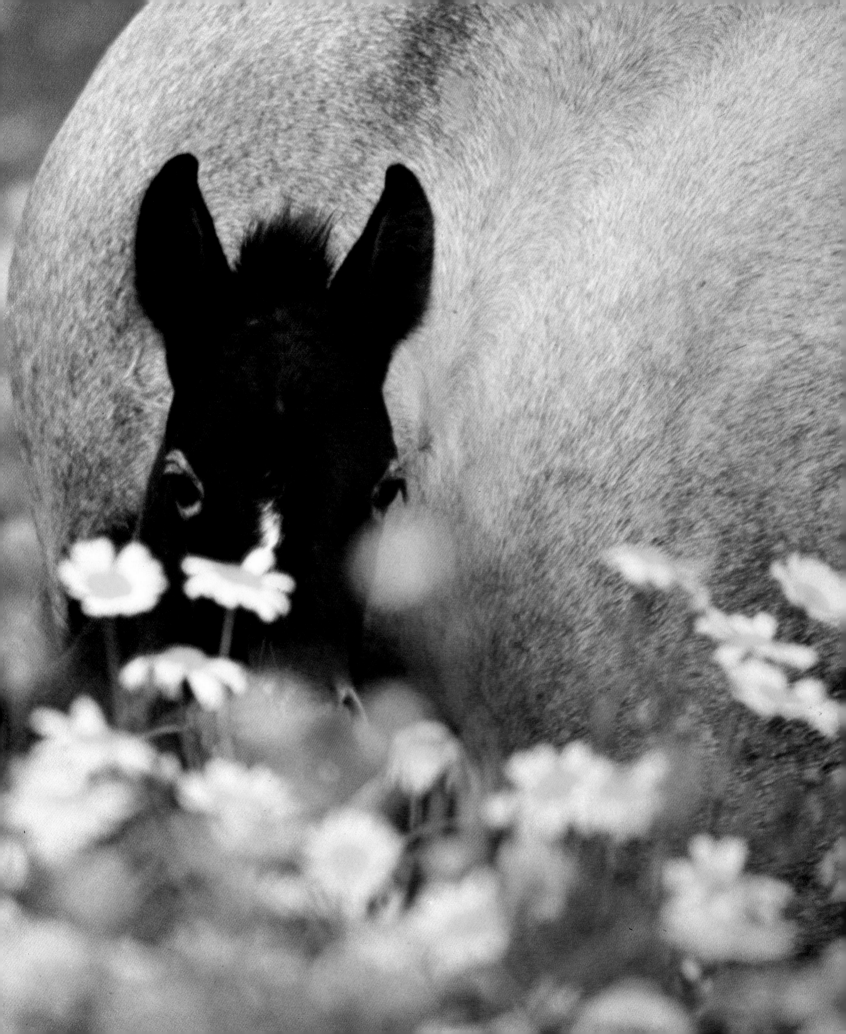

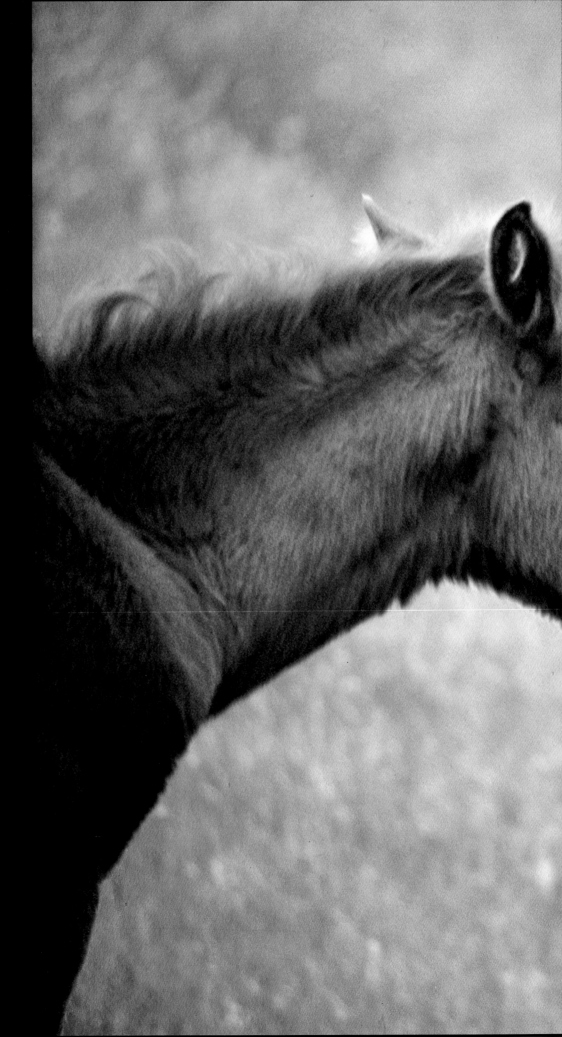

. . . they touched nostrils,

some explaining and

understanding must of

went on, cause it wasn't

but a few minutes later

when each was

scratching the other's

neck like two brothers—

and that's what they was,

brothers.

Will James

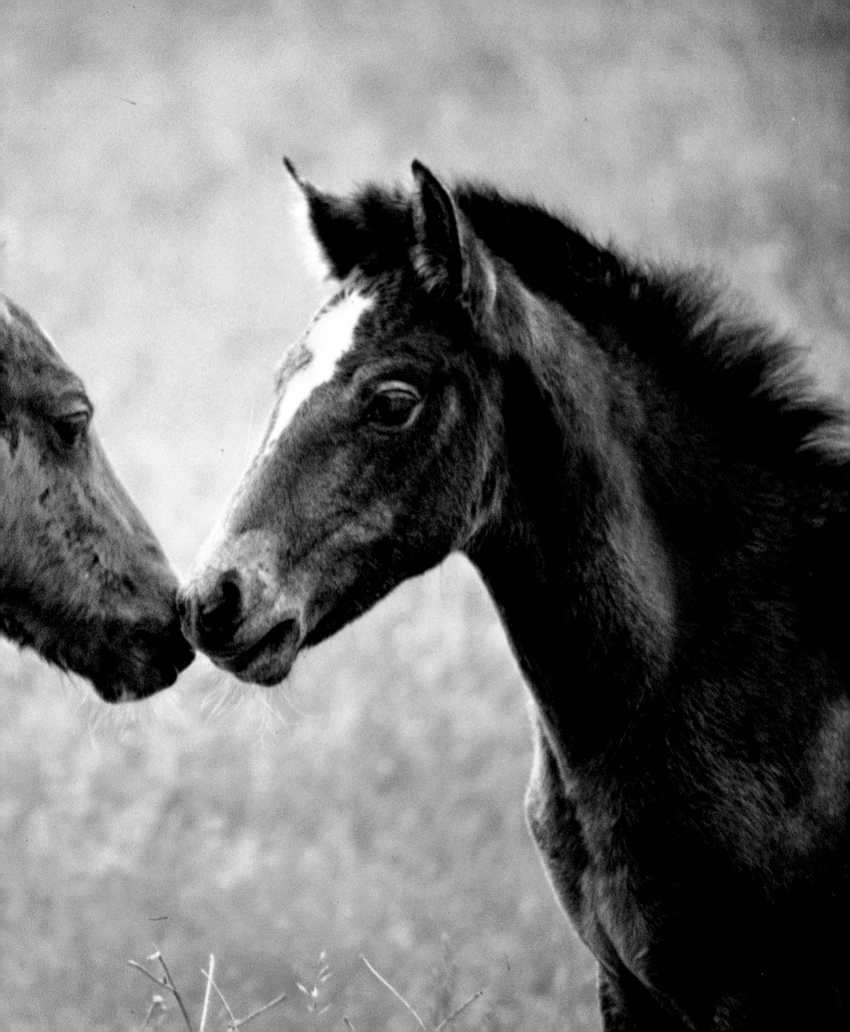

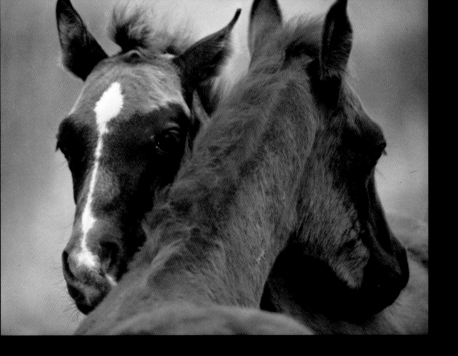
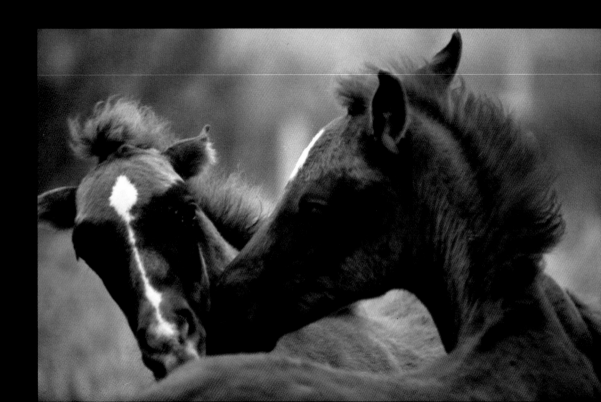

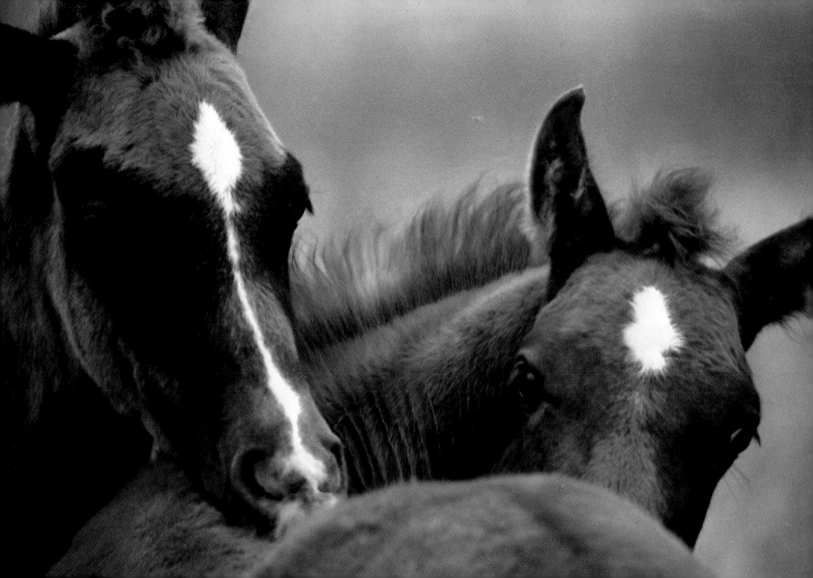

The butterflies there

in the brush were

romancing,

The smell of the grass

caught your soul

in a trance,

So why be a- fearing

the spurs and the traces,

Oh broncho that would not

be broken of dancing?

Vachel Lindsay

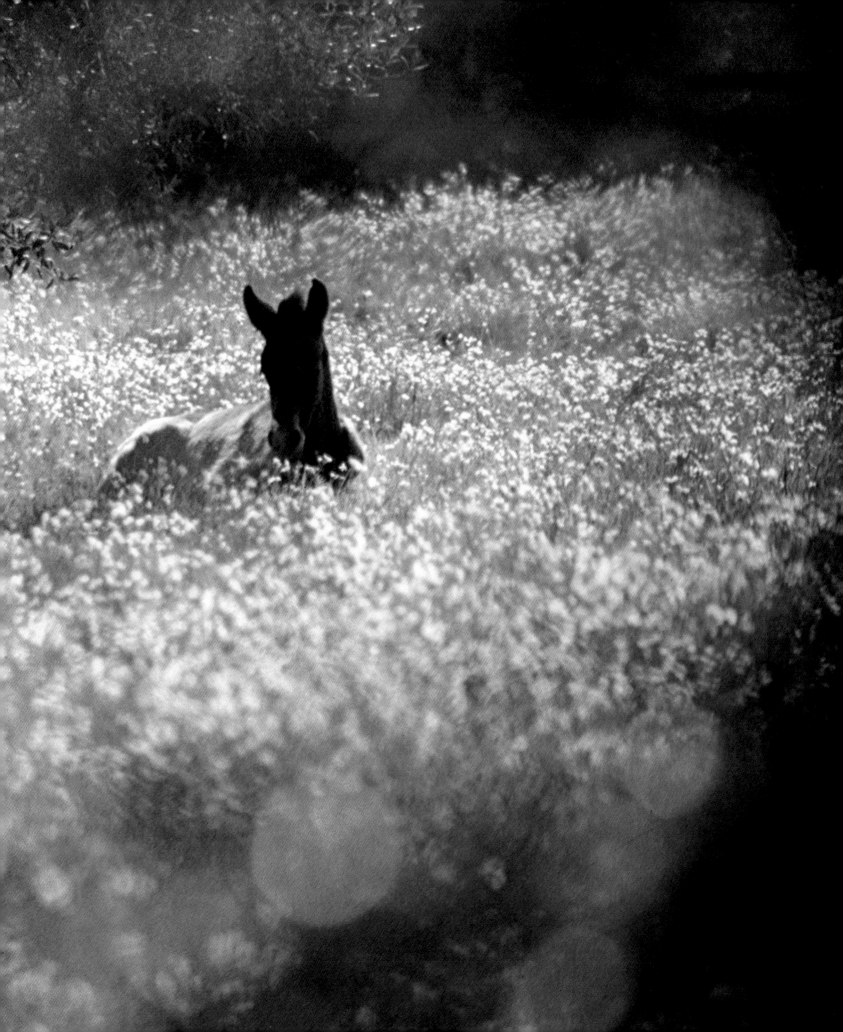

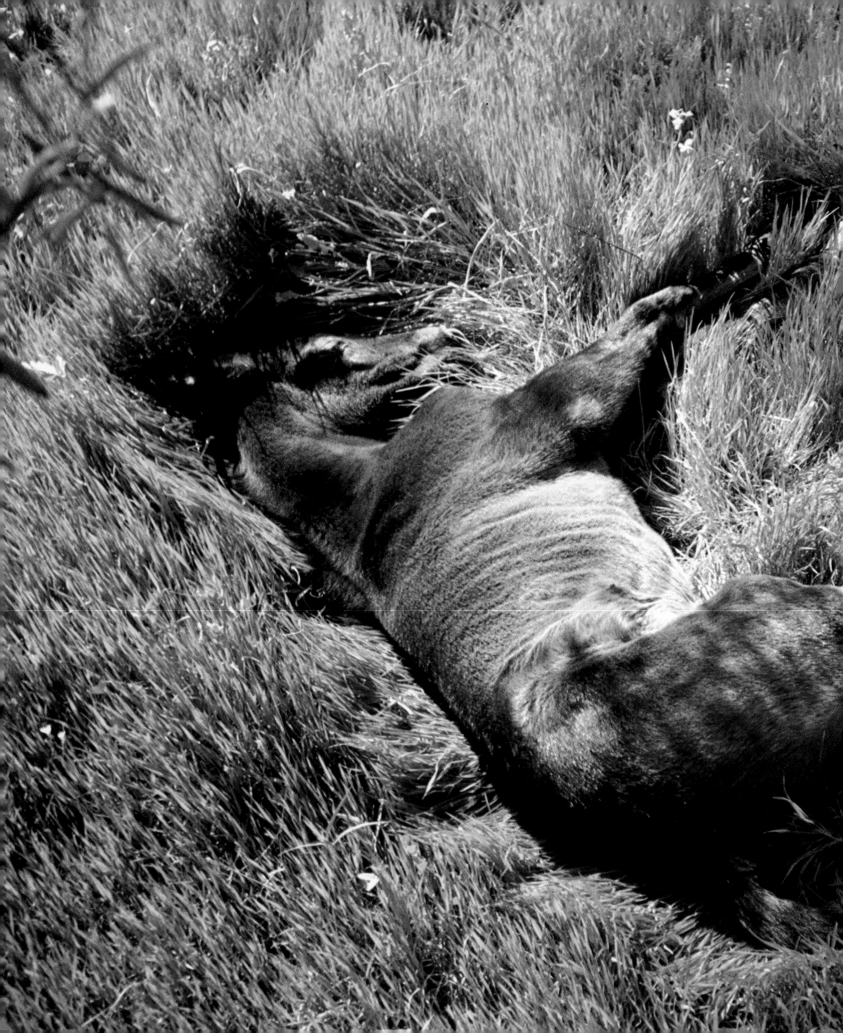

. . . there was a faint sound

of neighing of steeds . . .

no louder than the hum

of the bee or the summer-fly

in the drowsy ear of him

who lies at noontide

in the shade.

Washington Irving

Around and around

he galloped, and sometimes

he jumped forward

and landed on stiff legs . . .

quivering . . . ears forward,

eyes rolling so that

the whites showed,

pretending to be afraid.

John Steinbeck

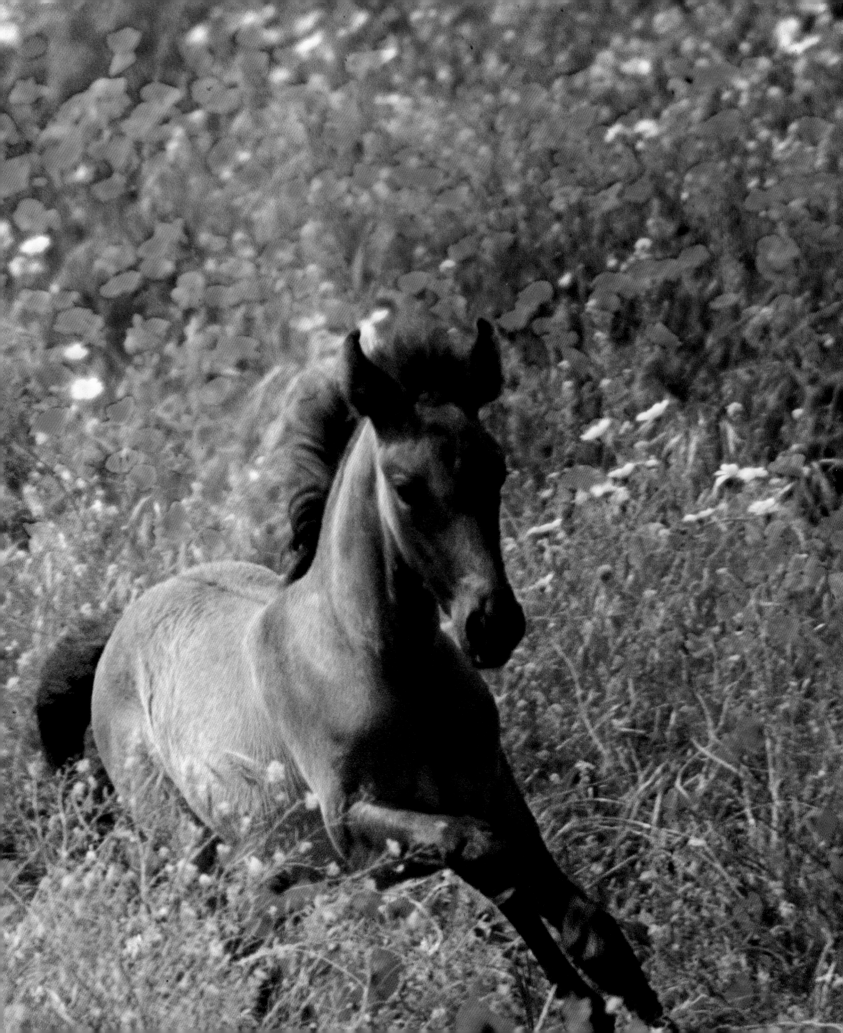

Nature is more beautiful than art; and in a living creature freedom of movement makes nature more beautiful.

Buffon

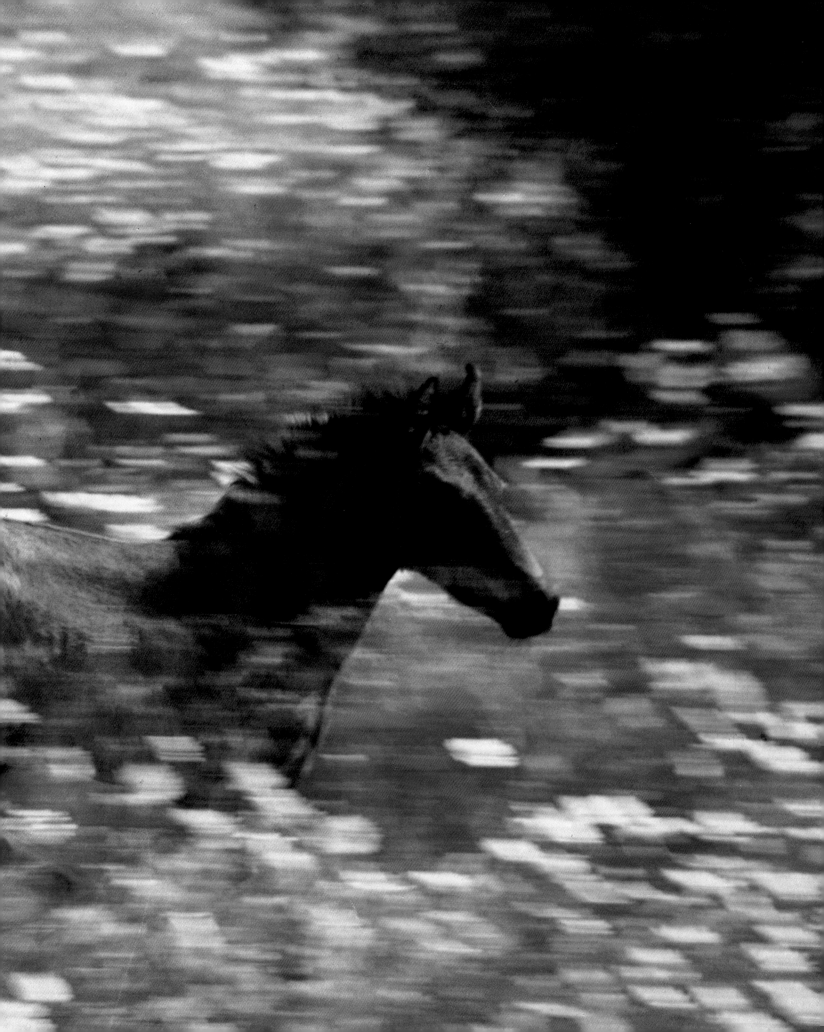

. . . virtue shall be bound into the hair

of thy forelock . . . I have given thee

the power of flight without wings.

The Koran

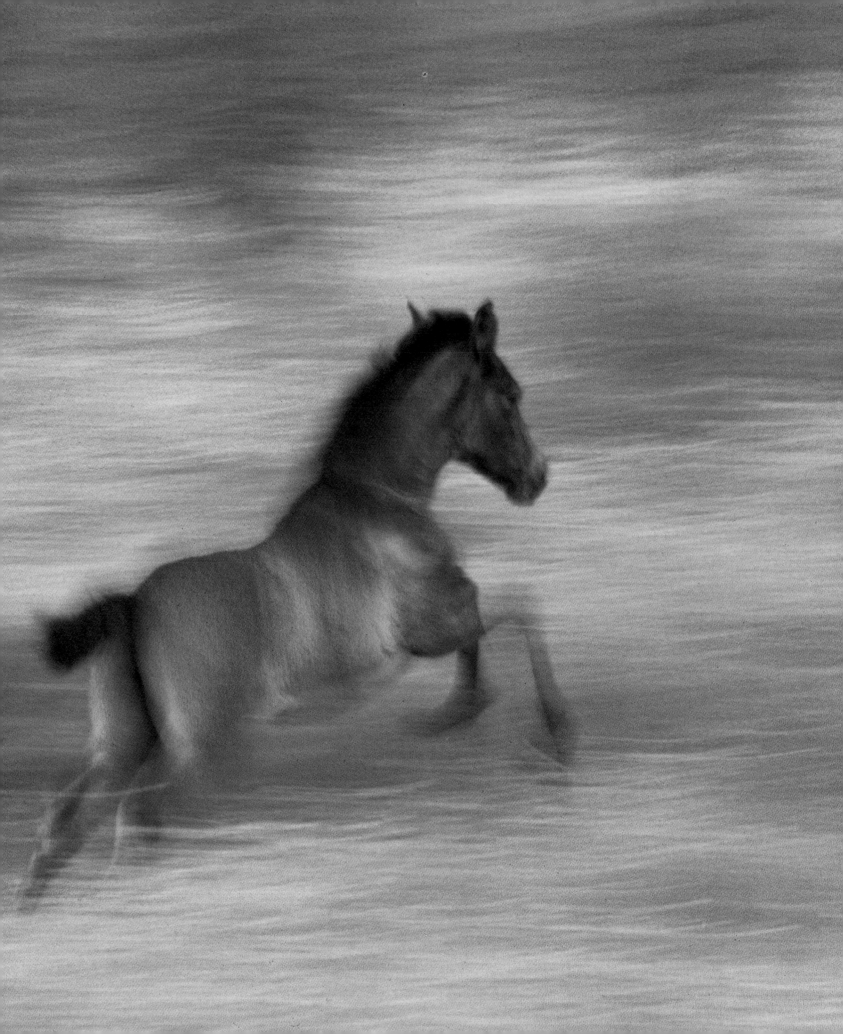

. . . presently he would

wheel around and stare

in another direction,

pointing his ears forward

to listen to some faint far

sound which had touched

his senses.

William Henry Hudson

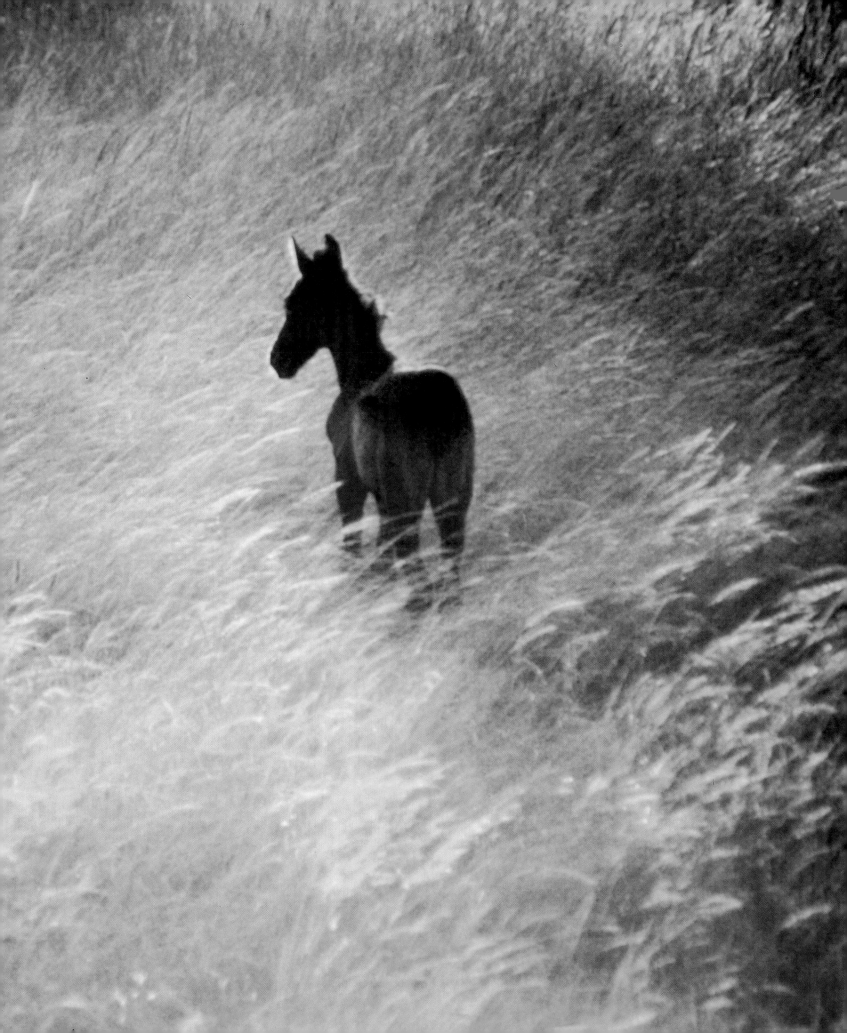

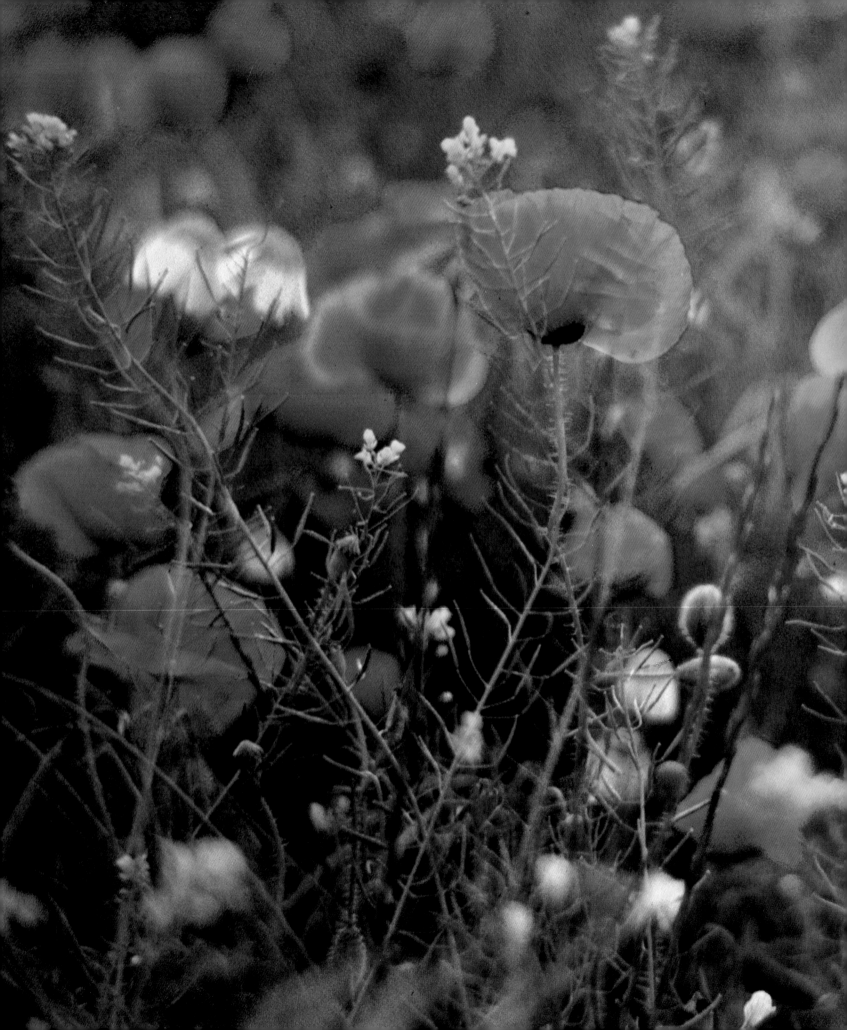

His neigh is like the

bidding of a monarch,

and his countenance

enforces homage.

He is indeed a horse . . .

William Shakespeare

125

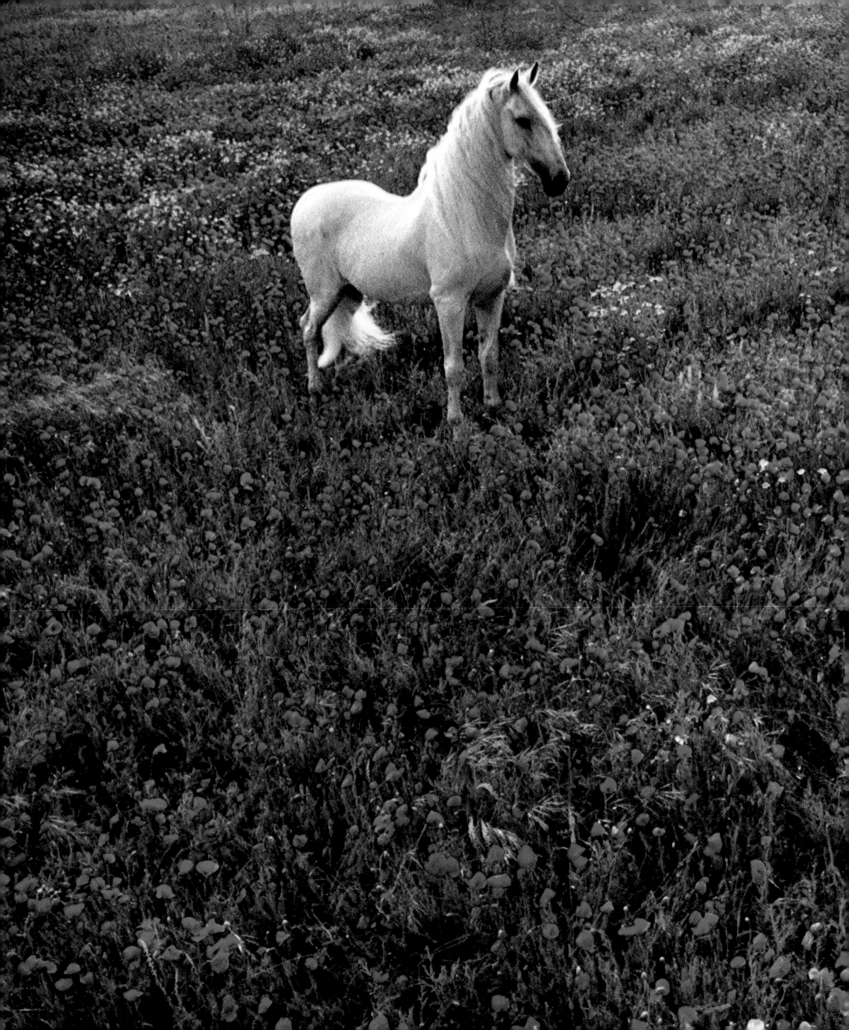

Before the gods that made the gods

Had seen their sunrise pass,

The White Horse of the White Horse Vale

Was cut out of the grass.

G. K. Chesterton

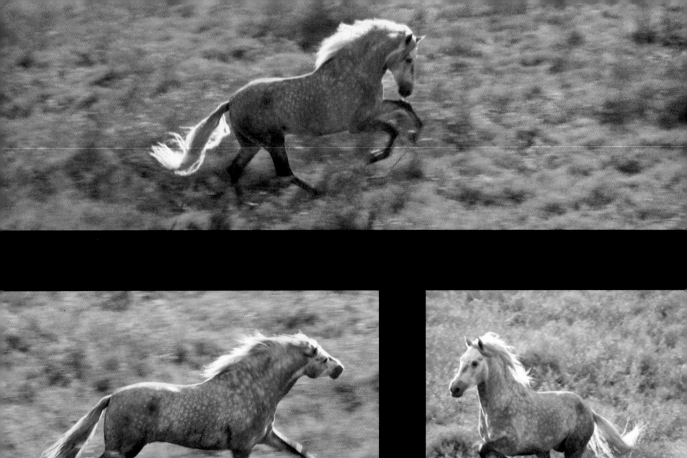
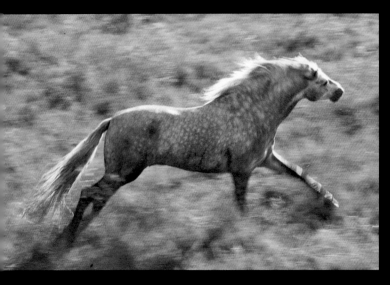
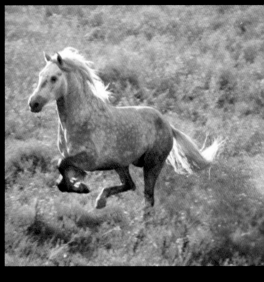
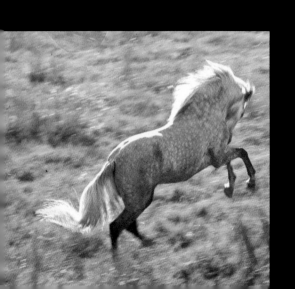
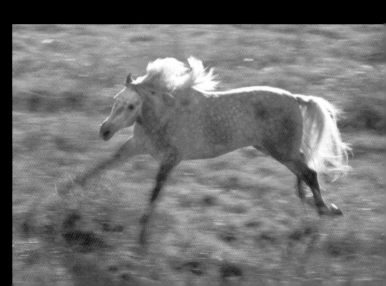

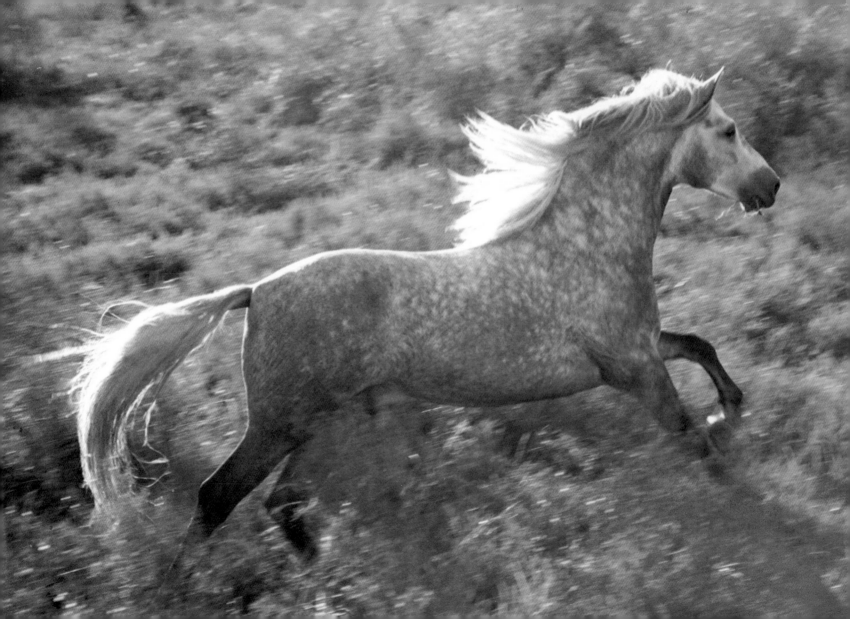

He dipped his head

And snorted at us. And then he had to bolt.

We heard the miniature thunder where he fled,

And we saw him, or thought we saw him, dim and gray,

Like a shadow . . .

Robert Frost

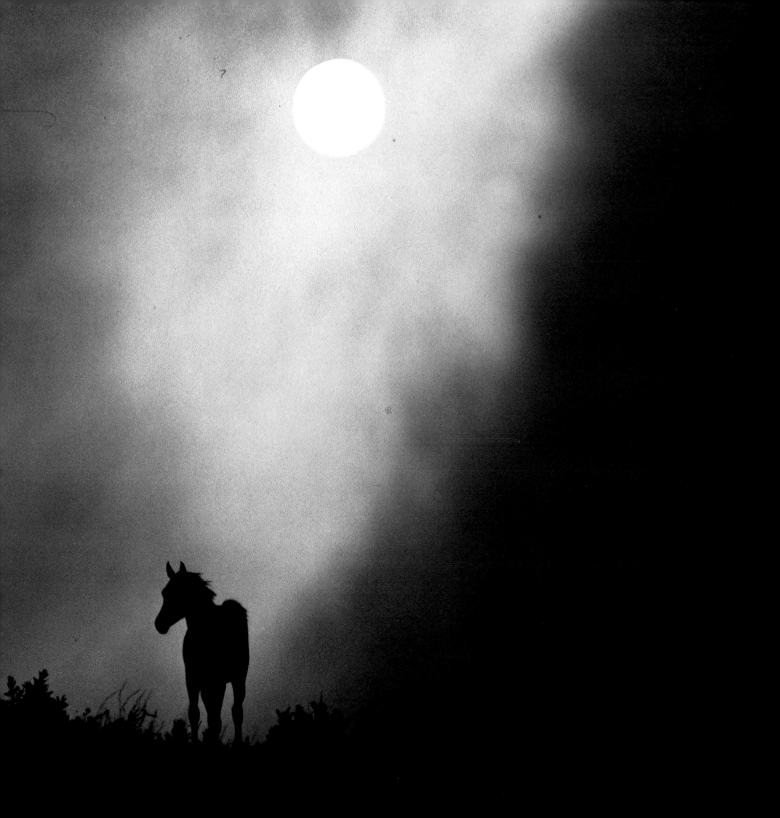

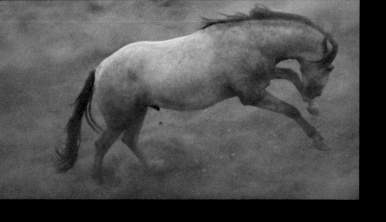
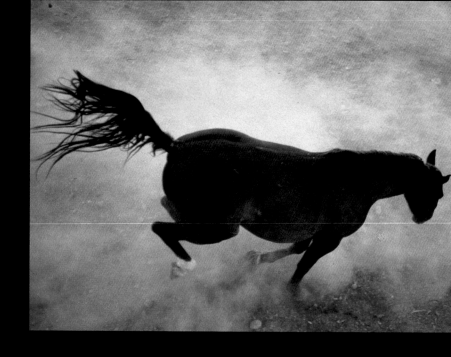
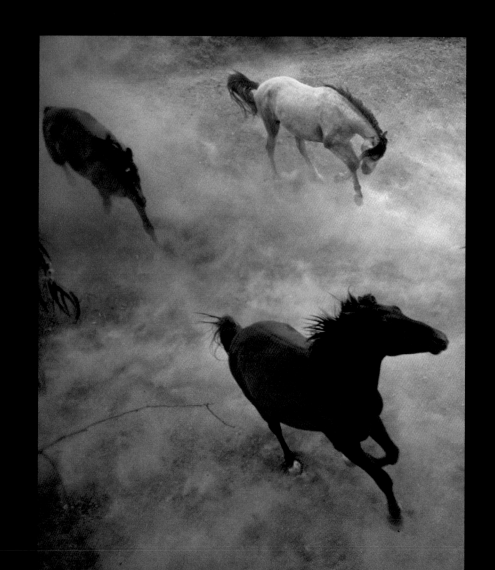

. . . *he fell a Trotting, and Winsing, and Yerking,*

and Calcitrating alias *Kicking, and Curveting and*

Bounding, and Springing and Galloping full drive,

as if the Devil had come for him in propiâ personâ.

François Rabelais

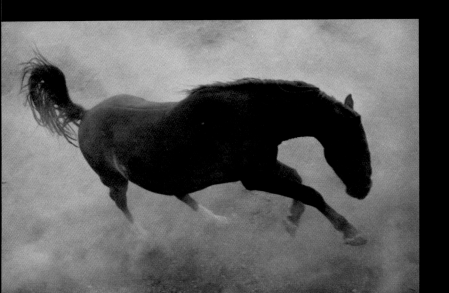

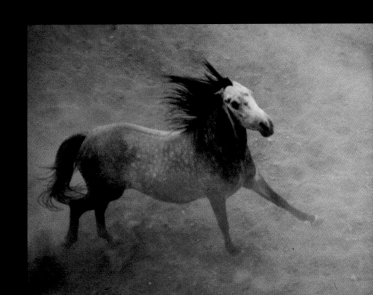

. . . a horse is a thing of such beauty . . .

none will tire of looking at him

as long as he displays himself in his splendor.

Xenophon

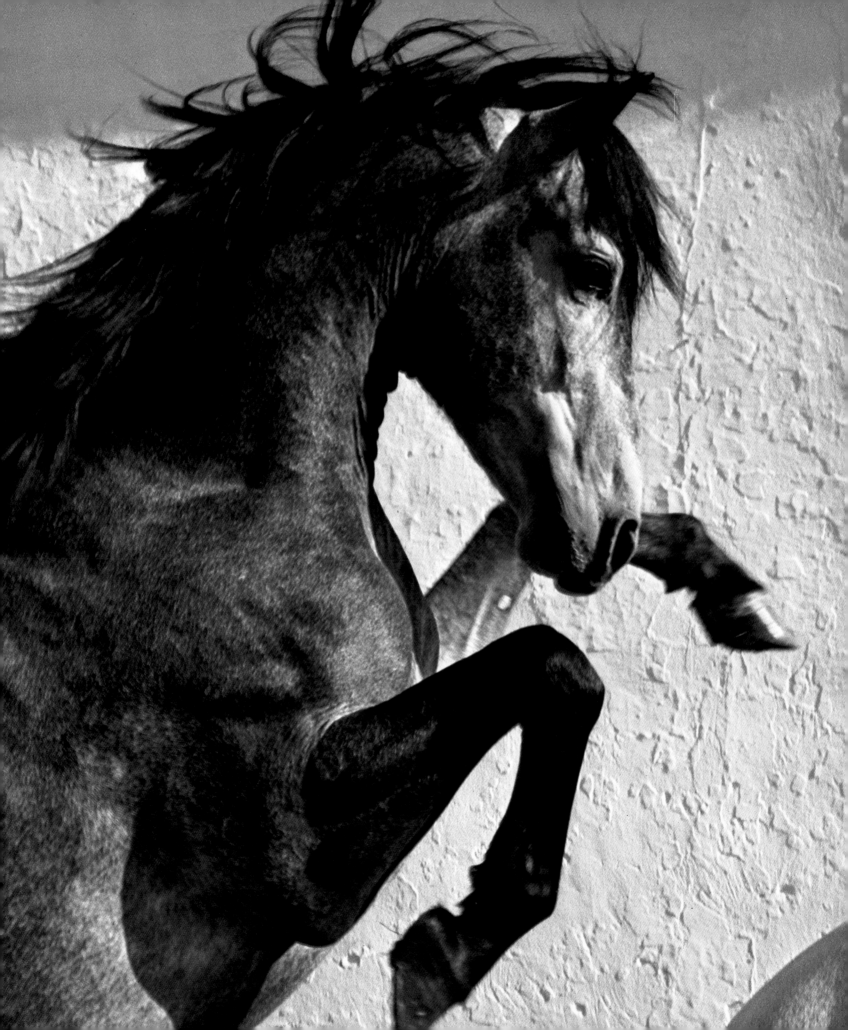

And when he takes a jump, anticipating, he

leaves the earth almost as if he could fly . . .

Hans-Heinrich Isenbart

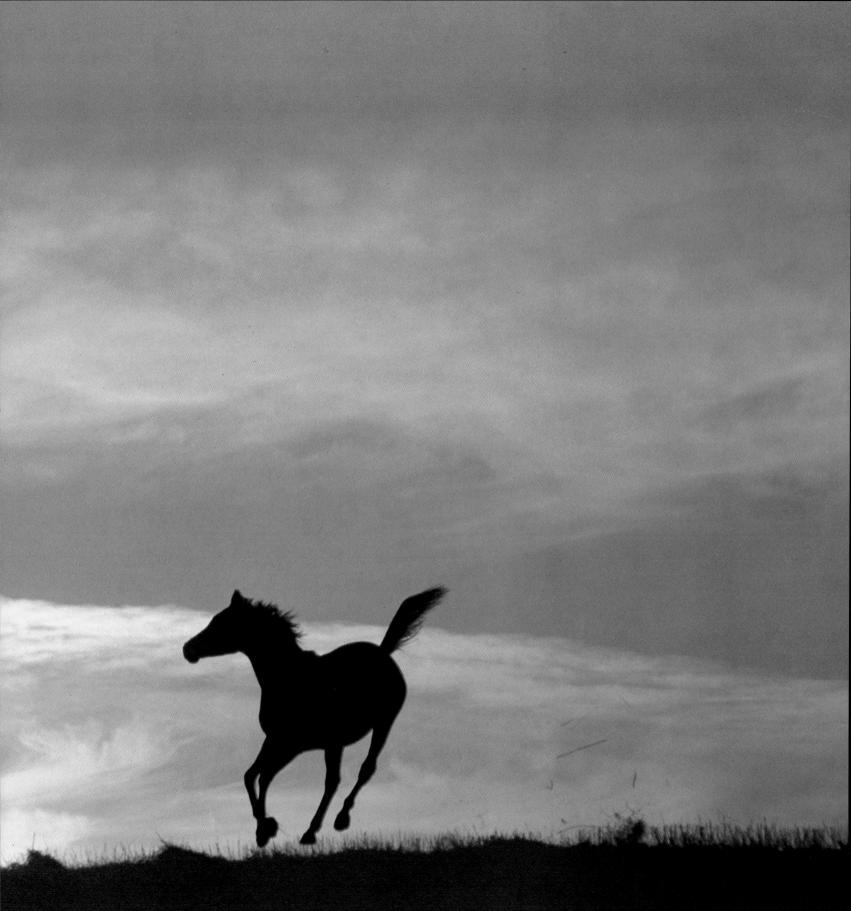

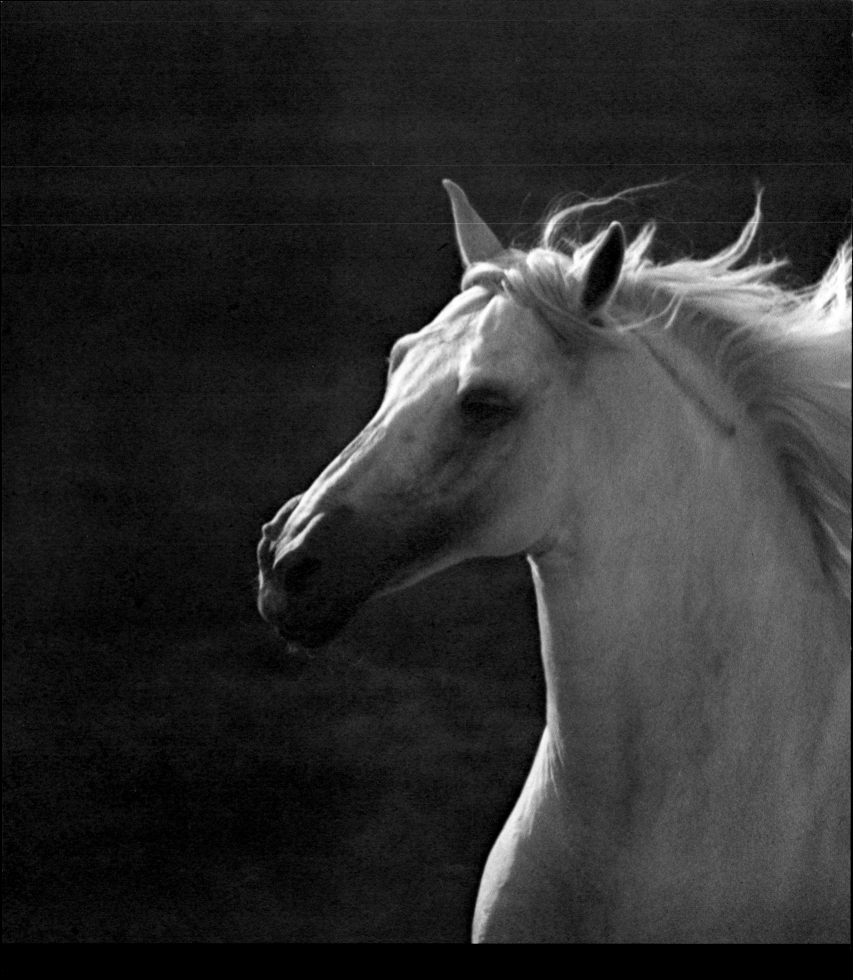

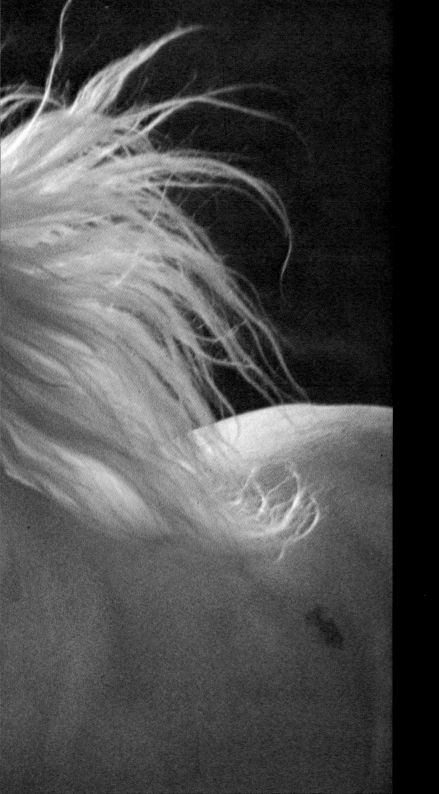

. . . Pegasus was a snow-white steed . .

as wild, and as swift, and as buoyant,

in his flight through the air, as any eagle

that ever soared into the clouds.

Nathaniel Hawthorne

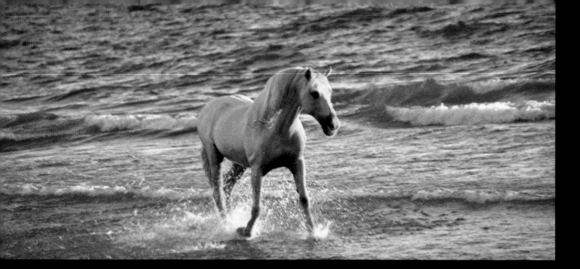

Now the wild white horses play,

Champ and chafe and toss in the spray.

Matthew Arnold

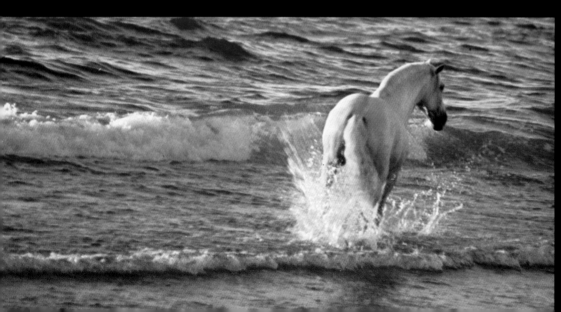

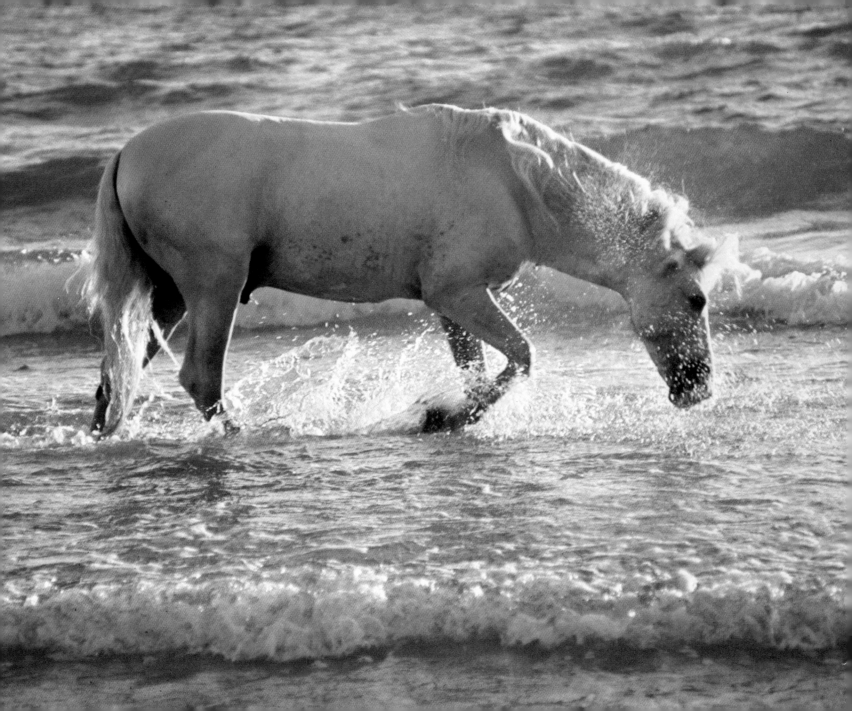

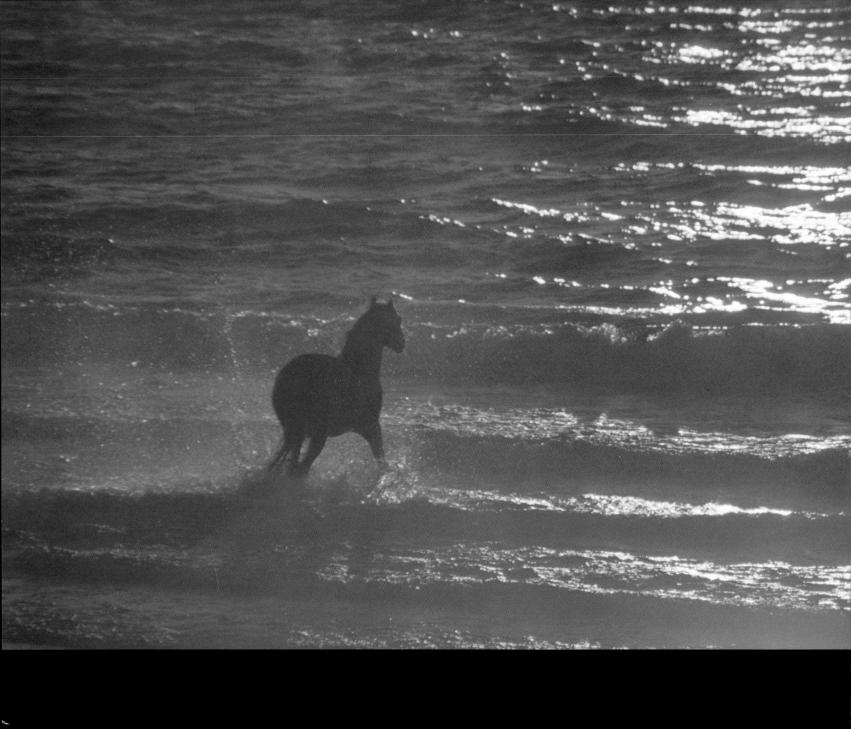

Fillies as lovely, stallions thrice as strong.

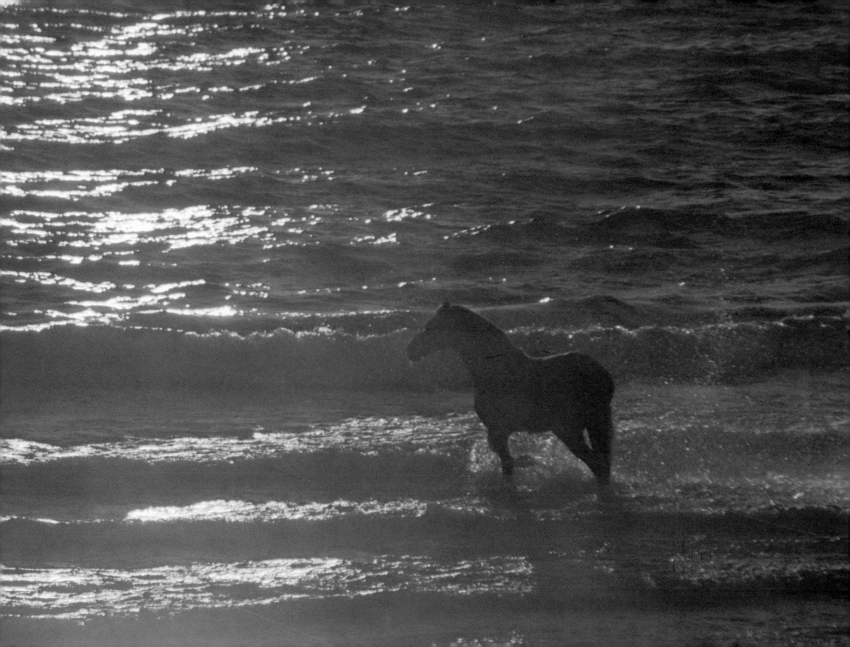

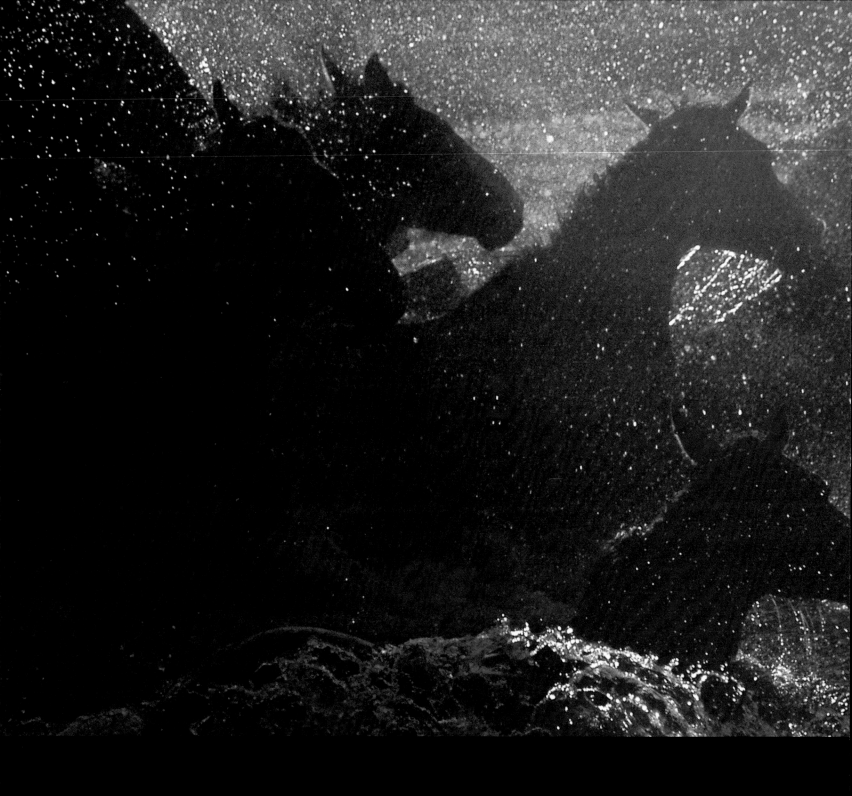

I heard a sudden harmony of hooves . . .

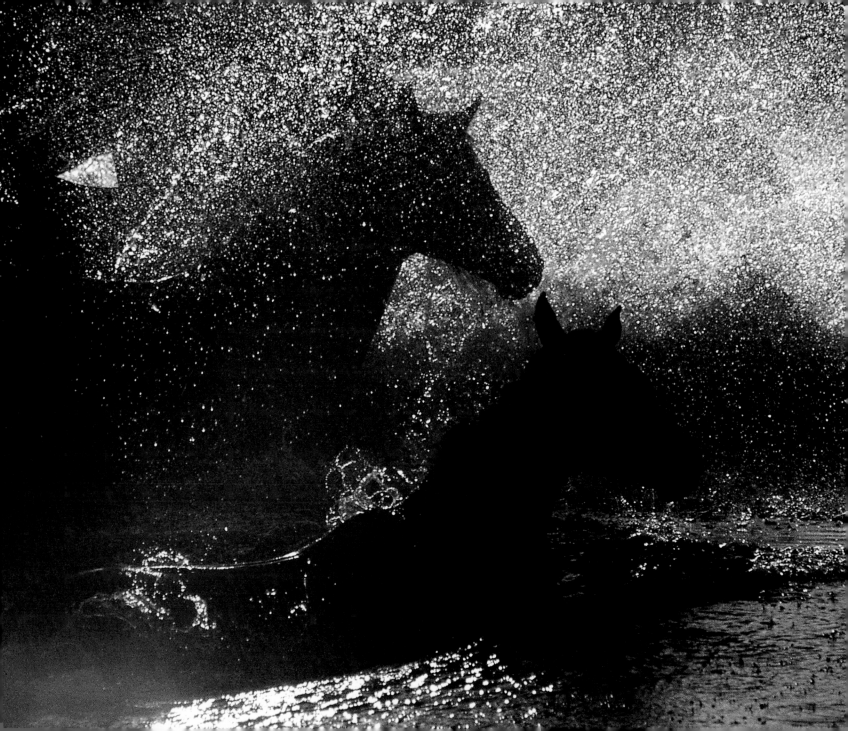

. . . stampeding horse that raves

. . . when it meets the sea at last

is swallowed outright by the waves!

Federico García Lorca

148

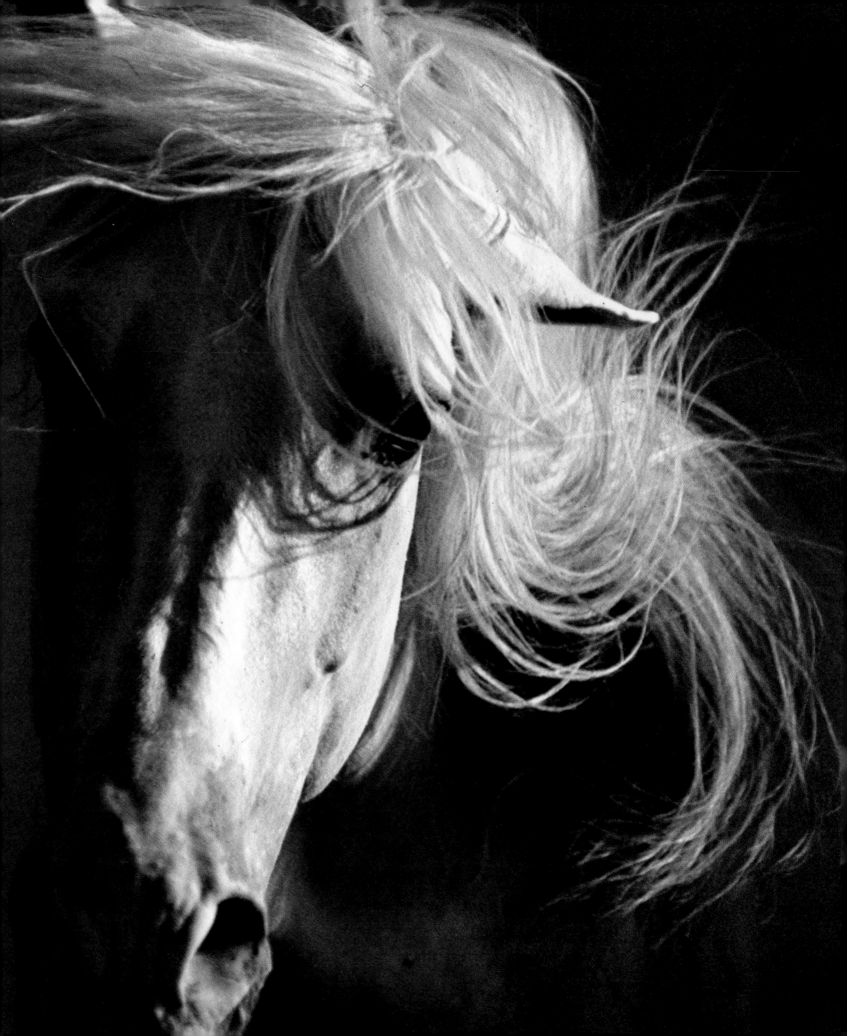

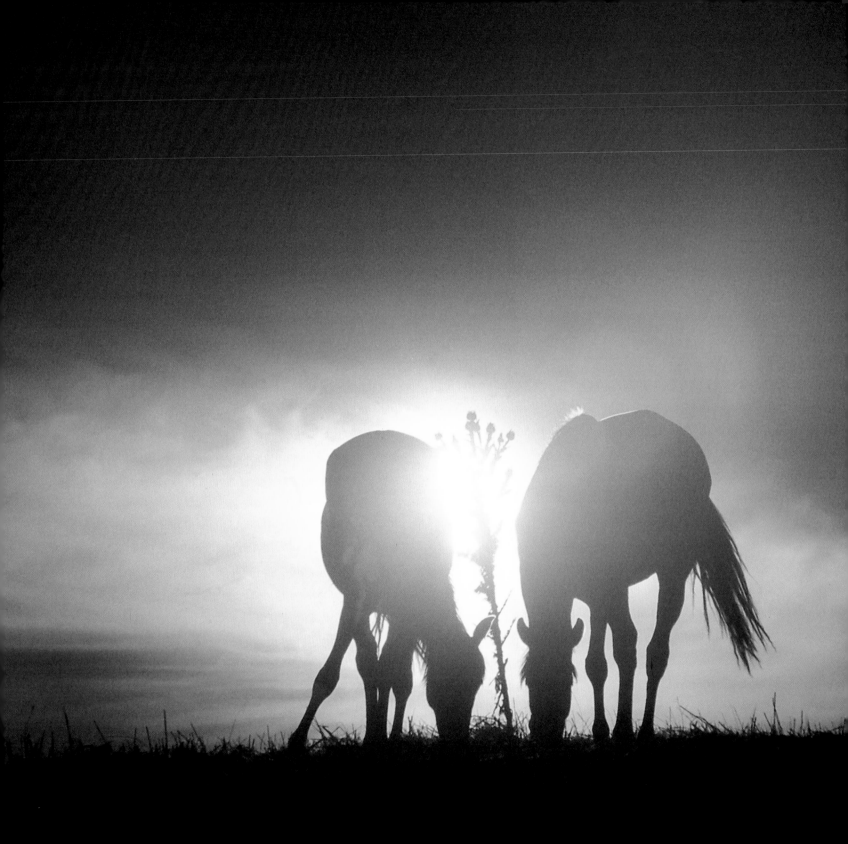

Under the last golden rays grazed the Sun's

Instead of grass they ate ambrosia;

Browsing quietly while resting tired legs,

In readiness to stampede the skies of dawn.

As the stallion rose . . .

the moonlight poured over him,

bleaching his hide . . .

a white horse dappled with shadows.

Mary Stewart

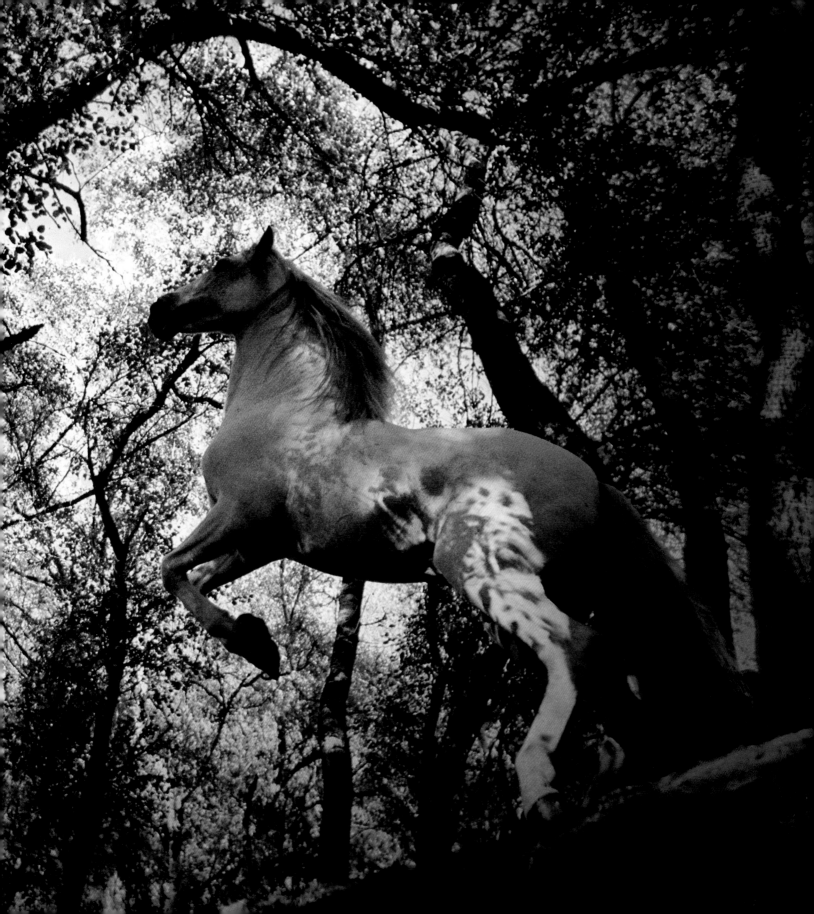

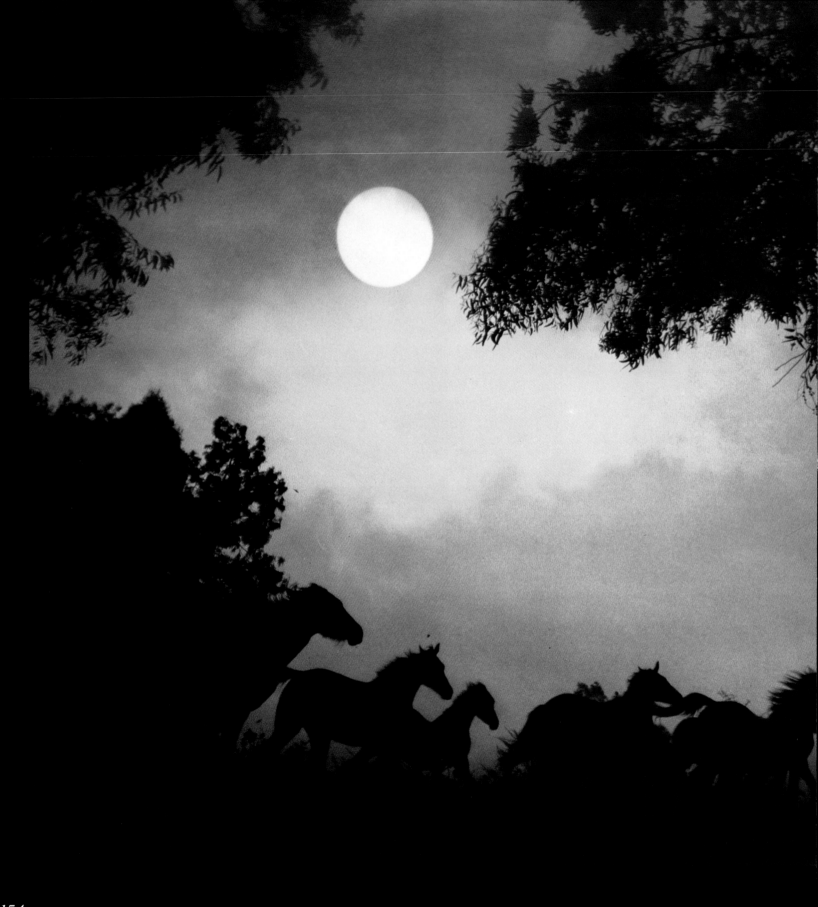

A shape in the moonlight, a bulk in the dark,

And beneath, from the pebbles, in passing, a spa

Struck out by a steed flying fearless and fleet;

That was all!

Henry W. Longfel

All the moon long I heard . . . the nightjars

Flying with the ricks, and the horses

Flashing in the dark.

Dylan Thomas

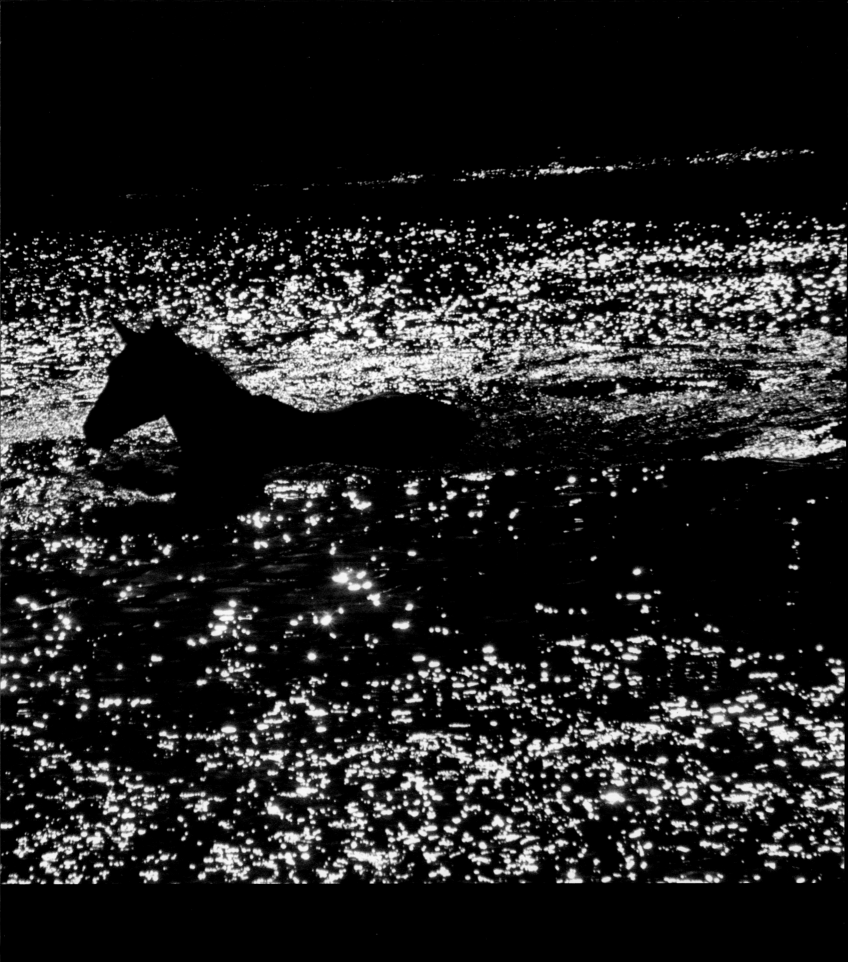

A blue stallion, a black stallion;

The sun's horse has come out to us.

Apache Ceremonial Song

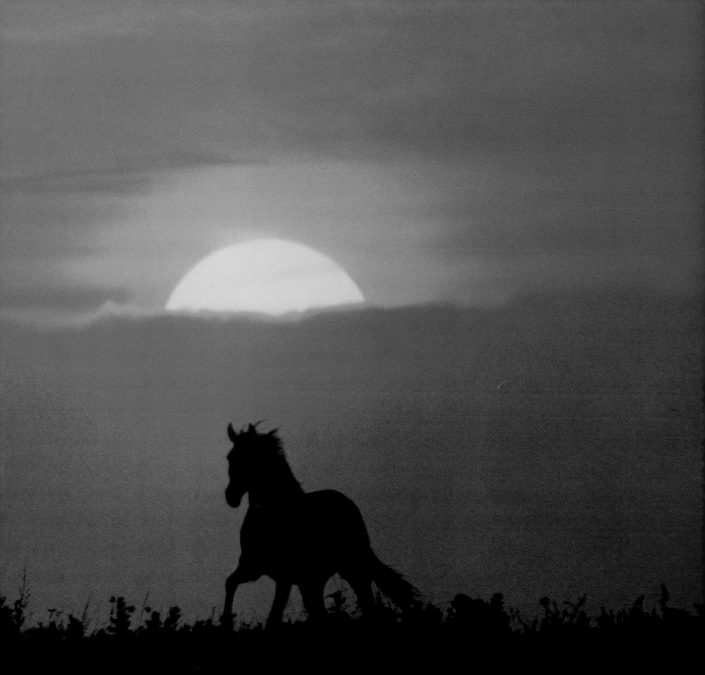

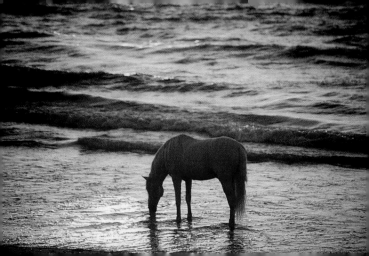

AUTHOR'S NOTE ON THE PHOTOGRAPHS AND A COMMENT ON THE SOCIAL BEHAVIOR OF HORSES

THE seed for this book was planted more than thirty years ago, long before I had a chance to observe at first hand the stallions of North Africa, Mexico, the Western United States, and of more than half a dozen European countries. When the colt Silver was given to me, Casablanca, Newmarket, Lisbon, Jerez de la Frontera, Paris and Querétero were merely romantic names in a geography book full of pale maps.

Silver, the only horse I ever owned, had just three legs, but oh, how we loved him! I was ten years old and my stallion was two inches high and cast in lead. On rainy days my twin, Ron, and I would play with our toy horses; to us they were as wild as any mustangs galloping free in the backlands of Wyoming or Montana. And though Silver was a cripple, for us he would run as fast as Man o' War.

Then there were the herds of horses at Columbus Grammar School. Ron and I and all our friends would split into two bands, tossing our heads and voicing shrill whinnies and, since each troop had a lead stallion, fights were inevitable. Often these combats became so violent that a stallion's war cries turned into the sobs of a small boy.

However, there were also real horses in our lives during those years of the Second World War. They belonged to my great uncle Charlie Jankovsky, a wizened, brown Czech who had come to America sometime at the end of the last century, where he had worked like crazy in Wyoming as a tailor, saving almost every cent he ever made until he could retire in Long Beach, California. Uncle Charlie's dream was to own a ranch and to have some horses, and happily for him—and us!—he was able to make his dream come true. After purchasing six hundred acres near Hemet, California, the first thing he did was to go to an auction and buy "livestock"; Polly was an old chestnut mare and Appaloosie was a sharp-looking Appaloosa. Uncle Charlie knew a lot about tailoring and saving money, but he always got taken at those auctions (even though my brothers and I were convinced he was a gypsy).

Our great uncle had bought Polly in foal with the promise that she had been bred to a prize Quarter Horse. This excited Ron and me so much that toward the end of the mare's pregnancy we talked our folks into spending as much time as possible at that old Last Gate Ranch that didn't have electricity or running water, and whose outhouse spider webs made us cautious about sitting on the seats. I can remember running down to the lower meadow the morning Polly had given birth. Her offspring, we were sure, would be as handsome a foal as the one in the film *Thunderhead* (which we had seen four times at the Alex Theater in Glendale). God, how sick we were when out of the sage brush stepped a baby mule! Polly died a year later. Appaloosie was another

problem. She shied so much that only my father could ride her, so Uncle Charlie went back to the auction and bought Gypsy, a coal black Morgan with a white star on her forehead. Soon enough, however, we found that not a fence on the ranch could hold that mare.

Once I remember Uncle Charlie got so mad at Gypsy that his brown face turned the color of split-pea soup. The mare leapt the barbed-wire right in front of the cabin and messed up the new pond and destroyed the water lilies that our great uncle had so carefully hauled in milk cans from Long Beach to Hemet. (Bringing those precious plants to the ranch the car had heated up twice and boiled over, but Uncle Charlie had refused to use water from his lovely lilies; he had preferred to walk a mile to the nearest farm.) I was scared and stood in the background when he tied Gypsy—our "Black Beauty"—to a tree and then beat her in the face with a bridle. It was an awful thing to see and it ruined the mare forever.

Chick was a small bay mare that also came from one of the auctions. How many owners she had had, and how many of them it had taken to spoil her, I don't know, but I never will forget sitting on Lizard Rock, above the outhouse, loading a B-B gun, talking with my mother who was currying Chick in the meadow, when the horse—for who knows what reason—whirled around, grabbed Mother by the shoulder, threw her on the ground and tried to trample her. If Dad hadn't raced up

from the cabin to scare the mare away, I don't know what would have happened.

Later, as we drove Mother to the hospital, Dad said we shouldn't let Uncle Charlie's auction misfits ruin our love for horses. They really could be noble and beautiful animals, he told us, and to prove this, a few weeks later he took us to what was then the Kellogg Arabian Horse Farm near Pomona, California. To our twelve-year-old eyes, what could have been more beautiful than the Arab stallions and mares that were paraded before us in the golden light of that late California afternoon—certainly not Veronica Lake or even a Buick convertible. "How could anything be lovelier?" Ron and I wondered, "except maybe wild mustang stallions galloping free across the mesas of Colorado."

Not much later we had the chance to prove in person what we had heard so many times: that stallions were wild demons, couldn't be trusted and had to be kept under lock and key. Ten miles from the Last Gate Ranch was a farm dedicated to the raising of Hereford cattle and Quarter Horses, where our uncle asked Dad to have a look at a Palomino stallion and to find out what kind of stud fee would be charged for covering either Chick or Gypsy. So early one morning we left the raw wilderness of the old Last Gate Ranch; my brothers Bill and Ron on one mare, and Dad and I on the other, we rode down the canyon, valley quail calling from the sage on either side of us, doves and jays taking off from dead branches of cottonwood trees that twisted silver against the sky. Finally, the dusty trail ended and we entered the neat white fences and lush green fields of the farm of the Palomino stallion.

While we boys stood outside with the mares, Dad went into the stable with a cowboy. All of a sudden we heard the banging of hoofs against wood and the battle screams of a horse. Bill ducked inside the building to have a look, returned shaking his head in respect, and then held the mares while Ron and I entered the cool darkness that housed not only the stallion, but the smells of fresh hay and horse sweat and manure—all lovely to our noses. "He's a real son-of-a-gun," the cowboy was saying to our dad. "Meaner than cat pee and twice as nasty." Then we knew why so few people in America had stallions for pleasure riding; it was like keeping a wild animal! Eyes rolled back, ears flat to his head, teeth bared, forelock tossing, the Palomino, like a dragon, thrust his head out of the box. "Stand back, fellas," warned the cowboy.

Later that night at the Last Gate Ranch, I couldn't get the stallion off my mind until I started for the outhouse and then stopped halfway along the path to unzip my pants; the nights in those mountains were so dark and the picture of the cougars trying to kill Flicka in the movie were still so vivid in my mind and imagination, that every movement or owl's hoot from the oak trees sent chills up my back. After midnight, when the kerosene lamps had been turned off and everyone was in bed, when

my father was snoring and the white-footed mice were scampering across the tin roof of the cabin, I remember thinking how sad it was that a stallion, except maybe in the movies or in a book, had to be such a wild beast, a savage to whom neither I nor any boy could be a friend. And yet, at the same time, I delighted in the thought of the Palomino's fiery display, for in truth, it was what I had always been told stallions were.

In the years that followed, I never lost my love for horses. Even today, in Sevilla, if I close my eyes and concentrate for a few minutes, I can brew up strong recollections of experiences with them from years ago. There was a rickety maze of corrals and loading ramps at a livestock auction near Downey, California, and we never passed it in our old Model T Ford without my father yielding to Ron's and my pleas to stop alongside the road.

Then we boys would climb up on the fences and stare down at the nags nobody wanted and who, if they weren't sold for a few dollars at one of the auctions, would end up next door in billows of stinking smoke that rose from a glue factory. But we didn't see bony nags or notice those odors much, we just saw horses—horses! And how we loved that sight.

Mixed with those same childhood memories are scenes from Taft, California, a hick oil town on the edge of Steinbeck country, where my wonderful old grandmother Hamilton lived; where on hot summer nights there was nothing to do but go to the rollerskating rink and whirl around the warm cement to phonograph records of someone playing Strauss waltzes on a Hammond organ. In the daytime, however, even though the sun beat down with such intensity that the blacktop roads became soft underfoot, we would wander over to some nearby corrals and do nothing but look at the mares and geldings. Ron, my cousin Gary and I would have liked to ride those animals, but, like the grey lizards that basked in the sun out of reach of our hands, we were satisfied just to hang on the splintery fences and stare at the horses; to watch them and listen to them and smell them.

Not all those recollections, though, are as seemingly unexciting as were the inhabitants of those slipshod board corrals. I wouldn't trade anything for an experience at Uncle Charlie's ranch that flashes as dramatically before me today as it did in real life thirty years ago.

Dusk was settling as Ron and I left the North Forty where we had been twigging doves with a .22. Happy with having shot enough birds for supper, we walked in tired silence; the only sounds were our boots through the dry grass, the distant yapping of a coyote, and the chatter of a covey of quail going to roost in the surrounding oak trees. Then it came, like the cry of another child, from the canyon behind us—the scream of a mountain lion. We whirled around, shaking, white-faced, each knowing that there never was a recorded case of an unprovoked attack on man by a puma in the wild (but still fresh in our minds were those two big cats in the film *Thunderhead,* clinging like shadows to a tree, heads turning weasel-like, yellow eyes and fangs gleaming, ready to pounce on Flicka and her foal).

Suddenly, from the far side of the meadow, muffled sounds of hoofs thudded madly from the weeds and soft earth. "God!" I thought as I looked at the panicked expression on Ron's face. "A big cat's after the horses!"

Gypsy burst first through the shoulder-high sage at the clearing's edge, head high in fear, ears laid back, her mane rising and falling like a black wave as she galloped in violent surges, closer and closer. Behind came old Polly, then heavy in foal, and just as she passed us—"Boom!"—into the air overhead burst a covey of what must have been almost a hundred quail. Ron and I exchanged glances; were we really at the Last Gate Ranch or were we slouched deeply into the cheap seats and darkness of the Alex Theater? But here the horses

didn't whinny in fear, they just ran like crazy, flying towards the cabin as if the puma's claws were touching their flanks. "What shall we do?" Ron's voice was trembling.

"Mountain lions won't attack people," I answered. My hands were shaking so that one of the doves dropped to the ground, but I was too frightened to stoop over and pick it up, sure the puma was crouching right then on one of the twisted limbs overhead. "But . . . but anyway," I whispered, "it might be a good idea to try to keep him from going after the horses." To which Ron emptied half his gun's magazine into the air, the shots ringing in lonely echoes off the granite boulders around the meadow.

Not many months after that experience, my uncle Jim introduced us to a new kind of horse. That chestnut filly, coming out onto the Santa Anita Race Track, sleek and gazelle-like, with large, lovely, dark doe eyes, and coils of charged-up muscle under her smooth coat—the beauty of that sight touched the deepest places of my soul. The infield grass was so green, the flowers so bright, and the silks of the jockeys so dazzling, that I grinned up at my handsome, silver-haired uncle and he smiled back because he knew that I then understood why he so loved the races. The horses were at the gate, they were inside while the world stood still for a moment, and then they were on the dirt, with the announcer's voice booming out to the purple haze beyond the track. Around the curve they glided, blossoms of color in the distance, swinging into the home stretch, coming so fast. Could horses move that fast? Each

spread out in great strides, full drive, the jockeys pressed tightly to their mounts, the roar of the crowd suffocating the announcer's voice.

Strangely enough, in those early years I never learned to ride well; I was content just to look at horses. The explanation is simple, I suppose; those misfits of Uncle Charlie's either had too many problems for us boys, or, like old Polly, they were nags. The other horses we rode were from one of the rental stables across from Griffith Park. Those plugs had long since been turned into walking robots and the only time they showed any life was when we turned them back towards the stables, and then there was no stopping their mad, homeward gallops.

Soon sports, girls and studies just about crowded horses out of our lives. At college, however, some new stallions—Bucephalus, Alborak, Rocinante, Marengo—did gallop from history into my imagination. To be honest, though, until shortly before coming to Spain, horses had been replaced in my world by other interests.

I was in Mexico one Sunday for a corrida when some friends introduced me to Carlos Arruza, a famous matador who, once he had retired from fighting bulls on foot in the ring, had turned to killing them from horseback in the classical tradition. The Andalusian mounts that Arruza used that afternoon were some of the most magnificent animals I had ever seen. They weren't large, though they did have full chests, exceptionally long manes and tails, well-formed heads, and body conformations that, although I knew little technically about

such things, seemed close to artistic perfection in their beauty. Two of Arruza's horses had unusually high and showy (but untrained, I was told) leg action. However, what most impressed me about those stallions was their gentle dispositions. At that time in America few stallions were kept for pleasure riding because they were generally considered dangerous. Thus, I assumed Arruza's horses were simply exceptionally beautiful and tame animals, and gave them little more thought. Also, this was the period in life when I was completely taken with what seemed to be the most impressive animals I had ever seen—fighting bulls—and I spent many free hours in Mexico studying their behavior and photographing them in the ring.

It was the fighting bull, in fact, that in 1958, when I was twenty-three years old, brought me to Spain, where I spent six years working on a naturalistic study of brave cattle. Not equipped with formal education for animal observation, I had to rely on the first lessons my father had given us in the ways of wild creatures which, along with an intense interest in nature, helped partly to overcome my lack of technical training by sometimes offering an open and fresh point of view.

During those wonderfully happy years in Andalusia, far from Uncle Charlie's Last Gate Ranch and the stockyards of Downy, I once again came in close contact with horses, spending day after day with the bulls, and it then became obvious that Arruza's mounts had been no exceptions in their extreme beauty and their

noble dispositions—Spanish horses were normally that way. It was also exciting to realize that most of the horses in America were in one way or another related to Andalusian stock taken to the New World by the conquistadors. Even the race horses we had watched with Uncle Jim at Santa Anita, Hollywood Park and Bay Meadows, as well as those I had seen in England and France, had backgrounds that could be traced in part to Spain and North Africa. The Wyoming mustangs my father had told us about, and the Quarter Horses I had known in Texas and Mexico all had some Spanish blood. So it seemed that most of the horses in my life were suddenly tied together in an intriguing manner.

During those first years in Spain, I had the good fortune to enjoy the friendship of a number of men who not only loved fighting bulls, but felt just as strongly for their horses. Of these, the one I recall with most affection is the late Juan Belmonte (the matador who half a century ago revolutionized bullfighting). Though seventeen years have passed, I can still almost taste those cold bowls of *gazpacho* that were served to us by Asunción in the dining room of Belmonte's country house, Gómez Cardeña, followed by afternoons of open-field testings of young bulls. In my mind, as well preserved as a fresh photograph, is the picture of Belmonte on a white gelding, far off in the distance, a white speck against a sea of grey-green olive trees, the portrait of happiness in the union of man and horse.

Those mornings and afternoons of *acoso y derribo* presented the opportunity to renew my interest in horses. Not content to photograph the testing from the edge of the field in the normal fashion, I asked Belmonte if there wasn't a new angle that could be used, a problem which he pondered on a number of occasions over coffee at the Café Los Corales in Sevilla. The first solution he suggested— with a slight smile on his rugged face—was to dig a hole a couple of meters deep at the edge of the field so that the action could be photographed from ground level. But I convinced him that the horses and cattle would flash by so fast there would barely be time to photograph them; those were the days before zoom lenses and motor drives were available to beginning photographers like me.

Then I remembered some pictures of an ox cart race in India that had been taken by the famous Hungarian woman photographer, Ylla, from the hood of a moving Land Rover. So one morning at Los Corales, with much enthusiasm, I suggested the use of a Land Rover to Belmonte who, after he listened attentively to the plan, thought for a moment and then in his stutter asked, "B-b-but, won't that be dangerous? The field isn't as smooth as the Palmera Avenue, you know." It was then that I had to admit that Ylla had been killed during the cart race in India, thrown from the hood of the Land Rover when it hit a hole. "And you still want to do this?" he questioned. I smiled and nodded yes.

So arrived the opportunity of not only being able to photograph bulls from the hood of a

fast moving vehicle, but also to observe at close range the brilliant action of Spanish horses at work. Never had I seen such noble heads, curved necks, flowing manes, and natural gaits on animals anywhere. It was as though the stallions of the Prado had come to life before us.

In those years of the late fifties and through the sixties, while photographing in the fields and bullrings of Spain, Mexico, Portugal and North Africa, I was each day brought closer to horses. Many of the animals were used by rejoneadors, mounted bullfighters, and of these, perhaps the finest horsemen were the Alvaro Domecqs, father and son (what a magnificent evening they gave when they appeared together in El Puerto de Santa María), the Peralta brothers, and Josechu Pérez de Mendoza. They were as serious in their somber formal country dress as the Portuguese rejoneadors, that I saw in provincial rings as well as in Lisbon's Campo Pequenho, were colorful. And what master horsemen they were—Conde, Nuncio, Lupi, and Ribeiro Teles—as was the Mexican, Gastón Santos, who performed splendidly not only in his own country but also in Spain.

It was while photographing in the Latin countries that it occurred to me that the preservation of the Andalusian horse was no accident. Famed as outstanding mounts for both war and parades, favored by the Romans, praised by the Arabs, used by Iberian knights and noblemen hundreds of years ago, these stallions have never become obsolete despite the advent of the car and a society whose values have shifted from the romance of the past to

the utility and comfort of a world that is moving towards universal conformity. Watching those Spanish and Portuguese gentlemen and cowboys carrying long lances, racing up and down hot fields while mounted on ''Velázquez'' stallions, or while performing in the bullring, made it clear to me that horses today are almost as useful and important to some Iberians as they had been to El Cid. And it is this usefulness, the need for working cattle with horses on the ranches and in the *plazas de toros*, as well as the Spaniards' appreciation of beauty and love of showing off on fiesta days (the Sevilla Fair is unquestionably the most spectacular display of horseflesh in the world), that has preserved living Andalusians as much as those rearing, galloping, parading, posing stallions have been preserved in the Prado.

In this way my childhood interest in horses was renewed in Spain, and it was thrilling to remember that wild Palomino stallion near Uncle Charlie's ranch and to imagine that hundreds of years ago his distant ancestors had maybe grazed the same pastures and marshes through which I trudged while photographing fighting bulls. Eighteen years ago those *marismas*, or marshes, were still untouched and wild, and frequently there was the opportunity to observe, hour after hour, semi-wild horses in games not completely unlike those of Ron and me and our fourth grade friends on the dusty grounds of Columbus Grammar School in Glendale, California.

It was not until the early 1970's, however, that my interest in equines leapt the barrier of

silent admiration to possible subject matter for a book. This came about because of a friendship with Bernardo González Real, a fine photographer and horse lover in his early twenties, who lived in Jerez de la Frontera, the undisputed equestrian capital of Spain. In the few short years of our friendship, until he was killed in an automobile accident in 1974, Bernardo often said that he dreamed of doing some kind of book on horses, a plan that I tried to encourage with as much enthusiasm as he had shown for my projects.

Some years following my friend's death, when a publisher offered a contract for a photographic study on horses, how I wished that Bernardo had been around to do his book. In late April I did sign the contract, but with some reluctance, for it stated that the book would have to be finished in August and ready to print in the fall, an incredibly short time when compared with the years I had spent on the bull book. Without the assistance given by some two dozen people—friends, owners and trainers—it would have been impossible to complete the photographs in the contracted time.

A great deal of enthusiasm for this project had been accumulating over the years, passed on by friends from all parts of the world who shared their love and knowledge of horses. In England Nora McAlpine not only took me on my first hunt, but also was able to communicate sensitively her love of Thoroughbreds. I learned something of polo ponies from one of the kindest men I've ever met, the Maharaja of

Cooch Behar. Colonel Tom Nickalls and his wife, Tigre, took me along on delightful afternoons at both flat racing and steeplechasing in Britain. In Texas, Tom Lea expressed a love for American horses that left a profound impression, and it was inspiring to see how often and successfully he had contributed both the graphics and texts for his fine books. Another Texan, the late Robert Kleberg, Jr., who has a living tribute in the Quarter Horse, provided generous encouragement for my animal studies. South American Criollos were made more meaningful because of the hours spent with Bob Adams and Michael Hughes, long-time residents of the Argentine and Paraguay. In France, Françoise Courriere not only showed me the beauty of her country, but of its horses. Casey Tibbs and Spike Van Cleve both brought into sharper focus the world of the rodeo and the livestock used for it. Arab horses and the American show world were carefully explained by Tish Hewitt and Father Robert Q. Kennaugh. Australian Neil Dougall offered new insights into stud management. A pride in Morgan horses was transmitted to me by Steve and Aline Reeves. Jeff Ramsey shared his experience with stunt horses in Hollywood. The American saddlebred was made more important by a friendship with Gwen Harrison. Christiane Cutter, a German, helped me to see better the relationship of horses to art. And Budd and Mary Boetticher, Carolyn Moyer, Marilyn Tennent, Chuck Nuanes and Floyd Scrivens were examples of just how much joy horses can bring into people's lives.

In retrospect, some two years ago a decisive moment occurred that led to the doing of this book, but not until several months ago, on a flight from Denver to New York, did I fully realize its importance. James Michener and I were discussing moments of artistic expression in the performing arts which had most moved us, limiting ourselves to five performances each. At the head of my list, next to a magnificent *faena* by Curro Romero in Sevilla, Alicia Alonso dancing the dying swan, a dazzling trapeze performance by a troupe of Mexican flyers, Bjorling and Nillson singing Act Three from *Turandot,* I selected, without question, a performance by the Spanish Riding School of Vienna during which a horse doing the extended trot had seemed to glide across the ring. The movements of that Lipizzaner—a direct descendant of the stallions of Andalusia—caused the kind of awe that touched emotions deeply enough to give me goosepimples.

The idea of using photographs with quotations from a wide range of literary sources came first when I was doing the bull book, in which, at the last moment, I substituted my own captions for the descriptive phrases of other authors. However, it seemed the ideal marriage for this book, in that the combination of pictures with quotations from all over the world and from all ages, would show the eternal beauty of and man's fascination with horses. All the photographs were taken before the quotations were selected. Also, I tried to photograph as many breeds as possible—Andalusians, Arabs, Quarter Horses, Thoroughbreds, Lipizzaners—so that the book would be

about the horse in general, and more important, the horse at liberty.

The photographic equipment used included two 35 mm cameras, one mounted with a motor drive, together with a 50-300 mm zoom lens and a 28 mm wide-angle lens. Film shot was Ektachrome X force—developed to 160 ASA.

The notes that follow were usually jotted down while scouting locations or while waiting for changes in light during actual photography. A good part of the material was drawn from observations of semi-wild horses during the past eighteen years, along with animals living at liberty in the marshes of the Guadalquivir. At various times horse observations were also made in the United States (mainly in California, Arizona, Texas and New Mexico), as well as in North Africa, Mexico, England, Portugal, and France.

It is hoped that these brief notes on behavior will encourage young naturalists to do further studies on free-living horses.

P. 2 At sunset a herd of Arab, Thoroughbred and Andalusian mares crosses a ridge at the Spanish Army farm, Vicos, located between Jerez de la Frontera and Arcos. In groups of horses like this, living in liberty or semi-liberty, there is a strong hierarchy. Distinguishable to even the most casual observer, this pecking order serves a vital need by giving the animals hard and fast rules for social interaction. Each horse knows his role and, as long as his station is well-defined, feels relatively secure, even

though he is at the bottom of the totem pole. In contrast to animals like the tiger, which come together just once a year during the breeding season, horses have had to develop a mode of living together which allows them to perform their life functions while united and with a minimum of difficulties. Only because each animal carries within itself the instinct for applying and functioning under this code of social behavior have equines been able to survive. Though domesticated for millennia, the horse's prime patterns of social behavior seem to have undergone mimimal changes. When freed today in the marshes of the Guadalquivir, a Spanish stallion probably behaves not too differently from his primeval ancestor who galloped through the steppes two million years ago.

P. 8 At daybreak a Quarter Horse mare emerges from a lagoon at the King Ranch España property of Los Millares near Huelva. By numbers the world's most popular breed, the Quarter Horse is a descendant of Andalusian stock taken to the New World by the conquistadors. Most modern horses boast some Spanish blood.

P. 10 Over one hundred and fifty Arab, Thoroughbred and Andalusian mares swirl together at Vicos. Fortunately for these breeds, the Spanish Army maintains stud farms throughout the country, a military tradition sadly lost in most of the modern world. Herds such as those of mares at Vicos, and of stallions

and geldings at Ecija, provided the chance not only to photograph large numbers of horses together, but also to observe their behavior while living in semi-liberty. In the strict sense of the word, these groups of animals cannot be considered true herds, since they are controlled by man. The legitimate herd, today almost extinct, except for the zebra and the feral horse, is generally formed by several family groups living in fairly close proximity, each headed by a lead stallion. Outside these highly guarded family units roam groups of young bachelors not yet psychologically ready to challenge an established stallion or take on the responsibility of a harem of mares. Herd living not only offers the collective warning system but is especially important to breeding. In these pages of captions, however, the word "herd" will be used to describe not only combined units of several family groups, but also will be applied to all groups of animals living together whether of the same or of opposite sexes.

P. 13 At the ranch of the Conde de Odiel near Sevilla, I observed horses like these form strong friendships and show obvious affection for one another. This old gelding's ears, pointed forward and slightly relaxed in a lateral position, together with his relaxed facial muscles, show him to be content. Between horses, much more important than vocal communication are visual signals and of these, ear positions are a virtual barometer for reading a fellow herd member's moods, and are essential in animal-to-animal communication. Positions can range from the forward, slightly lateral attitude of the animal in this photograph, expressing tranquility and well-being, to more and more backward positions, until the ears are virtually pressed flat against the mane—in a threat warning—to show massive aggression. Between extreme forward and backward positions are a whole range of subtle signals, all easily understood by equines. If the ears are flapped out completely laterally, they most often signal tiredness or inferiority. There are also combinations of positions, as well as an even finer means of communication in which one animal receives a message about the location of sound stimuli by glancing at the aperture position of a fellow horse's ears. After days of observation it also became apparent that horses determine the wind's direction mostly with their ears—by sound—and not by smell with their noses.

P. 15 Probably one of the most important means of social and physical interaction among horses is mutual grooming, as shown by these Arab and Andalusian mares at the Vicos Army farm. The Spanish mare on the right was standing moping on this hill when she was approached by the Arab mare, who was searching for a grooming partner. When such contact is sought, the passive animal is usually approached from the half front by the horse which desires to initiate grooming. This animal, with a subtle facial expression which can clearly be read by the other as "let's scratch backs," advances or retreats depending upon 175

the facial response of the horse it is proposition- ing. If, as in the case of the mares in this photo- graph, a proposition has been accepted, the animals will usually stand together for a few minutes moping or grazing, after which they will position themselves next to one another, head to tail, and start biting in short, firm nibbles at each other's necks. If the action is intense, the sound of their teeth is clearly audi- ble as they start on the mane crest, pulling at loose hair and dead skin. Slowly working along necks, shoulders and backs, they usually stop at each other's tail roots—one of the most delicious places to be scratched if you're a horse. When grooming is finished, horses gen- erally stand next to one another for a short while in the head-to-tail position, moping or grazing, before they wander off or change sides to resume grooming. Not only does this activity allow animals to scratch parts of their bodies that are unreachable by their own mouths, but it also probably serves to form friendships and strengthen the social contact that was once so important to the wild herd. Although most grooming takes place between just two horses, on several occasions I saw three mares at Vicos and three stallions at Ecija scratching each other's backs.

P. 17 During the hot noon hours this nine- year-old mare of the Conde de Odiel mopes under an olive tree. Since she is an old animal, wise in the ways of searching out food and familiar with the geography of the ranch, a bell has been tied around her neck which will not only attract the other brood mares to her, but aid man in locating the herd. The mare stands in the typical moping position, ears relaxed and laterally drooping, neck straight out (or down), front legs together, croup down, and one back leg cocked at an angle with only the tip of the hoof touching the ground. Equines spend more time moping than they do in either of their other two forms of sleep: resting, in which the animal drops to the ground with its legs posi- tioned partly beneath its body, or deep sleeping, in which the horse lies flat out on its side. In fact, after eating, more of a horse's life is spent moping than doing anything else. It is the one activity during which the animal appears least attractive to the human eye—even a fine stal- lion, when he is moping, will look like a nag to most people.

Among the horses I observed, moping gen- erally took place during the hot midday hours, lengthening in its duration as the Andalusian heat became more intense, or after eating (on a number of days at Ecija the temperature reached 114°F). At noon the Vicos mares and the stallions at Ecija divided themselves into groups of from five to twenty animals, and stood heads together, in circles, rear ends out, tails swishing in an attempt to protect them- selves from flies and other insects, and moped silently for hours. Primitive instinct man- ifested itself not only in this effective coopera- tive attempt to deal with insects, but also in the moping position which in the wild is the safest form of relaxation for a horse. If threat pre- sents itself to the moping horse he is not in too

deep a sleep to react and, being on his feet, can either flee or kick. The only effort that moping requires is to change fairly often the position of the back legs, which must be relaxed or moved to relieve a muscle tension that, because of the construction of the tendons, does not affect the front legs. Apart from hot weather, horses will also mope longer on cold or wet days with their tails to the rain or wind.

P. 19 At Vicos even though this Spanish mare was in close daily contact with man, because she was alone and grazing out of sight of the herd, my appearance was enough to put her to flight. Horses are timid animals, regardless of their size and strength, and can be put into blind panic by even the most harmless stimulus if it is unknown or comes as a surprise. Animals observed in the herd followed the same escape patterns, whether they were family groups like those at the Coto Doñana, the King Ranch or the ranch of Paco Lazo, or if they were exclusively mare herds or herds of stallions. If the surprise or threat was overwhelming to them, the entire group fled in blind panic, temporarily dissolving the hierarchy of the herd. However, if the threat was not considered great, the horses would react in the same manner and would escape with the high ranking mares and foals in the lead, followed by the rest of the mares with the stallion always bringing up the rear. When the group was made up only of mares, the stallion's position was taken by one of the more aggressive females, who snapped at the flanks of the animals in front of

her. Each herd of males at Ecija also had a high-ranking stallion. It appeared to me that when family groups were involved, the direction of flight was always set by the lead female, usually a wise old mare, while the stallion's duty was primarily to hurry on lagging animals which might become prey for pursuing predators.

P. 21 This sixteen-year-old Spanish stallion, Majestad, owned by John Fulton, has a face considered too long by many breeders, yet he is one of the most photogenic horses I have ever photographed. His head length, once typical of all Spanish horses, has the kind of artistic balance that attracted painters like Velázquez. Unfortunately this noble element is lacking in the shorter faces of some modern Spanish purebreds.

The lateral position of Majestad's closest ear here shows his attraction to some sound stimulus. Next to ear positions, facial expressions are the most important optical signals in animal-to-animal communication. So subtle that they were often hardly distinguishable, nostril flaring, muzzle wrinkling and jaw flexing played an important part in the expression of the horses photographed. The sticking out or tightening of the lips, the angle of curve at the edges of the mouth, and the amount of teeth shown were everyday means of silent communication utilized by herd members in Andalusia. Obviously, equines must be in fairly close proximity in order to use these forms of visual language. Mares use their eyes in expressing 177

feelings to a much lesser degree than ear and muzzle signals. Blinking or closing the eye, depending on the degree of opening, can serve as a show of passiveness to an outside stimulus. Most stallions, however, use their eyes constantly during display rituals.

P. 22 Majestad grazes in a field of spring poppies at the ranch of Rocío de la Cámara. Eating, in terms of time spent, is the most important activity in the life of the horse. At pastures where I was working, the animals often grazed between eleven and thirteen hours a day. Unlike carnivores, who can subsist on relatively small amounts of food because of the high nutritive value of meat, horses must eat immense quantities of vegetation in order to maintain enough weight and strength for normal activity. Because of the low nutritive value of their diet, equines have relatively long digestive tracts, requiring an extended digestive period in order to get the most out of every blade of grass.

Since their food-to-stomach process is a one-act operation, horses, unlike camels, cows and antelope, must mill vegetation and grain in their mouths more slowly and thoroughly than do their cousins.

P. 24 This five-year-old stallion, Jerezano, of Romero Benítez, is caught up in the excitement of having just been turned to a herd of mares. He rolls his eyes, arches his neck, and flexes the muscles of his cheek and muzzle in a

fine display of strength and masculinity. During this initial introduction-confrontation, some of the younger mares jealously guarded an older sister in heat, and when the stallion tried to get too close they kicked out viciously at him.

A pasturing herd of animals is generally peaceful until a strange horse, whether it be a stallion or a mare, arrives. Then, because of the rigidly defined hierarchy, each herd member must reestablish its position in the group either by challenging the newcomer or by reacting submissively. Even in the exclusively female herd at El Hornillo, quarrels for supremacy often lasted several days—depending on the ambition of the participants.

P. 26 A herd of Andalusian, Arab and Thoroughbred mares moves to higher ground as the wind that often thrashes the southern coast of Spain begins to subside. Since horses are extremely weather-conscious, weather fluctuations have a remarkable effect on their behavior. Apart from the temperature and air movement, the degree of humidity is also important to equines. On sultry days, the animals I observed were far less active than they were during milder weather. Just before a storm, when there was great atmospheric tension and the air was filled with ions, almost all the horses were nervous, restless and aggressive. Years before, when I was doing a study of the fighting bull, the effect of thunder storms on animals was even more apparent as I watched in single pastures perhaps five or six sets of bulls

concurrently engaged in combats triggered by atmospheric tensions—combats that sometimes ended in death. During similar weather there was also increased fighting among the stallions at Ecija; and horses of both sexes showed inner tension by hyperactive eating, which slowed down markedly once the storm had broken. Strong winds also stimulated activity—running and fight games—among the stallions at Ecija, to the extent that, before leaving home on such a day, I knew good camera material would always be waiting in the country.

P. 28 A herd of seventy-five mares rushes along a trail at Vicos. Later in the day some of these same animals returned to this dry basin for dust baths, which they usually preferred to take at noontime when the earth was hot and dry. A surprisingly large number of horse hours are spent engaged in grooming and care of the hair and skin. Some animals in the marismas seemed to prefer mud to dust for baths, probably not only because mud served as protection against insects, but because dislodged dried earth was effective in the removal of dead hair and skin.

Practically all the horses observed had favorite dusting spots like the dry basin in this photograph. Rolling on dry ground not only feels good to a horse, but it is essential in removing excess oil from the skin, thereby helping to order hair in its natural direction. When mares arrived at this basin, they would lower their heads, ears forward, smell the ground

and paw at it slightly, after which, with short steps, they would circle several times the chosen spot before lying down. It is not easy for horses to lower themselves to the ground, for unlike meat eaters, they do not have very flexible vertebral columns. To be able to get to the ground for a bath, a horse normally collects his four legs under his body, then bends at an angle so sharp that the muscles vibrate with tension until they will no longer hold his weight, at which time he drops down onto his forelegs and rolls over on his side. Clumsy, old or pregnant mares sometimes practically let themselves fall to the ground.

Once on the ground, the head and neck are pressed to the earth to scratch the flat sides of both, especially the cheek region. After having dusted and scratched one side of their bodies, most horses will roll to the ungroomed side. Active animals repeat this process several times. At the ranch of Francisco Lazo, one stallion would rise from the flat-out position to the huddling or sitting position, hind legs partly under his body, forelegs extended to dig at the soil with one of his front hooves, loosing the earth in preparation for another roll over. At the ranch of Juan Manuel Urquijo some of the heavily pregnant or old mares, which could not or did not want to roll completely, would get to their feet after having dusted one side, to lower themselves back to the ground to dust their other side.

Dusting is highly contagious, and once other animals have watched one horse start to roll, they follow suit. If the dusting area is large, such as the one shown in this photograph, several animals may be seen involved in self-grooming at the same time. If the area is only big enough for one or two horses, herd hierarchy is once again clearly seen, as dominant animals dust first, followed by the more passive members of the herd. The instinctive need for an animal to satisfy itself, by either dusting or taking a mud bath, is so great that within minutes after a stabled horse is freed into a corral where there is mud or dry earth, the first thing he does, once he feels secure in those surroundings, is to drop to the ground and roll.

P. 30-31 The herds of bachelor stallions at the Army ranch near Ecija, some of which appear in these two photographs, provided an excellent opportunity to observe the social structure of the all-male herd. The animals in the photograph on page 30 have just arrived at the crest of a hill and are on the run. The ear positions of the two horses at the left of the photograph, slightly pointed forward, show curiosity. The third animal from the left, with his ears flat against his mane, expresses aggression. The grey next to him has his ears in the lateral position, which indicates that he may be shifting his ear apertures in search of sound. The bay next to him has its ears back, as do the running horses on page 31. Horses moving at fast speed usually lay their ears flat in an attempt to keep dust and insects from entering the ear apertures.

The grey stallion biting the neck of the darker horse was one of the few animals at Ecija who, before he arrived at the Army farm as a two year old, had covered a mare. The behavior of such a stallion was completely different from that of the calmer male virgins around him. On a number of occasions I observed such animals among the young bachelors, and each of them, not long after having been turned to the herd, picked a companion who was possibly the same color as the mare that such a sexually experienced stallion had covered for the first time—most probably by accident. As in the case of the two animals in this photograph, the sexually practised stallion jealously guarded his virgin friend. This companionship, on one hand, had in part become real torture for the virgin, for he was never left alone, always being nipped at, hurried on and herded this way and that by his suitor; on the other hand, however, it meant that he enjoyed a high place in herd hierarchy. Since sexually experienced stallions are hyperaggressive and active animals, they are nearly always the lead males in bachelor herds. This means that their partners, like foals of dominant mares, can do as they want, having the security that the animal which loves them will always be there to protect them; prime spots are thus assured at dusting, feeding and watering places.

At Ecija there was one hyperactive half-Arab stallion who became such a pest to his virgin companion that on a number of occasions the virgin rebelled against his suitor with flurries

of kicks that several times brought blood to the

Arab's chest. In these partnerships at Ecija, though animals would often have erections while grooming one another, only once in many hours did I see an experienced stallion try to mount his virgin friend. Once the pairs of stallions at Ecija were gelded, the relationship between them remained just as close, or closer, but what did change was the aggressive behavior of the dominant stallion. Gone was the continual biting and driving, replaced by what appeared to be tender affection.

P. 32 In battle games when young stallions finally do rise up against one another, they do so as if in slow motion, which is delightful to watch in contrast to a serious, fast combat between mature horses. Shown here are two Conde de Odiel animals, Divertido aged four and Barquillero aged five. Often, I saw young stallions rear against one another and, as if in a slow dance, one would clasp the other's shoulders with his forelegs, both staying on their hind legs for a half minute or more. When the animals were in this position, the more aggressive one would take playful bites at the other's face. The ''attacked'' horse would raise his head high, trying to keep from being nipped, at the same time opening his eyes very wide. Facial muscles of both stallions would be relatively relaxed and their ears would generally remain pointed forward. Sliding away from each other to drop their forefeet once more to the ground, the horses might continue their fight or begin grazing or grooming one another.

Often, what started out with playful sparring would begin to look like a carbon copy of a serious fight, if one of the partners lost his temper or would not quit when the other signaled ''I give.'' In my first days of observation, it appeared that when this happened the horse that had had enough would turn tail and, chased by the other, dash off for maybe fifty yards, where sparring would be resumed. However, after several days it became apparent that what I had often interpreted as flight response was not that at all, but merely a part of the play ritual of young stallions. It was all a game to them; spar, bash necks, nip at faces and shoulders, circle to bite hind legs, rear up, drop back to the ground—and then turn tail and run to a new spot to repeat the activity, making the game more interesting. If one animal did, however, really lose his temper, wanting to end the game but failing to get this message across to his opponent, he would finally whirl around, screeching, and kick out violently, often thudding his hoofs against the molester's side or chest.

P. 34 These three-year-old stallions at the Army's Ecija farm are not involved in serious combat. Perhaps the most interesting hours of observation spent during the short work on this book were those with herds of young bachelors at Ecija and at the ranch of Romero Benítez near Jerez.

The play fights between young animals had none of the air of urgency and threat of violence that accompanied several battles that I 183

witnessed between mature stallions. Fight games were the primary source of exercise for most members of the bachelor herd. Often one animal with a mischievous expression on its face, ears pricked, facial muscles relaxed, would approach another and begin playfully to bite at the passive stallion's head and neck. When both animals were looking for a fight, they would gallop towards one another, stop face to face, and with neck muscles high and using imposing body movements they would position themselves side to side, smell each other's flanks and genitals, and start turning in circles, at the same time voicing shrill war cries. Sometimes, before this circling started, the animals would push at one another with their necks, taking only half-serious nips, shoving, feinting and dodging, each trying to bite

the other's forelegs, shoulders and flanks. Often, face to face, they would both drop to their knees and continue snapping and knocking their heads and necks together. Almost without fail, when they got to their feet from this position, they would again circle around and around, head to tail, each trying to bite the enemy on the hind legs. The number of circles usually ranged from four to ten, but once I counted twenty-four turns as two bays whirled in the dust, and I was surprised when they stopped this part of their battle to find that both were not only able to keep their balance, but that they renewed circling for a further ten turns in the opposite direction.

P. 36 At Ecija, a three-year-old stallion, screaming, lunges at an enemy's neck. Most

184

fights are ended really before they start because of the elaborate pre-combat display ritual which manifests itself when two older animals meet—that is, under natural circumstances. If the animals in question are not free-running stallions, but corralled or enclosed in the presence of mares, then violent combat is almost sure to explode. Only on a few occasions did I see stallions involved in serious battles that, although exciting, were disagreeable to anyone who loves horses. Animals that under normal circumstances probably would not have been pressed into such bloody combat, bashed at each other with their hoofs, slashed with their teeth and whirled to kick with blows that could break a leg or destroy a horse's face.

When stallions meet in serious battle they voice war cries, and rear up trying to thud their heavy, sharp-edged, fast-flying hoofs against the enemy's chest or face. Ears laid flat, they bite at each other's necks and heads. Even the most furious fight, though, cannot destroy a certain pattern of combat that is innate in horses. Because rearing up is exhausting for them, stallions soon have to come down on all fours, when they continue biting, circling around, throwing their weight against one another, before rearing up once more. When the loser has been determined, this animal will usually drop to the ground, whirl and kick out frantically just before fleeing. Violent fights are most often the result of an attempt to steal a mare from a family unit. Death or serious injury from such battles is not usual, and more than likely accidental. If the two animals involved in such a combat are very different from each other in physique and temperament, then the rules for normal battle may no longer apply, and the faster and stronger stallion may surprise his enemy and seriously wound him before escape is possible.

P. 38 At Vicos a lovely Spanish mare stands in a field of sunflowers. Although the leaves of these plants were green and seemed appealing in contrast to the July-burnt fields where this mare was accustomed to graze, she would not touch the sunflowers. At the Urquijo ranch, the first time I really paid any close attention to the way the mares ate, I was amazed at how adept they were in selecting and plucking individual grasses. Although springtime had filled the pastures with all sorts of plants, the animals I watched were quite choosey in what they ate; some, however, were more selective than others. Even very hungry horses (at liberty) won't eat everything green in sight, something cattle will do and which often has fatal consequences.

P. 40-41 Owned by Eduardo Tuya, this Andalusian stallion shows the breed's tendency to have thick, long manes and tails. A horse's primary means of defense against insects, especially flies which seek the moist facial and body areas, are his forelock, mane and tail. When I was in the marshes of the Coto Doñana, working on another book with the stallion Majestad, he had to contend with everything from small gnat-like insects that clustered around his eyes, mouth and genitals, to large, green flies that left pea-sized spots of blood every

185

time they bit him, mostly on the stomach. Even these bites, however, did not seem to bother Majestad much. (I'm sure they "hurt" the humans who were working with him much more.) A horse's pain threshold numbs him against degrees of hurt that would cause a human to scream.

P. 42 This picture was shot near Ecija. All the photographs of herds of young stallions were taken either at the Army farm there or near Jerez at the ranch of Romero Benítez.

One daybreak I arrived at the latter ranch shortly before half a dozen two year olds, which had spent a week at the Jerez Fair, were returned to the herd. Aware that each of the eight animals pasturing calmly before me would have to re-establish his position in the hierarchy, as would the six young stallions who had been absent, I expected some good material for my camera, but what started out as a photographic venture finished with the importance shifting from film to the rough notes on horse behavior that I was able to take.

As soon as the six newcomers were turned into the pasture, all fourteen animals raced around, galloping together, the lead stallion and two males which ranked below him posturing, crests arched and swollen, tossing their heads and nipping the necks and flanks of the younger horses. Finally, when this exuberant stampede stopped on the far side of the field, I picked up my cameras and took off in that direction.

Then, in no certain order, the lead stallion and the other three year olds would gather around one of the recently arrived horses and, lifting their feet in high, stamping steps, they smelled the younger animal's lower flanks, genitals and anus, at the same time voicing the high shriek of a male horse in close contact with another stallion. This sniffing was similar to that done by male dogs and other animals with *one* exception: when the herd members reached the lower flank of a recently arrived horse, sniffing became highly intense and breathing was exaggerated. At this point they seemed more like dogs at a rabbit hole. What were they trying to learn? What message could be received from the odor emitted by another horses's *lower* flank? It is said that horses can smell fear in humans. Can they also detect it in each other? Can dominance be determined without battle, by merely a war of nerves that results in a submissive animal signaling defeat through his odor?

Through a series of posturing and imposing their importance on one another or, on the other hand, communication by submissive gestures, and possibly odors, the hierarchy of the herd began to re-establish itself. Some of the animals, probably old friends, would suddenly dash off together in pairs, stop a short distance away and slowly rear up against one another, forelegs clutching shoulders, while one would nip at the high-held face of the other.

When this initial excitement was over, though things were not completely back to normal in the herd for another day and a half,

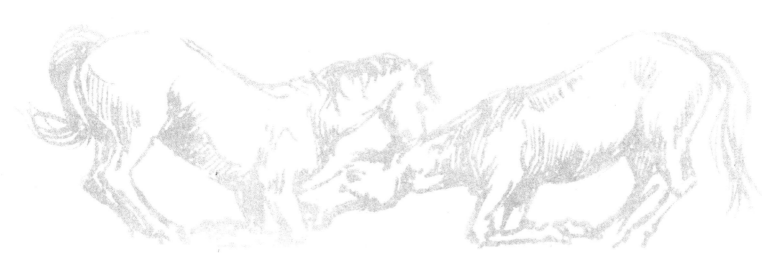

I noticed a form of behavior that was completely strange to me—one that I had never heard mentioned. While packing up the cameras I saw a handsome bay two year old approach and present his rump to the grey lead stallion. The grey smelled the younger bay's lower flank, genitals and tail root, at which time the bay playfully kicked out his back legs, seeming to try to capture more of the stallion's attention and excite him, before running off a short distance with the dominant animal in pursuit. The stallions stopped fifty yards from the grazing herd, where the bay once more deliberately presented his rear to the grey in exactly the same manner as I had often seen young baboons present themselves to the highest-ranking baboon male, gesturing submission in a clear definition of dominance hierarchy.

Distracted by the neighing of a horse in another pasture, the grey had his head lifted in that direction when the young bay backed his rump right up against the older horse's chest. Then followed more smelling by the lead stallion, during which time he had a half erection. Finally the bay again kicked out playfully and weakly at the top-ranking stallion before returning to the herd after a performance which clearly seemed to say, "I'm back in the herd and I've shown you by the most submissive behavior I can that you're still the leader I respect. So don't worry about me, I'm no threat." That day two of the other young horses presented themselves in exactly the same manner to the grey, as well as to the second-ranking stallion. The action I had seen was too clear to have been a product of imagination; however, I was left with the desire to see a group of male horses under similar circumstances so that I could verify this—new to me—ritual of submission of stallions.

A few afternoons later, upon returning to Jerez, I asked my friend Antonio Romero Girón if he could take a three-year-old stallion, one that had been dominant, but who had been moved from the pasture to the stable for training, and release him with the herd of animals I had observed several days before. Because Antonio has an adventurous spirit, because he was a close friend of Bernardo González Real, and because his great love in life is horses, he agreed to help with this experiment.

When the stallion was returned to the herd he postured, swung his head and rolled his eyes, finally standing still next to the highest-ranking animals in the group, at which time the flank-sniffing ceremony commenced. In two cases, because superiority may not have been determined by odor, there followed a series of brief skirmishes, first with the lead stallion, in which no blood was drawn and which, at its most serious point, was fought on their knees by both horses. After the newcomer clearly proved his superiority to the former leader, confrontations continued with other animals, consisting mostly of flank sniffing and posturing, in which the new and dominant animal imposed his presence on each of the other bachelors.

It was then time for my previous day's observation to be verified: that young stallions will make known their inferiority and submissiveness to a lead stallion by presenting their rumps to him, baboon fashion. The more serious confrontations over, the dark grey began to gather all the animals into a herd as, head held about eight inches from the ground and swinging laterally from side to side in fish-like movements, he nipped at flanks and legs to bunch the other stallions tightly, guiding them to a far corner of the pasture. Once there, he engaged in two or three brief confrontations with several high-ranking animals, after which all the horses began to graze. It was at this time that a black two year old emerged from the herd, trotted to the new leader, and presented his rump. The dark grey sniffed the younger animal's flank and genitals and when he reached the anus the submissive horse began to move forward, but only fast enough to keep the leader coming after him and interested. Fifty feet from the herd, the black stopped and again backed into the dominant horse. The smelling ritual followed, in which even from a fair distance the intense sniffing could be heard, after which the leader with a half erection tried to mount the younger animal, who kicked out playfully and rejoined the herd. That same afternoon I watched three other two year olds submissively present themselves to the new leader in the same manner. This behavior was initiated each time by a young animal, generally two years of age; never by any of the older,

higher-ranking bachelors.

Just before I left the pasture, the leader was once again involved in gathering the other bachelors into a group, herding them exactly the way a stallion drives mares. When he had accomplished this and was circling with his head held high, a two-and-a-half-year-old roan stallion lashed out so forcefully that his hind hoofs thudded against the leader's ribs, to knock him completely down and over onto his side. Before the leader could get to his feet— and I was truly worried about his well-being, since he had been knocked down with such force—the roan slipped back deep into the cover of the herd, like an assassin trying to hide in a crowd. The leader painfully got up, his dignity seemingly more hurt than his ribs, and again, head down, began circling the herd, moving them along the fence toward the other corner of the pasture. Reflecting on what had occurred, it was obvious that the young roan had stood in wait, his forequarters partly concealed by other horses, for the leader to pass, so that unidentified and at close range he could throw his blows with terrific force. This behavior was especially interesting in that the roan was both the chosen friend of the former herd leader, though their association was not as close as between the sexually experienced stallions and the virgins at Ecija, and also one of the few young horses who that afternoon had not presented his rump to the new leader.

P. 44 This is the Cárdenas stallion Vasallo.

P. 46 Grasses, dried by July heat, are back-lit by the setting sun in a field near Ecija. The amount of vegetation available to animals living in semi-liberty has a pronounced effect on their social life. When food is abundant, horses graze in close contact with one another, narrowing the distance from animal to animal, which escalates social interaction. High-ranking animals, ears laid back, teeth bared, necks outstretched, occasionally threaten other horses who pasture too close. When food is scarce, they must spread out in their search for it, with dominant animals monopolizing the choice spots.

P. 48 Paco Lazo's six-year-old stallion, Nostálgico, prances, arching his neck, before a mare. The mare, with forward-pointing ears and relaxed eyes, shows the stallion that he may approach without the danger of being kicked. In the top photograph on page 49, the stallion assumes the typical "smiling" position (called flehmen), head held high in the air, nostrils flared, lips peeled back, after having just lowered his head to smell the ground where the mare had urinated. Flehmen is an olfactory process used by most hoofed males to test a female's excrement to establish if she is sexually receptive. In the lower photograph on page 49, the mare's ears are still pointed forward, her eyes remain relaxed, as do the edges of her mouth, reassuring the stallion of her good intentions. The chests of most free-living males are marked with half-rounded

scars from the hoofs of mares. Although a stallion often harasses his mares, driving them and biting at their flanks and hind legs, most ranchers agree that a male horse receives much more punishment from his harem than he inflicts on them. Nostálgico's ears, held slightly back and in a lateral position, along with his flexed eye muscles, flared nostrils and tightened mouth that curves decidedly down at the edges, shows that because he is still not sure of the mare he is posturing in an attempt to impose his importance and strength on her.

P. 50 At Los Millares this Spanish stallion follows a mare in heat. The horse's tightly pursed lips, his extended neck, exaggerated eye rolling and the lateral snake- or fish-like wobbling of his head show him to be in an excited state and serves as a warning to females that they had better hold to his prescribed course of direction. This posturing, apart from signaling intentions to mares, also warns other horses to stay away. Most free-living stallions try to add as many females as possible to their family units. Even a strong animal, however, has far fewer mares than do the wild males written about in fiction or shown in most motion pictures. Of family units observed during the last eighteen years in the marshes of the Guadalquivir, none had more than eight mares, the average number of female members being five. No marsh stallion was lucky enough to rule over a dozen mares, as did the Concha y Sierra stallion at Los Millares, or to be pastured with

thirty females such as those enjoyed by Paco Lazo's stallion.

In the photograph on page 51, the mare has stopped and is not only showing the stallion by urinating that she is ready to be mounted, but is using two additional visual signs to indicate her receptiveness. Apart from use of ears and face, horses also employ several body signals in animal-to-animal communication. First the mare spreads her legs slightly, in a sawhorse position, and next she lifts her tail. Previous to having been approached by the stallion, and while at quite some distance from him, she had also lifted her tail and begun flashing, which consists of opening and closing the vulva lips, often to expose the clitoris. Besides flashing when in heat, mares generally do so following urination.

P. 52 Salerosa, an eight-year-old mare who has just come into heat, grazes at the ranch of Juan Manuel Urquijo. While watching horses eat, I was continually amazed at how selectively they seemed to take the blades of grass with their lips, before biting with their cutting teeth and slightly raising their heads. It was impressive to see how skillful they were, in spite of their broad mouths, in avoiding the less tasty vegetation.

At other ranches I visited in Andalusia, where fields were heavily grazed, mares often pulled roots up with the grass. This not only destroyed pastures, but where soil was sandy, quartz taken in with roots noticeably caused premature wearing down of teeth. One

twenty-year-old mare who had passed most of her life feeding on such fields near Córdoba, showed teeth that had been sanded down practically to stumps.

During the spring, when there was such a paradise of greenery everywhere, most mares seemed almost to suffer from a food mania as they chomped away, bulging their bellies to immense proportions, putting on fat that would help them survive the harsh, barren, baking summer months when temperatures in the shade often reached 111°F. During the winter, when the marshes of the Guadalquivir were flooded, I was fascinated to watch horses grazing with their muzzles below water, something I would have thought impossible for them to do. On a number of occasions when grass was scarce, food envy manifested itself as one mare threatened another—gesturing or lunging at her. Distance from animal to animal, however, never became so great as to dissolve the herd.

P. 54 Justiciero, a three-year-old stallion of Romero Benítez, opens his eyes wide and postures, threatening an intruder. Eye rolling, in which the eyeball rolls back in the head until only the white and the very red edges of the eye show, is an elemental part of a stallion's repertoire of display gestures. This action of the eye, accompanied by head swinging and exaggerated and impressive body posturing, has been accorded little importance by most human observers, probably because it occurs quite rapidly and because of the more obvious and distracting gestures that accompany it. Some stallions use their eyes more than others. One family leader at the King Ranch was so exaggerated in his gestures, that the first time I saw him driving mares—when another stallion was in close proximity—he rolled his eyes to such a degree that I had the feeling we were not watching a real horse at all, but rather some mythical creature sent to earth by Zeus.

Because of the rapidity of this action, the amount of eye rolling done by most of the stallions I photographed was not apparent until I received the developed film. Having to use a fast shutter speed to minimize the movement of a large telephoto lens on the motorized camera, I was amazed to see those images, frozen at a two-thousandth of a second, which showed very exaggerated and constant eye rolling of excited stallions, whether the stimulus had been another male or a mare. In bachelor herds, for some reason, I found that stallions who had covered mares rolled their eyes more than did virgin males, probably because they had sampled sex and were thus constantly in an excited state, desiring more.

P. 57 Barquillero, a five-year-old Conde de Odiel stallion, arches his neck impressively as he smells a mare's rear. In 1959, while photographing cattle on the ranches, I spent long hours in the marshes of the Guadalquivir, and often when the bulls' behavior wasn't interesting I turned my attention to the other inhabitants of that then-wild area: birds, horses and even camels. Those observations, together

with later, briefer periods spent casually watching several units of semi-wild horses in the Coto Doñana Wildlife Reserve, gave me my only contact with animals living under fairly natural conditions. In some ways, no doubt, their behavior differed from that of wild horses in other parts of the world, but still I'm sure that most ritual patterns were basically the same.

The stallions observed in the marismas did not seem to guard strict boundaries as I would have expected them to do. Family groups used their own paths and each had its own sleeping area, but on several occasions I saw families meet, and it was then that I witnessed a ritual strange to me, used by lead stallions, apparently to avoid bloody combat. One morning I had been sitting in a cork oak since two hours before sunrise, waiting to photograph bulls and cattle egrets, when from my left came the sounds of a group of horses which soon appeared with an old pinto stallion bringing up the rear. Just before they reached the oak, the herd stopped and the black and white stallion, head held high and ears cocked forward, posturing slightly, walked in front of the mares. Then from the right, from out of the scrub, appeared another group of mares and colts, followed by a handsome chestnut stallion who, when he sighted the pinto, also walked forward, posturing. As both harems stood still the stallions, who were then about seventy-five yards apart, approached one another, necks highly arched, ears pricked, and faces blessed

with the most noble of equestrian statue expressions.

When the horses met they stood forehead to forehead, muzzle to muzzle, smelling one another. It was then that their ears, which had remained straight forward, suddenly tilted back and forth, to remain pressed tightly against their manes in signals of massive aggression. This I read as a kind of symbolic fight action, which was accompanied by stamping and striking out with the forefeet and legs, along with the stallion-to-stallion high-pitched squealing, which grew in intensity but did not explode in violence. Head to tail they circled one another, smelling each other's flanks, genitals and anuses. Smelling of the lower flank lasted relatively long and sniffing was intense enough to be clearly heard. During this display ritual, in which superiority was determined or verified as clearly as if the animals had engaged in violent combat, the head-to-tail position was maintained seemingly as a symbol of peaceful intentions. Finally, one of the stallions stepped aside and defecated. The other leader then smelled the dung and urinated over it. Next, both horses lowered their heads to sniff the urine before they rejoined their respective family units.

On several occasions during those years in the marshes I saw symbolic battle rituals repeated in almost exactly the same form as described here. Perhaps this ceremony makes one stallion's mares taboo to the other, in which case certain distance restrictions, from unit to

unit, can be dropped, allowing relatively peaceful co-existence which makes possible the sharing of vital food and water supplies. A stallion respecting the rules will generally not pursue a mare from another family unit. During the encounters witnessed in the marshes between heads of families and young bachelors, the excrement-marking ritual was seldom practiced. These examples of fight posturing in which real battle is avoided through a ritual composed of symbolic attitudes and perhaps flank sniffing, were for me fascinating evidence of the horses' ability to coexist sensibly and peacefully by following a set of basic rules that were probably laid down hundreds of thousands of years ago.

P. 58 In this photograph, Barquillero has just smelled a mare's urine and is testing it to determine if she is in heat. Even before a mare comes into season, however, a stallion is generally aware of her condition by continually sniffing her excrement. When urine deposits carry signs of approaching fertility, the stallion starts watching the mare more carefully.

P. 60 One of Paco Lazo's stallions nuzzles a mare in heat. Does love exist between horses? Displays of undeniable affection are often seen between a stallion and his favorite mare, between mares, between bachelors, and between mares and foals. Individual horses, however, seem to differ in temperament and sexual appetite as much as do humans. A few stallions clearly favor one mare, treating her with attentive tenderness. Other studs are rough and unaffectionate with all females. Some mares seem to hate stallions, while others have sexual thirsts that are barely quenchable. Though a good many purebred, stabled stallions are sexually cold, to the point of being a problem at breeding time, most pastured males are always ready to mate. Mares, on the other hand, are sexually receptive only once every three weeks; their periods of fertility can last a couple of hours or, most usually, two to three days. Female horses who have not conceived come into heat approximately every twenty-one days during late winter and spring—a few, however, repeat their periods during the entire year. Mares who get especially "hot" while in heat rub their rumps against poles or any hard object, and often in moments of sexual frenzy mount other females. A rancher friend from Montana, Spike Van Cleve, says he keeps mares from getting "rank" during estrus by either putting copper in their water or in their mouths (a bit ring, etc.), a trick he learned in Mexico. Mares who have given birth usually come into season and are bred on the ninth, tenth and eleventh days after they have foaled.

P. 63 Shown here is Antonio Romero's splendid young stallion, Justiciero. A stallion's courtship behavior often depends upon the personal appeal of the mare in heat. If she is a young female that he hasn't covered, he will prance up to her, crest arched, forelegs lifted

high, body muscles flexed, to try and impress her as much as possible. If she is an old mare or former "girl friend," he won't waste time posing and showing off. Since experienced males know that mares at the beginning of their estrus are often not ready for coitus, a stallion will not approach such a female directly from behind, but from an angle, carefully measuring with his eye the reach of her hind hoofs. At this time unready females threaten with outstretched necks and ears laid back in the three-fifteen position. If a stallion doesn't respond to these warnings, most mares lash out with their hind hoofs, at the same time screeching and urinating. Seasoned males, however,

know how to avoid this punishment by quickly stepping aside, at the same time swinging their heads in a high arc.

P. 65 The mare that Divertido, the Conde de Odiel's stallion, has just smelled is clearly in heat and ready to be mounted. The stallion's excitement is triggered not only by the mare's lack of resistance, but by her use of the sawhorse position—legs spread, tail slightly lifted, head immobile, facing straight forward—and by the urine she has just poured onto the ground, and by her flashings. The visual signals used by receptive mares seem much more important in attracting a mate than are the sexual odors that their bodies emit.

P. 66 Here Barquillero strikes a handsome pose, frozen at a one-thousandth of a second, to remind one of the noble horses captured in action so well by Leonardo and other artists, who drew before the camera could provide reference images. "What eyes those men had!" I often thought when I looked at a roll of developed film for the first time and saw stallion attitudes and expressions that had hardly been noticeable in the field.

P. 69 When this lovely young Arab mare was photographed at Vicos, one of the soldiers with me remarked, "How could any stallion help but fall in love with her?" Some of the pasture-bred mares I observed while doing these photographs differed as much in their use of or abstinence from sexual foreplay as do humans. It seemed that sex to some mares was just a duty and they would never nuzzle a stallion. Other mares, however, if they were particularly fond of a certain stallion, would nibble sensually at his face and flanks or sniff at his genitals. The lovemaking of horses, especially if it takes place naturally in a pasture, can be erotic and exciting. One Army colonel, a retired veterinarian, laughingly said that during breeding time at the stud farms, city recruits were detectable because most of them got erections the first time they watched a stallion cover a mare.

P. 70 Pinturero, the Conde de Odiel's four-year-old stallion, in his excitement tries unsuccessfully to mount this mare from the side. The range of breeding techniques used by stallions, which vary as much as their individual temperaments, is best observed in pastures. Because of the risk of damage from kicking and biting, most mating of purebreds is done under controlled conditions in which the stallion is haltered and kept on a lead rein and the mare is not only held but restrained from kicking by hobbles that run from front to rear legs—unnatural elements that are necessary, but that remove most of the beauty, passion and display of individual personality from an act that, under natural circumstances, can be full of violence and tenderness.

One of the most interesting personal observations I was able to make while taking these photographs was to verify some stallions' preference for mares of a certain color (I had read of wild stallions in America limiting their harems to females of a single color). Of the stallions I saw bred, most had no color preference; however, some did prefer either light or dark mares. A few studs' color prejudice caused them to be so slow in achieving an erection with, for example, white mares (when they were excited by brown ones), that a dark mare would be presented and, once the stallion was sexually excited, she would quickly be replaced by the light-colored female who was scheduled to be covered. When color prejudice does occur, it usually stems from a stallion's memory of the first mare he covered. With the exception of one or two animals, all the stallions studied showed much more interest in young virgin mares than they did in the eighteen year olds they were frequently chosen to mate.

P. 73 Here the Conde de Odiel's stallion, Divertido, though he has not achieved a full erection, tries to cover a mare he has just mounted. The stallion's half-aroused state shows he is either young and inexperienced or that he has already copulated with this mare—no wise stallion would attempt to mount a female unless he were positive she was in heat and few stallions, having proved to themselves the receptiveness of a mare, would not, at this moment, have a full erection. If the stallion were not absolutely certain that the mare was ready for him and still tried to mount her, he would risk having a back leg broken if she decided to kick.

P. 75 Paco Lazo's Nostálgico covering a mare in the field was photographed on one of the most beautiful early summer days I spent while doing this book. Before gentle but spirited Nostálgico was turned into this pasture with two mares in heat, a bay and a chestnut, his stable mate, the larger, rougher, more aggressive stallion, Dichoso, was placed with them. For their first few minutes together this excited trio galloped around the pasture, the stallion posturing, until finally the mares slowed down and he, head low to the ground, began to try to direct their course of movement. At last, when the mares stopped, Dichoso began smelling the bay's flank and, just as he had positioned himself behind her, she lashed out with both rear hoofs to thump him on the chest, blows that he was unable to avoid.

Within minutes the stallion turned his attention to the chestnut mare who started flashing, urinated, and assumed the sawhorse position. With a complete absence of foreplay, Dichoso smelled the urine, raised his head to "smile," and then mounted the mare. When a stallion throws himself on top of a mare he is often unable to find her vagina with his penis, which means that he shoves and pushes, positions and re-positions his hind quarters, while

clutching the mare's sides with his forelegs. Frequently, in their attempts at mounting, excited studs do not rear up directly behind the mare, which foils the possibility of entry. Most stallions, when they have made entry, lay their straining heads against the mare's neck or shoulder. Other, more passionate, males bite their partner's mane, ear or shoulder skin, or sink their teeth into her neck, lustfully drawing blood. Coitus usually lasts about one minute, though after ejaculation some stallions will, with a completely spent look on their faces, remain relaxed on top of a mare for another half minute.

Dichoso's thrusts were especially vigorous once he was on top of the mare, but he refrained from biting her neck. When copulation was over, the two horses started grazing together, at which time the ranch foreman entered the pasture and haltered both of them. After twenty minutes had passed, the stallion was freed, although the mare was held on a rein, for a second mating. It was then that Dichoso, once he had smelled the chestnut who had her legs spread and tail lifted, must have remembered the bruises on his chest from the bay mare's kick, for suddenly—by biting—he vented his hostility on the nearest female: the chestnut mare he had just covered and who at that moment stood waiting to be mounted. Naturally surprised, the mare screamed, lashed out with her hind hoofs, and from that moment it was impossible to hold her still as long as the stallion was near.

This seemed like the ideal time to test a mare's preference for or reactions to a stallion according to his reputation as a gentle or rough "lover," so I asked Paco Lazo if they could remove Dichoso and bring the "charming and suave" Nostálgico to the pasture.

When the chestnut mare heard the new stallion's distant neigh, she swung her head around to stare, with an obviously interested expression on her face. Whereas minutes before she had been fidgety, nervous and defensive, ears laid back at the three-fifteen position, the mare now stood completely still with her ears directed sharply forward.

As Nostálgico was led around to the mare's head and began to sniff at her muzzle, she assumed the sawhorse position, grinding her teeth and flashing. When the stallion nibbled at her shoulder and started to get an erection, the mare, who had previously been covered by Dichoso, was led from the pasture, for she had proven that she, at least, was partial to a particular sexual partner. Just as both horses were leaving the field, I asked Paco if we might continue the experiment with the other mare, the bay who earlier in the morning had kicked Dichoso and who had been taken to another enclosure.

As the bay was being caught, I wondered if she had lashed out at Dichoso because she had not been completely in heat; because she was with the chestnut mare and felt some kind of jealousy of her; or because on a previous

occasion she had also been roughly treated by the big stallion.

Once the bay mare had been brought to the pasture and was quietly grazing beneath a cork oak that served as my perch, Paco released the stallion. As Nostálgico approached the stationary mare, he raised his legs higher than even the unusually high natural Spanish lift, arched his splendid neck and came towards us fast enough for the wind to lift his black mane. Five yards from the mare his pace turned to a walk which led him slowly to within inches of her face. The stallion caressed the mare's lips with his warm, velvety muzzle, and she lowered her head, seemingly entranced by his sensual nuzzling. Already she was in the sawhorse position as Nostálgico nibbled at her neck and shoulder in gentle bites that left silver threads of saliva on her deep red coat. How different was this scene from that we had so shortly before witnessed between Dichoso and this same mare, or even with the chestnut he had covered.

As the stallion rubbed his muzzle against the mare's flank she turned her head to sniff at his genitals, softly nudging them with her muzzle. The stallion began to get an erection as he gently bit the elbows of the mare's hind legs. The horses were directly under my tree when Nostálgico, having smelled the mare's urine, lifted his muzzle, lips peeled back. Then his head flew up into the air, towards me, as he reared, mounting the mare. What a moment that was. The sun was high and there was no sound but the calling of a hawk and the stallion's heavy breathing, as the shadows of the mating horses moved slowly across the earth like a prehistoric cave-painting brought to life.

P. 76 In this photograph two horses mate in the marshes, under a tree full of cattle egret, night heron, little egret, purple heron and spoonbill nests. When a mare is in heat, a stallion will mount her several times a day. If a number of females come into season at the same time, not all of them will be covered. Witnessing courting and copulation in the free-living herd is an important part of a foal's or colt's formation. Horses who have not grown up in a family unit, like captive animals in zoos, are sometimes not effective breeders partly because, while young, they were deprived of the learning process of seeing their own kind mate.

Members of free-living herds watch with interest when a stallion covers one of the family mares. Foals in their excitement even get underneath the mating horses or jump around them. Occasionally a domestic stallion will turn colt killer, and, during breeding, nine- to eleven-day-old foals must be carefully guarded when their mothers are mated. This danger, however, is rare among free-living horses, though wild stallions have been known to kill very young foals who were slowing down the escaping herd. Fillies show an open curiosity toward pairs of mating horses, as do young 199

stallions, who often become so excited that they masturbate.

Settings, like the one in this photograph, provided the most pleasure during my hours of horse observation. To see animals living in semi-freedom such as in the Coto Doñana National Park or in the marshes—still wild and primitive as I knew them nineteen years ago—made the observer feel almost as though he were in paradise. Watching stallions and mares, curtained in diamond beads of spray, gallop through shallow water over which circled hundreds of egrets and spoonbills, their white wings flushed by the setting sun, I enjoyed priceless moments, seeing horses at home with nature and—thus—at their best.

P. 78 Being surrounded by spring flowers like these at El Hornillo, the Conde de Odiel's ranch, made doing this book even more enjoyable. California has magnificent fields carpeted solidly with golden poppies or Indian paintbrush—but nowhere in the world have I seen anything that could compare with the lush, wildly mixed varieties of flowers found in Southern Spain. Sometimes the colors seemed almost too intense, to the point that at any moment I expected an animated butterfly or sparkling Disney dewdrop to light on one of the blossoms that appeared in the camera's viewfinder. In scouting floral backgrounds for the photographs in this book, I imagined some of the excitement that Monet must have experienced when he discovered his red poppies, or that Van Gogh might have felt when his eye

zeroed in on a field of sunflowers. It is into this glorious setting that Andalusian foals are born.

P. 80 Eighteen-year-old Divertida, the mother of fourteen Conde de Odiel horses and of the stallion who appears on page 136, grazes, heavily pregnant, in a field of wild mustard. The gestation period of horses is from 320 to 355 days.

P. 82 During her fifteen years at El Hornillo, the mare in this photograph, Ibérica, has given birth to ten foals. Unusually youthful for her age, always ready to play or run, Ibérica, like most female horses, became quiet and serious during pregnancy. Even four-year-old mares, once they are in foal, behave in a more mature manner. As the fetuses grew inside them, all the mares at El Hornillo showed marked appetite increases. During the last three or four months of pregnancy, when embryos grow most, changes in the mares' drinking behavior could also sometimes be noted. It seemed that the very heavy mares drank less early in the morning. Perhaps especially cold water, if taken in large quantities, causes cramps and stimulates movement of the embryo. Some two months before birth, when the embryo seems to change position, mares appear not only to experience discomfort, but also sometimes discharge small quantities of blood or mucous. Especially important to free-living mares is their ability to delay birth a few hours. At least ninety-eight percent of the more than two

hundred pregnant mares that I observed foaled at night, usually in the hours shortly before dawn.

P. 84-86 The series of birth photographs on the following pages is the product of a small amount of patience and a great deal of good luck. When work on this book was begun, I didn't have the slightest hope of being able to include the birth of a foal in its pages. Experience from work on the bull book, when six weeks were spent before I was able adequately to photograph a fighting cow giving birth, convinced me of the impossibility of harboring such a hope, especially since the actual full working days of photography on this book would be limited to less than forty. "Horsey" friends were unanimous in their advice: "Concentrate on all phases of horse life, but completely dismiss the idea of including a birth in your book, an effort which will not only be a great waste of time, considering the almost impossibly short period allowed for photography, but which can only end in disappointment."

One spring morning, after watching the breeding of a mare at El Hornillo, I decided to wander down to one of the lower pastures where the foals and their mothers were almost sure to be found. Just before leaving the dirt road to enter an olive grove, I met the *yegüero*, Alfonso, who was complaining that one of the ranch's nicest mares, Noticiera, was several days overdue in foaling. "I don't know what's wrong with her," he grumbled as he left me

and plodded through the wildflowers that were still heavy with dew.

The clouds that had greyed the past week's skies had been blown from Andalusia. Somewhere ahead in the olive grove a nightingale was singing, accompanied by the faint, alluring sound of the mares' bells.

After reaching the herd, most of which were grazing in a field of mustard, the better part of an hour was spent photographing new foals at play. At about ten-thirty I decided to leave the yellow field; somewhere not far away the nightingale was still singing, and I wanted to try to get a close look at him. Of all the spring mornings spent on the book, this was perhaps the loveliest; the sky was so freshly blue, and dew was sparkling on the thousands of brilliant blossoms that spread out around the olive trees.

Locating the nightingale was not difficult, but staying with him as he tried to lure me from his nearby mate, who was sitting on a carefully woven, cone-shaped nest, was not easy. However, because there was nothing else to do—the sun was almost too high for good photography—I followed him.

After I wandered about a quarter of a mile, the bird's singing suddenly stopped and, as I swung around hoping to see his rust-colored body bursting in flight from one tree to another, I noticed a white horse spread out on the ground, almost hidden from view by low-hanging olive branches. At first, this sight did not rouse my curiosity; often mares could be seen stretched out in deep sleep, but usually somewhat earlier in the morning and closer to the

herd. Approaching the white mare, I noticed that she was breathing heavily and that her eyes were not shut—she was also obviously pregnant, but so were a number of other females in the herd.

When Noticiera heard footsteps she lifted her head and swung it around to stare with large limpid eyes. Fourteen years old, the mother of nine foals, she was handsome for her age and, washed clean by the recent rain, looked beautifully white against the thousands of flowers that blossomed around her. As I walked towards her tail she stood up, and it was then the thought flashed: "She's giving birth!" But, as the mare turned around and started to graze, no secretion could be detected coming from below her tail. Still, I was terribly excited. Then, seeing Noticiera on her feet, I began to worry that if she were really in the process of giving birth my presence might disturb her. Mares, I knew, could postpone foaling for hours. Off somewhere in the grove the nightingale had resumed singing and, trying to remember every landmark in sight—the grove was so extensive and each tree looked alike—I began walking in what seemed to be the bird's direction. I also checked my watch; I would give the mare fifteen minutes before returning to her.

I could barely contain the urge to turn back, as the nightingale's song grew louder. Reflecting on the existing birth photographs I had seen, before me appeared pictures of mares foaling at night, taken in boxes where the camera's flash gave a ghoulish cast to what should be a beautiful scene; the blood and placenta always seemed like something out of front-page photographs of a car accident. I thought of another set of photographs where the photographer had been lucky enough to find a mare foaling during the daytime, but the morning had been so grey and the mare's sides had been so dirtied with mud that the pictures, though they were fine shots, somehow seemed tainted, and had none of the freshness and poetry of creation that vibrated from the animal and setting that waited so close to my lens.

When eight minutes had passed I turned around and rapidly but cautiously retraced my steps to one of the larger olive trees that stood not more than twenty feet from where I had left the mare. Through the leaves Noticiera could be seen stretched out on the ground, a pair of small, blue hoof tips just emerging from below her tail! Obviously, before lying down she had expelled the birth water, and was now on her side, which would help to press out the foal. The mare sighed and her sides rocked with heavy breathing as she lifted her rear top leg into the air, straining to force out the baby horse that her belly had carried for nearly a year. Almost ten minutes passed before the foal, except for its hind legs, slid from its mother.

P. 89 The foal, who had been sleeping inside his mother, was not only suddenly bumped awake as he slipped onto the ground, but was also shaken into consciousness by the terribly bright light around him. Front-lit, the scene

was beautiful, but it became even more poetic when I moved around cautiously to the other side of the mare to photograph the back-lit foal. Noticiera, breathing hard, was still in too much of a trance from the birth to notice me. When the foal became more awake, he lifted his head and a front hoof to break the sac, which hung over his head like an Arab hood.

P. 91 In this photograph the foal's hind legs are still inside his mother. The sac membrane was strong and not easy for him to break. After about ten minutes, Noticiera raised her head, glanced back at the foal and then, with a great effort, got to her feet as the foal's back legs slid free from her body. The mare turned around and looked curiously at the foal, as if to say, "Where did you come from?" before she briefly licked his muzzle, probably instinctively trying to remove any remaining birth fluid from his nose.

P. 93 When the foal felt his mother's tongue he made a soft, bleating sound, which she answered. Seemingly stimulated by the brief licking, he feebly attempted to get up, which freed him from the sac. At this point, I was so caught up in experiencing the scene in front of me and enjoying photographing it, that I didn't have time really to reflect on my extraordinary luck.

P. 94 After another few minutes had passed, the foal again tried to get up. Watching him and his mother, who had started to graze, it was suddenly obvious how completely exhausted the birth had left both of them. Occasionally mares who give birth for the first time are frightened by the foal, an apprehension which disappears as soon as the new baby gets to its feet and takes on the appearance of a horse, though a very miniature one. At times the foal's completely wide-eyed look fully expressed his reaction to the newness of absolutely everything around him. Each time he tried to get to his feet, to make work the legs that had never been used before, he rose slowly and then wavered before tumbling back to the ground, limbs spread in all directions.

P. 96 Three-quarters of an hour had passed before the foal was able to stand and maintain his balance. Taking a few wobbly steps this way and that, his long, slim legs seemed not at all sure of their course. It was a great effort for such a new-born animal, and each time he fell to the ground he had to stay there and rest, before making another attempt to stand. Shortly after he was able to keep his balance, one of the younger mares appeared through the trees and came curiously toward the foal. Noticiera, who had seemed to pay abnormally little attention to her new offspring (from the time she had licked his muzzle she had continued to graze), lifted her head in threat, ears flat back, neck outstretched, teeth showing, to discourage the young mare from approaching any closer. The foal's sense of balance was still so delicate that it seemed if the slightest breath of wind

swept through the grove he was sure to capsize.

P. 98 In this photograph the mare grazes, the torn sac still hanging from under her tail. A few minutes later the afterbirth was cast out (horses, unlike other animals, rarely eat their afterbirth). Then, the foal, who had been nosing around his mother's forelegs, sides and tail, knowing instinctively that somewhere there was something to be found and sucked, discovered one of Noticiera's bulging teats. In those moments the foal appeared to be in a vegetative state, barely able to make out forms, his muzzle testing rough and smooth surfaces, his ears, eyes and nose taking in stimuli that were all then unidentifiable to him. The mare, however, at precisely the wrong moment, took a step forward toward taller grass, and the foal lost contact with the udder. Those were anxious moments—I wanted to put down the camera, take hold of Noticiera's bell strap, grab the foal and press his muzzle to the mare's udder. Finally, though, he found the teat again and fastened on. A few minutes later he stopped drinking and lifted his tail to expel a thick, bad-smelling excrement, the digested product of the metabolism of eleven months as an embryo. I released the camera and let it swing from the shoulder strap. My watch showed just before noon. I had been with the mare for little more than an hour, and now she was moving off into the olive grove with the foal behind her, and what a handsome *potro* he was. It was then I named him—Potri—though Noticiero would be written on his pedigree. Walking back through the olive trees, I felt completely but joyfully spent as the nightingale sang somewhere ahead. Every minute of that walk through the grove I tried to enjoy, knowing that shortly my happiness would be blemished with the worry that the undeveloped film of the birth would be lost in the post or damaged in developing.

P. 100 At El Hornillo, the two-day-old daughter of Revoltosa fills her stomach. The foals spent their first few days nursing, exercising their legs and becoming acquainted with everything around them. However, it seemed that most of their time was spent sleeping, periods of rest that lasted from twenty minutes to an hour. Once they were on their feet they nursed every ten to fifteen minutes; short feeding periods that prevented their stomachs from becoming too full.

P. 102 For the first week after Potri was born I returned to El Hornillo as often as I could to see him. The photo on this page shows him walking along behind his mother. Because I was the first living thing the foal had seen after being born, and because his mother knew I presented no threat, I had little trouble getting as close as I wanted to both of them. Noticiera only threatened me once or twice, and then it was because I had approached her from down wind in the pasture and she had been startled by sudden, nearby movement before she recognized my form. None of the mares was allowed to approach the colt, and once Noticiera attacked a burro who in curiosity was sniffing at Potri. Most of the mares at the ranches where I worked, those with new foals, would start walking away if I got too close to them or their young. Some were very touchy about my presence, as were their foals. Because of this,

it was a real joy to have established a close relationship with Noticiera and Potri, for when the light in the grove was too white for the kind of photographs I wanted I would seek out the mare and her black offspring, and spend those afternoon hours, until the sun was lower and the light was warming up, playing with the colt or lying in the flowers near him and his mother.

P. 103 A Quarter Horse mare and her foal emerge from a lake at Los Millares. Horses are natural swimmers and foals can take to water, if the distances are short, when they are surprisingly young. Upon emerging from water, equines spread their legs, sawhorse fashion, for stability, and then what first starts as a head shake travels all along the animal's body to the root of its tail.

P. 104 These spring flowers filled the fields at El Hornillo, where I spent most time working with mares and foals. It was here that I first observed that foals, almost without fail, inherit hierarchical positions from their mothers. Inevitably, the offspring of high-ranking mares were privileged with their mothers' positions in the herd, just as the young of low-ranking mares were generally low on the social totem pole in relation to their contemporaries. Obviously, there are certain genetically inherited characteristics that are essential to achieving

high rank, such as the physical ability to be extremely active and aggressive.

At El Hornillo, each member of the herd respected Potri as much as they did his top-rank mother. The black colt could afford to be mischievous, teasing the other foals and some of the older mares, because he was always able to run to Noticiera. He could be seen growing up with a feeling of self-confidence, something that was lacking in the offspring of most submissive mares. Even though the foals of insecure mares might be bigger and stronger than their contemporaries, it seemed almost impossible for them to obtain a higher rank than that of their parent.

P. 106 This filly foal stands beside her mother in a field of poppies, daisies and wild mustard at El Hornillo. When vegetation is abundant foals, toward the end of their first month, nurse less and nibble more at grass. This nibbling, however, begins shortly after birth, for in their curious explorations of the world, baby horses test all sorts of objects with their mouths, chewing and sucking branches as well as the hair of other horses. Now and then some animals experience a hair mania, and as adults are a serious threat to the good looks of horses with long manes and tails. In arid regions, because foals need to obtain nourishment by drinking more milk, which extends the period of suckling, some mares are reported to conceive every other year, so that their foals

can nurse longer and have a better chance of survival.

P. 108 These foals meeting one another at El Hornillo are both moulting, as can be seen from their mottled coats (most Andalusian foals are born with dark hair which later turns grey and eventually becomes white). Friendships usually develop between horses of similar temperament, and practically always between young animals of the same sex. Apart from engaging in running games, filly foals are more subdued than are young males, who quite early begin to form their own "gangs."

P. 110 At Vicos two Arab foals engage in mutual grooming, a pastime young females prefer to the rougher games of colt foals. Grooming among young horses usually terminates with running contests or playful fighting. Foals, until they are well over a year old, show little interest in mud and dust baths, probably because they spend much time on the ground where they can rub and scratch themselves. Stallions rarely groom their foals.

P. 112 At El Hornillo this foal dozes in the late afternoon, lulled by the singing of goldfinches and nightingales and the call of cuckoos. While their mothers moped at El Hornillo and Vicos, most of the foals I watched dozed. To doze—the horse's second and more intense way of sleeping—the animal lowers itself to the ground to rest in a huddling position, legs half positioned under the body, and the head either raised or stretched out on the ground. A few of the mares at El Hornillo, as far as I could tell, never stretched flat out on the grass in the deepest form of sleep, but seemed to prefer the huddling position. They were generally animals that were either heavily pregnant or of uneasy temperament. When horses get up from this position, they first straighten both forelegs, pull their back legs under their bodies, hunch, and with a strong push of the hind legs, stand up.

P. 115 Here Potri is sleeping so deeply that I could touch him and he would not awaken. To prepare for this third and deepest form of sleep, horses roll from the huddling position completely onto their sides, with head, neck and body relaxed flat on the ground. During deep sleep, which usually takes place more often at night than in the daytime (unless the ground is very wet), they are almost completely unconscious. I always enjoyed watching Potri when, having woken from deep sleep, he got to his feet to stretch, arching his neck and back like a cat, rising up on the tips of his hoofs to stretch his hind legs one after the other. When he was less than a week old, he would become so tired from any activity that often I had to laugh as he literally threw himself into tall grass, to fall deeply asleep immediately, with Noticiera moping or grazing nearby. Since mares feel most responsible for their

youngest offspring, several times I saw Noticiera chase off—in a real show of temper—her two-year-old daughter when the filly became too rough with Potri.

In the weeks that followed, the white mare's concern for the whereabouts of her foal lessened, and on more than one occasion Noticiera followed the grazing herd, leaving a sleeping Potri behind. When the black colt awoke and couldn't find his mother, terrified he began neighing and galloping up and down until he heard either Noticiera's bell or her short, guttural call. Of the young foals at El Hornillo, the only one I ever saw mope was a sick filly. Sick adult horses rarely lie down—they seem to fear being unable to get up if danger presents itself.

The horses I watched would never rest just anywhere. They had special places, and while the mares at El Hornillo often had favorite trees for moping, deep sleep always took place with the animals stretched out in the open where the wind's messages could easily reach them. Apart from choosing areas that offered more security by being open to the wind, the mares' only other bedding preference seemed to be that of dry ground.

The normal distance horses keep from each other while grazing was generally respected at rest time. For example, one ancient white mare at El Hornillo, who seemed to enjoy her solitary life, grazed far from the herd and also stayed away from the others when she slept. However, family members, especially young foals,

could often be seen sleeping in close proximity, occasionally even touching one another.

P. 116 Three days after Potri was born, I was in the grove watching him and his mother when suddenly he stopped nibbling at a fallen olive branch, looked about with wide eyes and then stretched out his long, thin legs to gallop in tight circles around Noticiera. It was one of the most delightful displays of freedom I've ever witnessed. Around and around he ran, like the brown filly in this photograph, galloping full out until even his mother had to lift her head from the grass and stare. Obstacles that lay in his path he leapt with complete confidence.

In the weeks that followed, Potri often repeated his running games; the gallop became faster and the circles larger as he grew older. It was fascinating to watch him learn about himself and the world around him. At first it wasn't easy for him to keep his balance when he tried to scratch behind an ear with a rear hoof tip; and he was forever licking, tasting and gnawing at almost everything he encountered. When he tried to imitate Noticiera grazing, his neck was so short that he had to spread his legs out, giraffe-fashion, to reach the grass. Potri had great ability to learn, something that is imperative to the survival of horses in the wild. He was curious about everything, and ever ready to play, even if he could only find some tall flowers to run back and forth through or a butterfly to chase.

P. 118 This is the same filly as on the previous page, shot at one-sixteenth of a second as I panned the camera after her while she practically flew through a field of poppies. Often a foal would start circling its mother and then dash off to race through the grove with a "school" of friends. The raising of the tail root was a sure sign of the wish to run, and once the colts were rushing through the flowers, even some of the old mares would join them. Running is so contagious to horses that if one starts, most nearby herd members join in.

P. 120 At the age of about two months, male foals, like the one in this photograph, running through a field of wild mustard, are forever engaged in vigorous play, pushing and nipping at each other, while laying down the rough framework for future fight games. When one foal, wishing to play, approaches another, he not only approaches with both ears pointed forward, but also wears an expression that can only be described as mischievous!

Potri not only had a stronger play instinct than the filly foals around him, but unlike them showed an interest in sex when only several days old. Often while smelling his mother's genitals, he would spring an erection, and not much time passed before he began to mark excrement with his own urine. The older he became, the more clearly could be seen the stallion in him.

P. 122 Early summer has already dried this field at El Hornillo. The foal stands, his ears pointed forward; no visual stimulus is present, so he cocks his ears in search of sound. To watch a horse's ears working independently of each other, the right one pointed forward while the left is turned toward the back of the head with the aperture in a lateral position, is like watching two radar antennae rotating at the same time but scanning in opposite directions. If a colt's mother is out of sight, he relies on his ears and nose to locate her.

P. 125 Red poppies like these photographed at El Hornillo blanket expanses of cultivated land in Southern Spain. A photograph that I really wanted for this book was one of a white horse in a poppy field. Rainy weather, the threat that upon the first hot day the flowers would lose their petals, the difficulty of finding a handsome white stallion who would stand still for the photograph, had me uptight, but finally the skies did clear, the petals didn't fall, and the stallion didn't run away until the last roll of film was in the camera.

P. 126 Here Majestad "poses" for the poppy field photograph. His sharply pointed ears show him to be alert to some sound, in this case the neighing of another horse. When facial and body signals can't be seen, horses use their voices. At El Hornillo, for example, with its fairly dense olive groves, there was more vocal

communication among herd members than at Vicos, where there were few trees to obstruct vision—and where repeated calling was unnecessary to keep the herd together. Potri only used his voice if he suddenly found himself alone, separated from his mother. Noticiera, because she was an older mare who had foaled many times, didn't seem as concerned with her son's cry as were new mothers, and often was fairly late in giving him a reassuring answer. As the black foal grew older, Noticiera's vocal response to him changed from a reassuring neigh to the contact call normally used by herd members. All the horses I observed seemed to recognize each other not only by sight but also by their different voices. The high voices of the colts begin to change at puberty (roughly at one and a half) and reach their full depth at the age of two to three.

P. 129 In the early morning at El Hornillo, upon finding the sleeping herd, I felt as though I had come across some bloodless battlefield, with horses' bodies flung out flat and still in all directions.

This seven-year-old Conde de Odiel mare, Tamborilera, was sleeping so soundly that minutes after the photograph was taken, I touched her lightly and still she didn't wake. Breathing loudly, something most horses do in deep sleep, she was probably dreaming—moaning and groaning, as well as twitching her eyelids, ears, and now and then a leg. Patrick

Duncan told me he's not only sure that horses dream but also that males sometimes have erotic dreams. Several times he's observed his Camargue stallion in deep sleep, breathing loudly while voicing courtship sounds, only to wake in a flash, spring to his feet and mount the closest mare.

When finally I touched one of Tamborilera's hoofs she gradually began waking in various stages of consciousness. First her breathing changed, becoming forceful and louder. A couple of minutes passed before her ears showed more pronounced movement, her eyes opened and a few seconds later she lifted her head, stared at me through half-opened lids, then put her head back to the ground. In less than a minute, however, the message that something was not right reached her mind and she raised her neck, bent back her head, straightened her forelegs and jumped to her feet.

Many horses live their entire lives without being able to stretch out on the ground to enjoy deep sleep—their only form of rest is moping. At El Hornillo I rarely saw a mare sleeping deeply for more than an hour. The combined resting period for adult horses observed—moping, resting and deep sleep—averaged about six to eight hours a day. At the Andalusian ranches, not only did most births take place between midnight and sunrise, but horses also slept deeply during those hours. A possible explanation for these time preferences: since

most predators hunt and kill between dusk and midnight, the safest hours of darkness for a horse are those from midnight until dawn.

P. 130 In this series of photographs, together with the photograph on page 131, the four-year-old stallion Farruco, owned by the Marqués de Salvatierra, gestures, postures and plays, assuming attitudes that are not only obvious expressions of joy, but which also spell "stallion." When the photograph on page 131 was taken, Farruco was also neighing. His imperious call differed from the voices of the Salvatierra mares around him, being clearer and more penetrating, and having a metallic tone distinct from the tonal quality of females. As soon as Farruco saw or heard a mare he gave the stallion's high neigh. I often wished I had recorded on tape some of those rolling and impressive sounds that seem to come from a stallion's very depths and that are heard most often during the spring. The shrill, abrupt war cry that males emit when in close contact with one another, lifting their legs stiffly to strike at the ground, is fascinating.

During love games, mares have their own forms of vocal expression. Females (such as the one at Paco Lazo's ranch) who are not ready to be mated but are bothered by a stallion, use a scream that starts out almost normally but can build to a real war cry. Mares also screech when squabbling and kicking at each other, but seem to avoid serious battles by arguing, something they do quite often. I almost never saw one female rear up against another in battle. In most fights the mares used their back legs to kick out violently. A sexually "hot" female will occasionally grind her teeth while she is flashing, as well as use subtle neighs to encourage a stallion.

Often, if I surprised an animal of either sex in the open field, I was greeted with yet another vocal signal, a warning snort which seemed a breath of apprehension issued almost unconsciously, but which served as a warning to herd members.

132 At Vicos, a young Arab stands on his favorite ridge, which overlooks a meadow where the herd grazed most afternoons. Some animals seem to become quite attached to certain areas. Most hot summer afternoons this same horse could be found either on the ridge or walking toward it, shaking his forelock and mane up and down or from side to side in a continual effort to shoo away the flies. Horses also have the ability literally to vibrate their skin in order to flush insects.

When equines are in the herd or alone, like this Arab, they often groom themselves, using their teeth to scratch their shoulders, backs, legs, stomachs and flanks. Scratching is also done with the fore edge of a back hoof, which allows a horse to reach areas that are inaccessible to his teeth—behind the ears and parts of the head and neck. When a horse is scratching

himself, generally done slowly, seemingly to savor every second, his satisfaction can be read in the look of complete ecstasy on his face. Low-hanging olive branches were used as back or rump scratchers by all the mares at El Hornillo.

P. 134-5 Shown on these pages are some young Ecija bachelors at play. Much play time was spent practicing posturing and threat displays. The young males were far more active than the fillies at Vicos and gave the impression that they were cleverer, being more interested in everything new around them. On several occasions I also saw them mark each other's excrement. When this book was started I wondered if family stallions marked territories with excrement, something I was never really able to prove. The freest animals observed (those with almost unrestricted territories) were the marsh horses that I had casually watched years ago, and I had not then cared about or been aware of this kind of equine behavior.

The family stallions at Paco Lazo's ranch and at Los Millares seemed to mark certain places in their pastures with dung and urine. What was clear, however, especially at Paco's, was that the stallion, when he came to fresh mare excrement, would smell it, "smile," and then usually mark the spot with his own urine. In the marshes I observed that one group of horses, when they came to a road that had to be crossed daily, would frequently defecate, seemingly from nervousness.

Last spring, when I started visiting the horse ranches of Andalusia, I asked country people if they had noticed horses in the pasture marking boundaries with excrement. Though the answer to this question was generally "no," most of the grooms said that stallions quite clearly marked their boxes—which can be considered territories—each time the straw was changed. After a summer of observation, however, I concluded that in fact these stabled stallions were not marking territory, but simply waiting until the box floors were covered by clean straw to prevent their hocks being splattered with urine. On a number of occasions in the field I did see both stallions and mares seem to choose ground that was soft or covered with grass before urinating.

P. 136 Divertido, like most of the horses I got to know, had a strong personality. Aggressive, determined horses—regardless of size and strength—usually get their own way. It was easy to rank animals in the dominance hierarchy, observing how each was punished or respected by the rest of the herd. Superior animals were always the first to eat and drink or to use prized dusting and scratching areas. Once an animal had achieved a high rank he jealously guarded his position and when not given proper respect he laid back his ears and started swishing his tail. If he was ignored,

he extended his neck, showed his teeth and, if necessary, either bit or kicked.

The respect shown a couple of the stallions at Vicos was such that the other bachelors seemed too overwhelmed even to think "challenge."

P. 138 At Vicos, I watched horses like this young Arab mare gallop, jump and leap in what to the horse, apart from sex and eating, is undoubtedly the ultimate pleasure—running. Often young animals would race off half a mile across a field, one chasing the other, until they were just specks in the distance, where they would stop to rear up against one another. During those late summer afternoons in Andalusia, I felt privileged to be the only witness to equestrian spectacles that included variations of the curvet, cabriole and levade, performed by horses living in semi-liberty against backgrounds of summer-yellowed fields or the purple mountains of Ronda.

P. 140 Vasallo, the ten-year-old Cárdenas stallion, performed so beautifully when set free that I wished the camera in my hands could be used for motion pictures instead of still photographs. Working with Spanish stallions all summer, each day I was more impressed by their nobility. While we were resting between photographs I often went into the enclosure with free-running Vasallo, who not many days before had been covering mares, put my arm around him and brushed his long mane. He was such a splendid subject that, upon receiving the developed film I had taken of him, and finding that the camera had malfunctioned, and that roll after roll was black, I returned to Ecija in 114°F heat to work again with the white stallion—and every second of that time with Vasallo was a pleasure.

P. 142-3 In these photographs appears one of the "grand old men" of Spanish horses, the Terry stallion Nevado. Without exaggeration, when working with horses like Nevado I felt as privileged as if I had been photographing Goya's in the Prado. The men, like Sebastián Gómez of Terry, whose jobs and lives were these horses, made the afternoons in Southern Spain doubly enjoyable. Jerezano, Divertido, Nevado, Vasallo, Farruco, Nostálgico and Majestad are names I'll never forget, and the memory of them will always stir up recollections of the most profound beauty.

P. 144 A summer evening at the Puerto de Santa María beach with the Terry stallions Hosco and Nevado, was 'the perfect way to finish work on this book. When Nevado was close to his son, he often postured, neck arched, and once reared up against him. The neck is not only one of the key forms of communication among horses, but tail lifting is also used by both mares and stallions. The degree of raising or tucking of the tail and, most important, the

elevation of the neck, as a prelude to the arching of the crest or extending or lowering it, are codes in the "reading" of a stallion's aggressiveness or temper. When one stallion is trying to impress another, he arches his neck to the most imposing attitude possible, ears are cocked forward, nostrils half-flared, and the tail is raised. The lateral swinging of head and neck increases the sense of superiority. Again, however, the most common threat warning is signaled by the ears.

P. 146 A herd of Spanish mares at Los Millares bursts across a lake in late afternoon. In moments of panic like this, all signs of herd hierarchy are dissolved.

P. 148 At two thousandths of a second, the camera freezes Nevado's mane in the air and his ears in a lateral position. The appearance of a horse in photographs can vary drastically from one frame to another. Some stallions are beautiful but not photogenic, others are not so beautiful but very photogenic. Nevado was both.

P. 151 These grazing mares at Vicos may spend the next twenty years of their lives at this same ranch, being bred year after year to some of Spain's finest stallions. Often it appeared that the brood mares were overworked mothers; bred one spring, in foal for the next eleven months, and just nine days after giving birth, mated once more. However, on second thought it seemed that the greatest pleasure in life for most mares was sex and taking care of their young.

P. 152 The Marqués de Salvatierra's Orgulloso rears up in a grove of poplars. As I photographed stallions in scenes like this, I couldn't help but imagine the excitement horses have stirred in artists since the beginning of time, an excitement that is the best testimonial to the animal's beauty.

P. 154 A group of mares gallops under the tree where I was waiting at Vicos. Even though moving rapidly, there still appears to be some unity to the herd. At most ranches, animals could be seen day after day walking in single file from food to water or from dust bath to moping tree. Trails etched into the earth were proof of their habitual use, whether on the side of one of the hills at Vicos or scored across the flat marshes. Well-worn paths were found even in small pastures. Horses are such animals of habit that they not only eat and drink at approximately the same time each day, but also may be found under a moping tree at close to an established hour.

P. 156 This Quarter Horse mare at Los Millares swam a few circles before returning to shore. Several times when I watched herds of mares wade into water, which was soon over

216

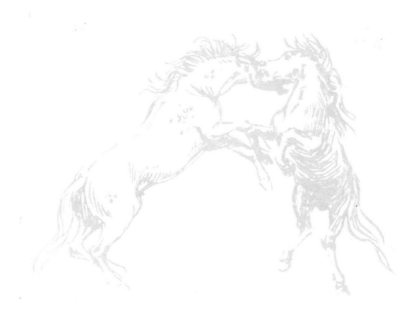

their heads, they were always led, as in the pasture, by one of the older females, not necessarily the highest-ranking horse.

P. 158 At Vicos a Spanish horse crosses the crest of a hill at sunset. Scenes like this made me feel close to Arizona and California.

P. 160 This photograph of Nevado was the last picture taken for the book, and as the horses were led from the beach and I was packing up my cameras, I felt some sadness, knowing that soon I would be leaving Spain for a stay in California where I would miss the beauty and gentleness of Andalusian stallions. However, a few days later I was surprised to hear that in my home state not all that far from Uncle Charlie's Last Gate Ranch and the stock yards of Downy, there was an established breeding herd of Andalusians said to be related to Nevado and in number larger than all but two of the herds I had been working with in Spain.

Until I phoned Jesús Terry, I doubted this could be true. Before 1963, by government regulation, Andalusians were not allowed to leave Spain, and even since the lifting of this embargo, the U.S. Department of Agriculture's health tests make importation of Spanish horses just about impossible. Also, I had always been under the impression that the Terry ranch (which has the most sought after of Andalusian blood lines) had never sold mares.

Greg Garrison, a Hollywood television producer, by his unwavering determination and dedication is responsible not only for the first serious introduction of Andalusians into North America, but for establishing a breeding farm that is the largest in the Western Hemisphere. Garrison's horses, which are as fine as anything to be seen in Spain, are mostly the progeny of Spanish Grand Champion Legionario III (of Terry), and of a number of Terry mares that were sent to America in foal. The story of how Garrison was able to obtain these ''unavailable'' animals and get them to his ranch in Thousand Oaks (where his herd now numbers over 50), is material for a book in itself.

Legionario III, shown on this page in John Fulton's drawing, is an animal splendid enough looking to make me regret he had not been in Spain when I took the photographs for this book. Seeing at first hand Garrison's dedication and search for perfection as I later accompanied him to Spanish ranches, and considering the beauty and noble disposition of Andalusians, it doesn't surprise me that his Thousand Oaks farm has for its clients Orson Welles, Dean Martin, Jimmy Stewart and other celebrities. Happily, the Andalusian in its purest form, after an absence of nearly five hundred years, has returned to North America.

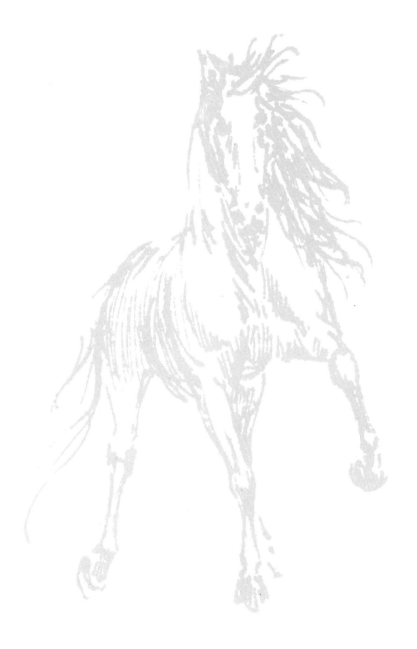

While the Spanish edition of this book was being printed, I had the good fortune (thanks to Laura Castroviejo of the Coto Doñana) to meet the ecologist Dr. Patrick Duncan and his wife, Clare. Our introduction was especially happy, considering the hope expressed in this book that further studies of equine social behavior will soon be done.

Patrick, who has spent years of field study in the Serengeti, is now working on such a project in the Camargue. I thus had the opportunity, often feeling remote in Southern Spain with few sounding-boards for my work, to show him the manuscript of this book.

Not many days after our visit (which had lasted into the early morning hours), I received from Patrick the following letter, which seems a fitting end to these pages:

Station Biologique
de la Tour du Valat
Le Sambuc, Arles, France

November 1st 1976

Dear Robert,

Of all that Seville has to offer, meeting you was the most rewarding. It was exciting to see the photographs, illustrations and text for your remarkable book, and to have the opportunity of discussing them with you. As a student of horses over the last two years, I was able to learn from your own acute observations of horses' behavior, which are illustrated so well

by your photographs: these are of considerable scientific value in addition to their beauty. The reader is moved by, and will also learn much from this book. Communication between horses, as you show, is subtle: for example, it may rely on nuances of facial expression (fleeting signs such as the configuration of a stallion's lips or the flaring of his nostrils), and olfactory signals that the human nose cannot detect. While in the text, you rightly stress the intensity and frequency of ritualized sniffing (particularly between stallions), your photographs are a unique record of the less obvious means of visual communication.

Why has the horse, inspiration of so much creative art over millennia, been so little studied except in captivity or for breeding purposes? This lack of scientific attention is particularly striking when contrasted with the abundance of excellent new work on the behavior and ecology of exotic and distant species, such as gorilla and lion (George Schaller), elephant (Iain and Oria Douglas-Hamilton) and chimpanzee (Jane Goodall). As for the genus *Equus*, the best behavioral study is that of the plains, Grevy's and mountain zebra in South and East Africa by Hans and Ute Klingel. Zebra live in ecosystems not yet dominated by man and where, we presume, conditions are similar to those under which they evolved. But the results of studies of free-living horses (such as mustangs in the U.S.A., or the New Forest ponies of England) are hard to interpret, since man has altered not only their genetic make-up (by artificial selection) but also the conditions under which they live (most obviously, by reducing the numbers of predators or even eliminating them). This difficulty may largely explain the paucity of scientific studies of the horse.

However, I thought you would be interested to hear more about the research in which I am involved. In the Camargue, a study of horses' behavior and ecology was begun three years ago as part of the program of the Foundation Tour du Valat, an organization created by Dr. Luc Hoffmann to promote conservation in the Camargue and similar Mediterranean environments. In spite of industrialization, intensive agriculture and tourism, the Camargue retains extraordinary numbers of water fowl (particularly in winter), important breeding colonies of herons and egrets, and the only European breeding colony of flamingoes. For over twenty-five years studies of the ecology, numbers and migration of certain bird species have been conducted at Tour du Valat; in the early 1970's the program was broadened to include studies of aquatic communities and of the commonest mammalian herbivores, namely horses, rabbits and coypu. Though herbivores are, in a sense, the product of their environment, they in turn modify it, and thus affect the plants and other animals. In the short term, horses may make trails and bare patches of earth (used as rolling places), open up reedbeds and keep down grass height; in the long term, their presence alters the biological cycles of matter and energy (by consuming and excreting large quantities of plant material).

The horse study involves several people and 219

has two aims: one is to describe the social organization which Camargue horses develop when human interference is kept to a minimum, and the other is to discover the ways in which the environment affects the horses and *vice versa.* A breeding herd of fourteen horses (one stallion, seven mares, six juveniles) was released in an area of 300 hectares containing plant communities as diverse as deep-water reedbeds, coarse grasslands and desolate salt flats. Various studies have been completed or are in progress—on social structure, stallion behavior, the mare-foal relationship, feeding behavior and diet, activity patterns, movement and choice of habitat—and we are beginning to get some exciting insights into questions which have interested you and which you raise in your book.

To work with horses which are not exploited by people, either for riding or for breeding (nor indeed for meat) is a moving experience. The first consequence of this lack of human interference is that there are in the herd (now totaling 33) animals of both sexes and all ages, and it is thus possible to watch the maturation of foals in a social environment which is richer than the standard artificial herd of brood mares. We have found (as you have seen) that after the stage in which foals' relationships with their mothers exclude almost all others they develop not only links with other foals but also strong bonds with their immature siblings. Within the herd, the horses live in matriarchal families. Females preserve weak family bonds, even after integration into the hierarchy of breeding mares, at two or three years old; young males, however, are closely associated with their mothers until sometime in their third year of life. Between 15 and 40 months of age, nine young males had left the herd and formed a bachelor herd; some of these were seen to be driven out by the herd stallion, and the evidence strongly suggests that they all were. Their mothers appear to have acted as a partial barrier against the stallion's aggression; nonetheless, for those which remained in the herd until their third year, these maternal links disappeared and the young males usually attached themselves closely to particular mares, selecting those who spent little time close to the herd stallion. In one three-year-old, behavior patterns typical of an adult stallion appeared: he drove mares, attacked young horses and became involved in conflicts with the herd stallion—with the full ritual of imposing postures, sniffing and defecation which you have described—and even combat.

After the exclusion of all the young (weaned) males, the herd stallion has recently driven a yearling female from the herd. Her arrival in the bachelor herd had a much greater effect on it than had that of the males, whose advent was marked by rituals and play fights resembling closely those you describe—*except* that we have not observed the presenting and leading behavior shown by submissives towards a dominant stallion in Spanish herds. The female and her two-year-old brother, who had not been members of the same herd for five months, immediately renewed their strong attachment

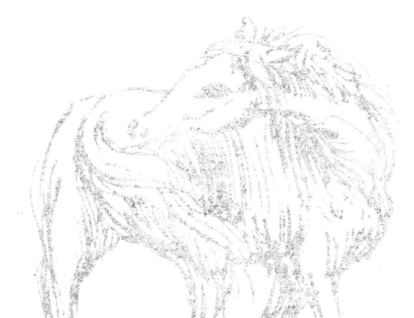

to each other; and the older members of the bachelor herd spent a day in intense conflicts over the new arrival which resulted indirectly in the death of the dominant one. At the time of writing, the "bachelor herd" consists of eight males and one female, living as a single group which has consistently displayed the kind of close attachments between individuals that you describe.

However, in their grooming behavior, Andalusian and Camargue horses differ; you interpret grooming as a major factor contributing to group unity, but in our herd grooming is rare—and never shown by the dominant mares. Obviously our study is young; group composition is changing rapidly and our breeding herd is very large compared to zebras and mustangs: we hope to continue for long enough to come to some firm, general conclusions.

Much of our effort has gone into studies of feeding, by which the horses modify their environment most. Observation throughout the year is showing us some of the ways in which selection of habitat and diet, and the time of grazing, are modified in response to the sharp seasonal changes which occur; experimental exclosures provide quantitative data on how the vegetation would be were there no horses. You have pointed out that Andalusian horses can feed very selectively; in the Camargue, we have found not only that horses feed very selectively, but also their selectivity changes dramatically from one season to another. For example, they feed intensively on reeds in spring and summer, but ignore them completely in winter.

Feeding behavior is thus flexible; social behavior is also subject to variation both within and between herds. And it is certain that social behavior can be understood only with a knowledge of environmental constraints, as you yourself point out. It is striking that the eye of the artist can see in a very short time what takes scientists years to discover and describe. Most impressive of all, to me, are your unprecedented observations of eye-rolling in experienced stallions—a facet of behavior which will no doubt occupy students for years to come!

Clare and I look forward greatly to a visit from you, and this brings our very best wishes,

Patrick

PS: A suggested bibliography for your book: 1) J. D. Feist (1974), *Behavior of Feral Horses in the Prior Mountain Wild Horse Range*, M.Sc. Thesis, University of Michigan, USA; 2) H. Klingel (1969), *The Social Organization and Population Ecology of the Plains Zebra* (Equus Quagga) and Zoologica Africana (pp. 249-63), and 3) M. Tyler (1972), *The Behaviour and Social Organization of the New Forest Ponies,* Ph.D. Thesis, University of Cambridge, UK.

ACKNOWLEDGMENTS

FOR the time, help and encouragement given me while doing this book, first thanks go to friend, publisher and printer Rudolf Blanckenstein, who kept my spirits up with his enthusiasm and advice for this project.

Patricia Luisa Serrano not only helped during the photographing of foals on a ranch near Sevilla, but upon her return to America she spent many hours supplying page after page of quotations from which most of the material used with the photographs was drawn. Without Patricia and her sensitive selections and long hours spent, it would have been impossible to finish the book within the four month deadline. Mary Boetticher, Carolyn Moyer and Marilyn Tennent also supplied quotations.

While working with mares and foals, I enjoyed the company and assistance of Jim Ray and Federico Fulton.

To John Fulton I am grateful for the splendid design and drawings he supplied.

Juan Manuel Urquijo Novales, the Conde de Odiel, was the first rancher to give me complete freedom of his breeding farm. During the hours spent at El Hornillo, I enjoyed the company and help, especially at breeding time, of foreman Antonio Garamendi Márquez.

For work in and around Jerez de la Frontera, I counted on the friendship of veterinarian Francisco Abad Alfaro. It was Paco who provided the introduction to a young rancher who is not only completely dedicated to his horses, and whose company and sense of humor I looked forward to enjoying during visits to La Ducha, but who often carried out personally requests for arranged situations with his horses. Antonio Romero Girón, who was a special friend of Bernardo González Real, will always have my deepest gratitude, as does his foreman, Juan Aguilar Herrera.

Quite by accident I met General Pedro Merry Gordon, the Captain General of the Second Military Region, and his charming wife, and once the horse book idea had been explained to him, the General took immediate interest in the project and generously arranged for visits to two of the Army farms in Andalusia.

At the Army farm at Vicos, near Jerez de la Frontera, I spent a number of days with the hundreds of mares and colts that are kept there, thanks to the wonderful gentleman who is in charge of that operation, Colonel Eduardo Pérez Ceresal. For work in the field at Vicos, I was assisted and given advice by Captain Antonio Ribarda González, and NCO Alfonso Cañero Muñoz. During those trudges around the rolling hills of the Army farm, I enjoyed the company and conversation of several recruits: "El Sevillano," "El Granadino," and "El Rubio."

Arrangements at the Army's farm near Ecija were kindly made by Colonel Antonio Doce López. At La Isla, I profited from the help and suggestions of one of the most charming and dedicated men I met during my work, NCO Antonio Sola Castillo.

It was Antonio Méndez Benegassi, a Sevillan veterinarian friend, who supplied some important introductions in this area. Through Antonio I met Francisco Lazo Díaz and his wife Mari Tere, who not only offered their assistance, but also perhaps the most open hospitality I have received anywhere. Paco even helped carry the cameras and umbrella. The umbrella was used to shade lenses from the sun, and on each of the occasions that we used it at Lerena

222

it brought rain to the countryside. I am also appreciative of the assistance given by Paco's foreman, Antonio Sánchez Carrasco.

For observations of marsh horses and work done at the Coto Doñana, I thank its director, Javier Castroviejo, and his wife Laura. During the past few years Javier has been an example of friendliness and cooperation on each visit to Doñana.

This book would have been incomplete had it not contained photographs of perhaps the most famous of all Spanish horses, the Terry stallions of Puerto de Santa María. I wish especially to thank Jesús Terry Merello and his wonderful old foreman, Sebastián García Nieto, for the time and interest they devoted to this project.

Though I had a short time in Ecija at the ranch of Miguel Angel Cárdenas Llavaneras, the owner's son, Miguel Angel Cárdenas Osuna, in his willingness to help, provided the opportunity to try for some photographs that I very much wanted to include in this book.

In Sevilla at the ranch of the Marqués de Salvatierra, one of the five most important breeders of Andalusians in this country, I was assisted by the owner's son, Rafael Atienza Medina, and by the ranch director, Francisco Montaño Galán, and had the pleasure of working several afternoons with foreman Manuel Cervera Camarero and his brother, Diego.

Michael Hughes of King Ranch España was the key figure in helping me through the last stages to publication of *Bulls of Iberia*. Once again, with this book, he demonstrated his great love for livestock, his generosity and his friendship, as he and a wonderful gentleman and cattleman, Bob Adams, actively helped to photograph the Quarter Horses and Spanish stock at Los Millares.

Some of the photographs in this book were in part made possible by the Club Pineda of Sevilla, most especially by José Calvo Dorca, Antonio Espigares Molinero, and Ricardo Jurado Castillo.

The fields of red poppies were photographed through the kindness of the Señora Viuda de Fernando de la Cámera, and with the assistance of her foreman, Antonio Cortez.

Félix Moreno de la Cova, Agricultural Delegate for Andalusia, provided sound advice, as he had warmly done for many of my previous projects.

For help with certain photographic problems, I thank my long-time friend and fellow photographer, Emilio Sáenz Cembrano, along with Santiago Saavedra Ligne.

Carolyn Murphy, friend and secretary, has my thanks, as does Perdita Hordern, Matthew Robinson, Jim and Abby Werlock, and Gerald Guidera for their help with the manuscript.

Time, advice, and various forms of assistance were generously given by old friends, John and Cecilia Culverwell, Guillermo and Virginia Benvenuty Díaz, as well as by Jacobo Delgado López, José María Conde Muñoz, and Ramón Guerrera and his sons.

For care and concern with book production, the staffs of Imprenta Sevillana, Folies and Fotomecánica Castellana have my deepest gratitude.

And for having such tremendous patience I thank all the mares who appeared in my camera viewfinder, especially Noticiera and her son Potri, as well as Nevado, Divertido, Vasallo, Majestad, Farruco, Nostálgico, Jerezano and Justiciero, the stallions who turned the spring and summer of this year into one of the most beautiful memories of my life.